U0038081

Before it was rare to live to seventy,
Today common to last a century,
Just as I write my own history,
Father at home becomes a memory.

從前七十古來稀，今朝百歲未稱奇，

正書他年陳舊事，家中父親正留離。

Wong How Man

In 2002, Time Magazine honored Wong How Man among their selection of 25 Asian Heroes, calling Wong "China's most accomplished living explorer". Other honorees are Aung San Suu Ki, the Karmapa, Yao Ming, Jackie Chan, among others. CNN has featured his work over a dozen times, including a half-hour profile by anchor Richard Quest. The Wall Street Journal has put him as a front-page story. Al-Jazeera's Anchor Riz Khan also conducted a half hour interview. Discovery Channel and National Geographic Channel have made several documentaries and features about his work.

Wong began exploring China in 1974 as a journalist. He is Founder and President of the Hong Kong- based China Exploration & Research Society (CERS), a pre-eminent non-profit organization specializing in exploration, research, conservation and education in remote China and neighboring countries. Prior to starting his own organization in 1986 in the U.S., Wong has led six major expeditions for the National Geographic. His writing for the National Geographic was nominated for the Overseas Press Club Award of America.

At the magazine, he was an explorer/writer/photographer and credited with the discovery of a new source of the Yangtze River. In more recent years, he also defined the sources of the Mekong, the Yellow River, the Salween, the Irrawaddy and the Brahmaputra.

Wong has authored over two dozen books. Among these, "From Manchuria to Tibet" won the prestigious Lowell Thomas Travel Journalism Gold Award in 1999. His book "Islamic Frontiers of China" was first published in the UK in 1990, long before the topic became of worldwide interest.

Today CERS operates several centers and small theme museums throughout Asia. Wong is often invited as keynote speaker at international gatherings for institutions, corporations and select groups of audience. He particularly enjoys speaking to students, at times to youngster in elementary schools where he found much similarity among students to his own life-long curiosity. His lectures have been honored as Best of the YPO, the Young Presidents' Organization. His organization is supported by private foundations and individuals.

Wong has received numerous awards, including an honorary doctorate from his alma mater the University of Wisconsin at River Falls where he graduated with a double major in Journalism and Art.

FOREWORD

Explorers are known for looking forward. How Man has acquired so much knowledge, that we have to be grateful if he is willing to also take a look back and share with us some of his experiences – and photos – of the past decades of his work.

He is, and always has been, a master in the dialogue with the environment and in transmitting this knowledge to his friends and collaborators. I have been fortunate enough to call How Man my friend for over two decades, and he has rewarded me with some of the most memorable trips and visits of my life. He is a master in planning for the unforeseeable and therefore thwarting potential dangers that any daring traveller would inevitably step into. His interests are so diverse that the expression 'never a dull moment' would be an understatement in his presence. The colourful diversity of his interests, from aviation to geography, from pipe smoking to religion and music, show his ability for a holistic approach in the passion and love for the countries he is studying.

We are looking forward to an exciting new series of books by How Man, sharing with us the beauty of his experiences and inspiring us to explore more of this world! How Man, thank you for your friendship!

Karl von Habsburg
HIRH Archduke Karl von Habsburg

PREFACE

I am sailing on the Meta IV in the Mergui Archipelago near the southern tip of Myanmar. The twin-mast yacht is 85-feet long, some twenty feet longer than the estimated length of the Santa Maria, the ship that Columbus sailed from Europe across the Atlantic in the late 15th Century with the goal of reaching China, unintentionally discovering the New World in the process.

This boat is a rather fancy ketch with five cabins on a wooden hull, decked out and detailed in teak. Unlike the Santa Maria, it is air-conditioned if one chooses use it. And this morning, four young Moken sea gypsy kids, in one dug-out canoe each, paddle up to trade some freshly gotten squid with us. No cash changes hands, it is just bartered in return for a few cans of soda.

Meta IV, a friend's yacht, is a perfect metaphor for a latter-day explorer whose journeys were first on land and now at sea. I started for China in 1974, followed by an overland trip in 1975 to explore the New World from North to South America by land, first in a van and then with a backpack. Today, our own HM Explorer on the Irrawaddy River is a hundred some feet long boat. The HM Explorer II, plying the southern seas of the Philippines, is almost the same length.

Another ship, far from our financial reach but still part of my exploration story, is the Space Shuttle Columbia. During Mission STS-2, the second flight of the Shuttle in 1981, it provided SIR-A (Shuttle Imaging Radar) data for our analysis to not only open up access to the empty quarters of the Silk Road around Lop Nor, but also allowed me to view from space the terrain and landscape of Hainan and Yunnan.

This year I turn 70, and my career is slowly entering its fifth decade, having started when I was barely 25. Why slowly? Doesn't time move faster as we age, checking it against not the external universal clock but rather our own internal calendar of time past, measuring the proportion against our own ages? As we age, that proportion becomes smaller, thus time should seem faster.

Exploration, however, is a very slow process. Knowledge, especially first-hand knowledge gained through discovery, takes time. Our ancestors spent millennia to gather such knowledge, which has become the base and foundation of almost all of what we know, of all of our second- and third-hand knowledge. Much of that knowledge may not seem relevant today, in an age of fast track fast return instant gratification. For me, however, the term R&R is not about rest and recuperation, it is relevance and reference. When knowledge is not relevant, it can still be used as a frame of reference.

It is for this purpose of reference that I choose to go back in time, selecting a few images out of the tens of thousands in my archive, in producing this book for reference by future generations. Yes, there is nostalgic reminiscence involved too - I am not entirely altruistic after all. How my generation and my world was may have little relevance to future generations, but it may still provide a reference for the younger set to understand our past as they chart their own exploration into the future; where we came from and how we got here, how our generation thought and acted. It is not only the destination but the process; that is just as important, if not more so.

Reference, hopefully, would allow our descendants to realize how fortunate they are and to value what is left behind to them as future custodians of our world at large and a heritage that may be unique.

May this book, first in a series of five, bring back memories for those of my generation, and provide some insight and reference for those of future generations.

Dr Wong How Man
Founder/President CERS

January 7, 2019

Content & Chronology

1974 – 1975 Beginning in China..15

1975 – 1976 North, Central & South America...........................31

1977 – 1979 Coastal & Southern China....................................59

Hong Kong and Macau in the 1970s.....................................105

1979 – 1981 Northern, Western & Southern China..................123

1981 Southwest & Coastal China..149

1982 National Geographic Western China & Tibet Expedition...................201

1983.1 National Geographic Hainan & Southwest China Expedition259

1983.2 National Geographic Northeast China Expedition..........................321

1974-75

I supposedly graduated from the University of Wisconsin in River Falls at the end of the fall quarter in 1973, toward the end of the year. I walked through commencement as if graduated, took an "incomplete" on my last course in Press Law without submitting the final paper on an independent study of British Press Law, and returned to a job waiting in Hong Kong. Armed with a newly minted double-major degree in Journalism and Art, only in photo but without the diploma, I entered an advertising company.

Soon after, I befriended some "leftist' journalists and newspaper people, and began my first of many excursions into China. Every long holiday I had, I went to southern China, then soon started to roam further north. From shooting with negative films, I quickly switched to positive slides, Kodachrome X as the ASA64 films were known then. An extended trip in December 1974 took me from the southern city of Guangzhou to Beijing and beyond, including cities in Liaoning, then considered the southern capital of Manchuria.

I marked each paper frame of the slides by hand, started with A to Z, but over the 21-day trip, it did not reach even Z, only up to K, accounting for eleven rolls of film. Each frame was also numbered, for example, A1 to A36 for the first roll, so on and so forth. Thus began my first foray in photographing China. A few minor trips followed. But it never occurred to me at the time that over the next four and a half decades, my archive of China photos would accumulate over time to exceed a quarter million images.

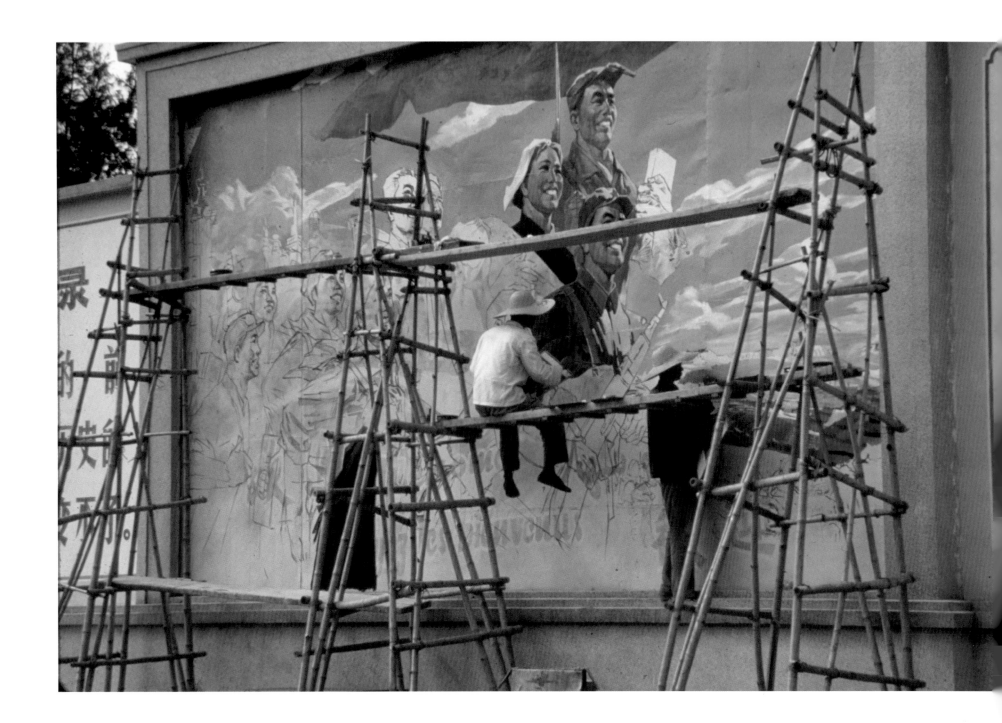

This photograph, marked by hand on the slide frame as A1, started my long career of almost half a century in documenting China. To date, it culminated to well over a quarter million images. Like the video films I made, my old as well as current photography are not considered part of "Media", but instead they are "Records". If I use it for this generation, they may be fitting as being a part of media, in order to reach out, be it for vanity or to advocate something I believe in. But as "Record", like archival material, it will serve many more generations, into the future.

The picture was taken in December 1974 as I crossed the border from Hong Kong into Shenzhen, before boarding a train to continue my journey to Guangzhou and onward into the great interior. The mural, depicting popular propaganda theme of the time, highlights the Worker, the Farmer, and the Soldier, as trinity flag-bearer of the Chinese masses. Murals like this one from the Cultural Revolution, painted at the entrance to the Overseas Chinese Hotel situated next to the railway station, greets every passenger soon after crossing the Shenzhen river into China.

/

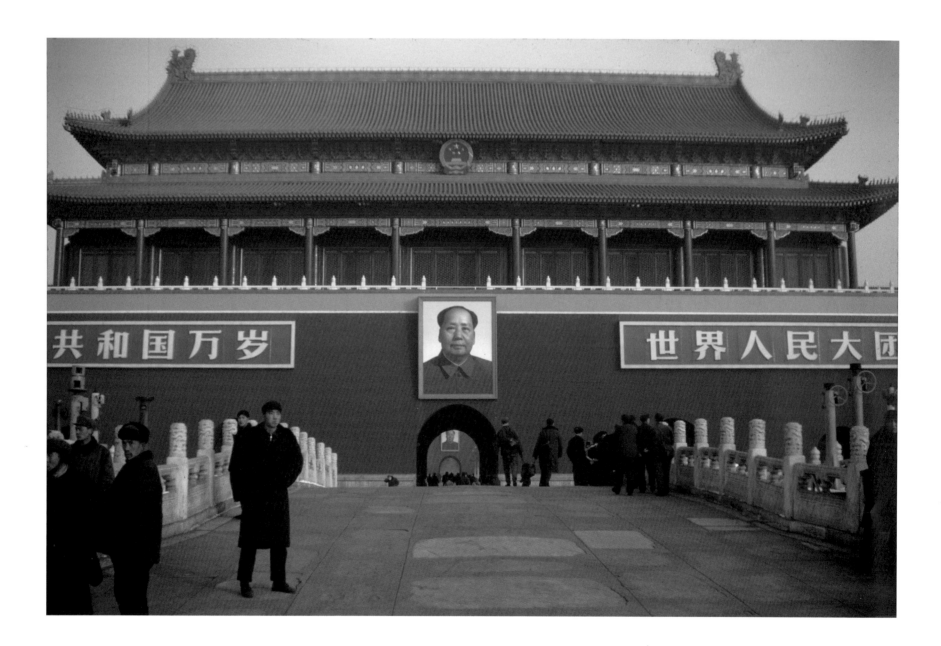

This image, hand-marked as A34, is also within my first roll of film taken in China in 1974. Though into December, there was not much snow on the ground at Tien An Men Gate, the entrance to the Imperial Palace in Beijing, then known to the world as Peking. At times I wonder why all the city names like Canton became Guangzhou, revolutionary icons like Mao Tse-tung became Mao Zedong and Chou En-lai became Zhou Enlai, adopting the Pinyin transliteration, yet China stuck fast without changing to Zhong Guo. If such were to be adopted, Made in China would become Made in Zhong Guo.

Clad in army overcoat or other mono-tone heavy jackets, green or blue, the populace of Beijing visiting the city grandiose square and the palace are few and far in between in the early 1970s, not just because of the weather. Such sparse scene would never be replicated in the decades ahead.

Tien An Men were to be known to the world through the most volatile of event of modern China, in 1989. But for historians rather than political activists, that happening is but one of many throughout Chinese history that played out in and outside of the Imperial court. The immortalized image conveniently freezes on a roll of tanks to make a universal political statement, rather than advancing forward into frames further on, when the tank would turn, not once, to avoiding its blockade by a lone protester. But the freeze frame has already frozen in the mind of millions, if not hundreds of millions! I wrote to Time Magazine at the time to reflect on my view, and received a reply by an editor that he found my perspective interesting and shared it with some of his colleagues. But the letter was never published.

Am I a revisionist? Maybe.

/

This image, also with my first roll of film taken in China, is numbered A34.

For me, the Imperial Palace is more than a relic, though in 1974 very few visitors had the opportunity and the leisure to see it. Tourism was then a capitalist and bourgeois preoccupation for the leisure class. I was member of a study group, all journalists and advertising executives from Hong Kong, albeit a bunch with leftist leaning, or outright leftists. But this first visit led to my making several additional visits on assignment for the Architectural Digest. It also helped me in developing an eye for historic architecture types, which led also to future years of conservation to ancient architecture.

The white marble balustrade was aligned with the intention to capture the faraway buildings and pavilions in distant hills, that of Coal Mountain in the adjacent palace garden inside Zhongnan Hai, inner sanctum of today's Communist Party bosses.

/

Early morning Beijing winter. This image provides a sense of what biking is like through the cold morning air. The face mask to protect penetration of the breeze may offer a deterrent today also for face recognition surveillance. It is strange the same technology written regarding face recognition when put into a western context would be for protection of its population, from danger, child kidnapping or whatever. But for a socialist state, the same newspaper or journalist would find different context to describe the use of such technology as authoritarian, Orwellian, or draconian.

The sun was just rising, as reflected in the huge billboard with a selected verse of Mao, urging young intellectuals to go through a re-education process, which I must have subconsciously adhered to, being born in Hong Kong and subjected to a Jesuit school education. The architecture behind is that of the National Art Museum, a pantheon of contemporary Chinese Art.

I was born in the East, educated and matured both in the East and West, and now cross both worlds. So, it seems appropriate that my mental state migrates from East to West, and vice versa. Yet I must thank my US education in journalism for giving me a free and analytical mind, and my art education for honing my emotional expression. /

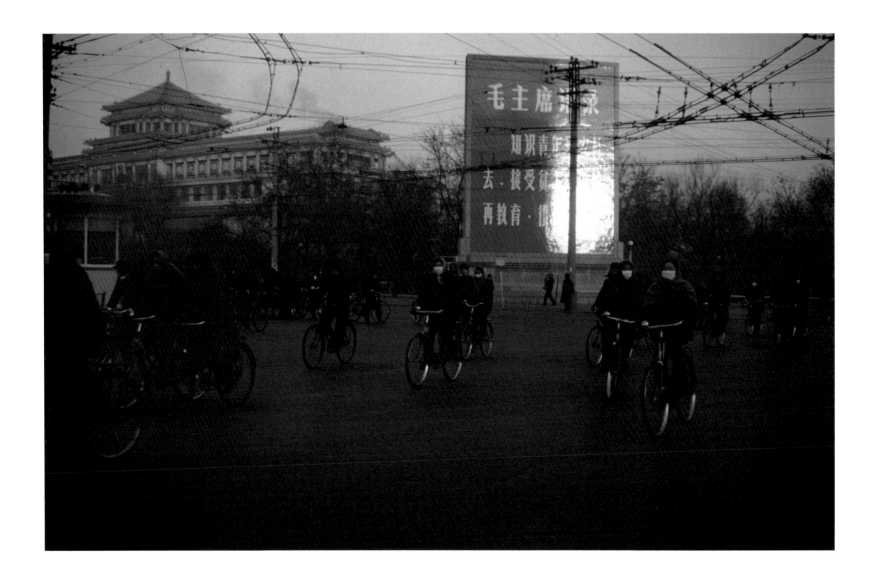

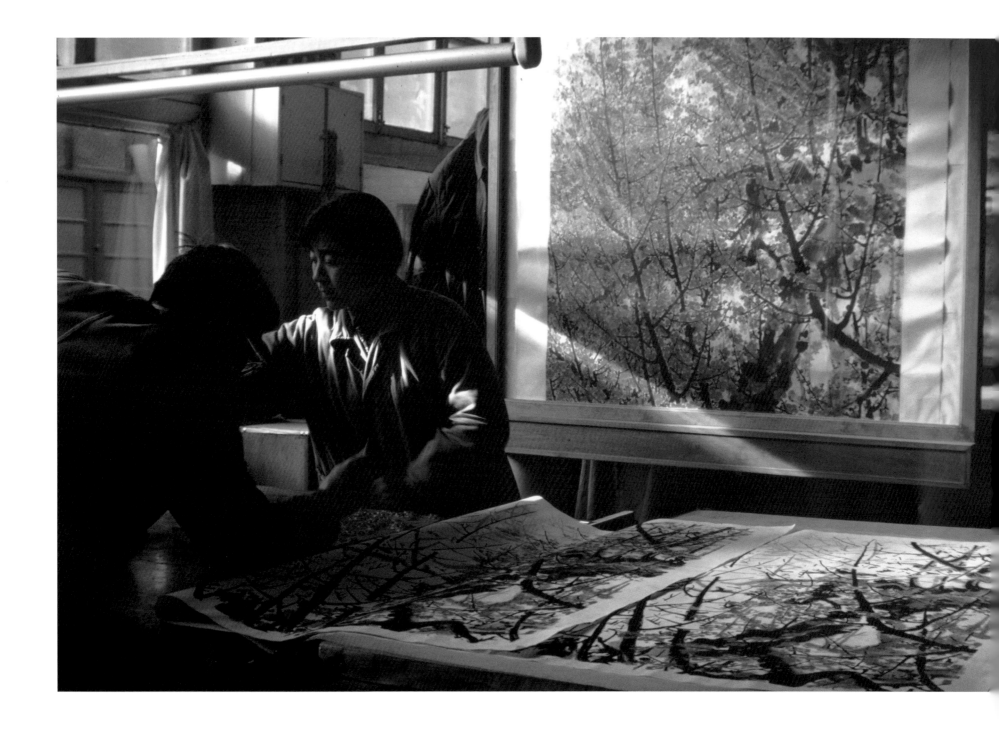

Rongbaozhai is a very historic art store and workshop studio in Beijing. One of its most famous undertakings is the meticulous reproduction of traditional Chinese paintings by a process called "wood block water printing". The copies thus produced is almost a perfect replica of the original. Here I observed craftsmen in the process of reproducing a work by famed artist Guan Shanyue, by applying a variation of red paint to the wood block before printing. An original on the wall, though not of the same being printed, is used for adjusting colors and hues. Guan is celebrated for his landscape paintings as well as portrait of peach blossom.

/

In the early 1970s, visitors to Beijing was still rare, let alone going to Shenyang and beyond in the former Manchuria. A train took my group to Liaoning province where we visited several historic and industrial cities. A special sleeper carriage was assigned so we could leave the heavier luggage in the train without bringing them to the hotel of our accommodation. This is the city center of Shenyang adjacent to the hotel, where a tall statue of Mao stood with his arm stretched, pointing to the future direction of the country.

/

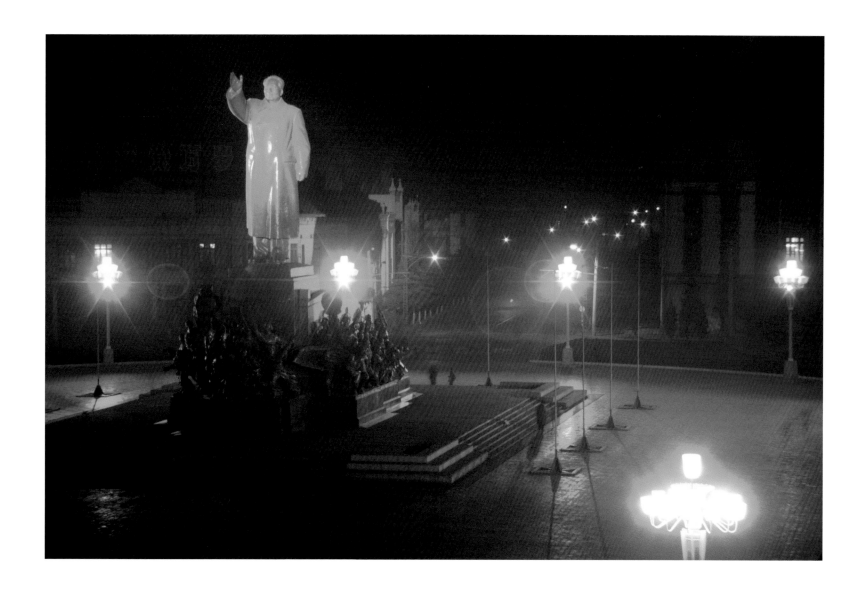

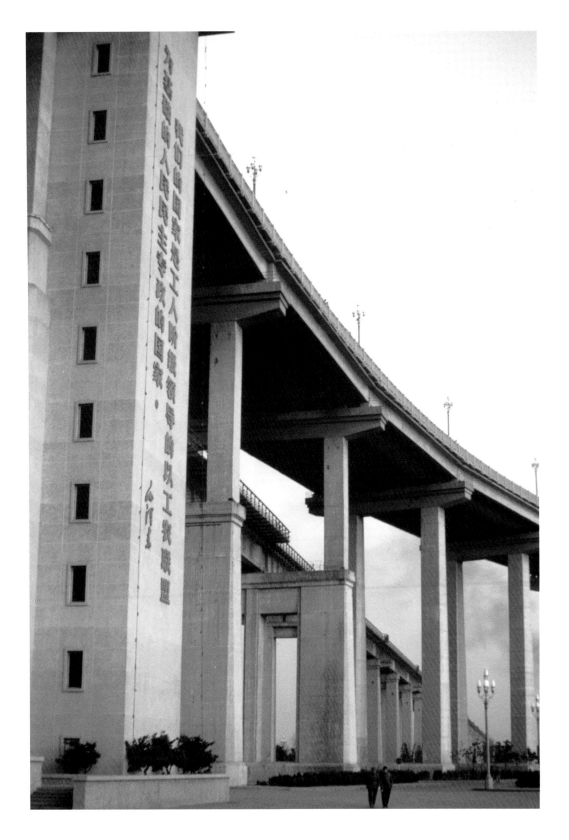

The Nanjing bridge over the Yangtze took eight years to complete. When it was ready for train and car traffic in 1968, it was hailed as a major engineering accomplishment as it was designed and built totally by the Chinese without foreign help. I visited it within six years of its completion and the government was rightly proud to showcase it to visitors like us. I was taken by the height of the approach bridge on the south bank of the Yangtze.

The government however left nothing to chance, making sure that Mao's political slogan were engraved to help in holding up support of the weight from above. This particular inscription glorifies leadership of the proletariat in an effort to build a unified country together with the peasants.

/

風雨欲來天先黃，
久逢秋旱井也乾，
天年盡數國變色，
富貧懸殊缺小康。

從來但聞官征寇，
何見今朝賊討王，
天地無情人漸老，
正道人生是滄桑。

The Grand Canal at Suzhou is a section leading from the capital of Beijing to south of the Yangtze, ending at Hangzhou. Historically it served the function of transportation and communication. It became a water artery connecting northern China to the south. The function of this 1800-kilometer waterway served the imperial court well in time of war and peace, carrying troops during turmoil and tribute and grains from the south when the nation was calm and prosperous. At time of my visit in the early 1970s, long train of boats sailed up and down this busy channel carrying all sorts of commodities, with a tug in front. Also present are political slogans and banners attached to the bulkheads of many of the boats. There was no trash to be seen in the waterway. China was still in a mode of highly organic living, consuming everything with little to no waste. /

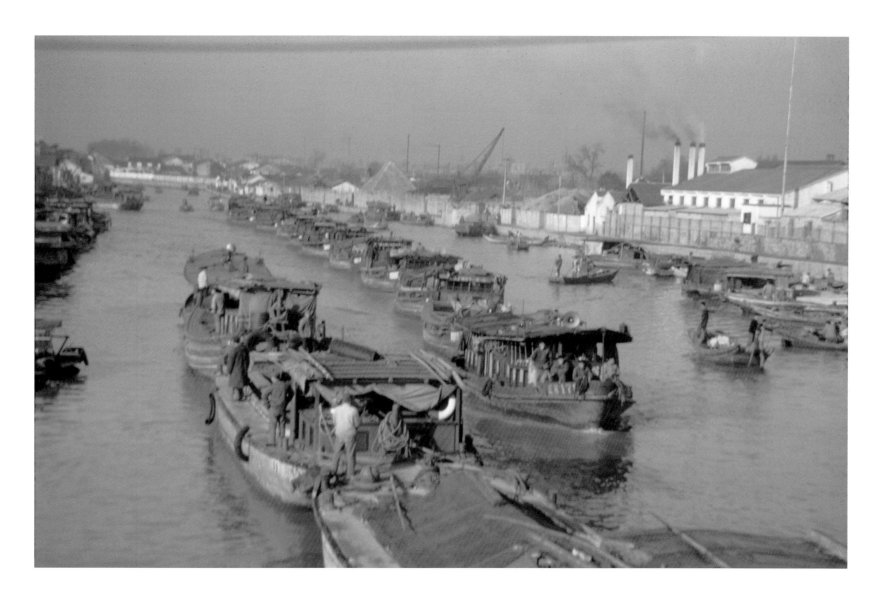

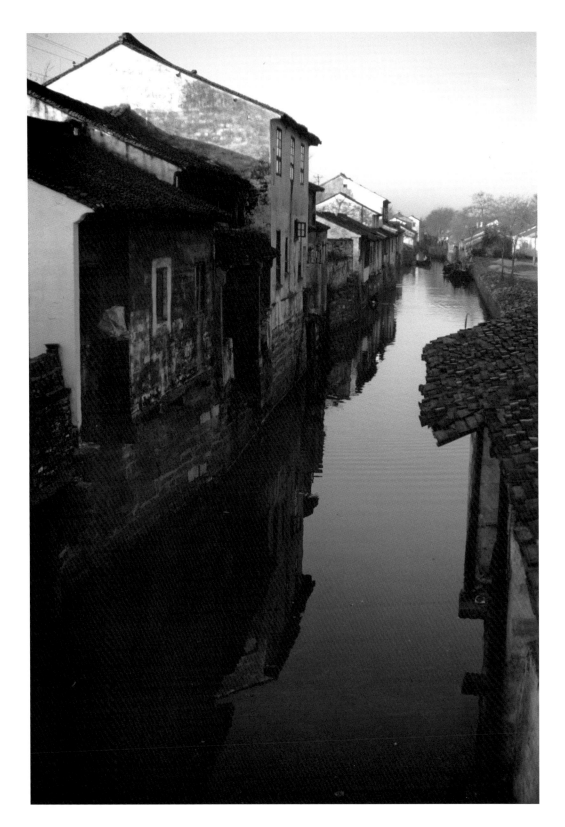

Suzhou in the mid-1970s was quiet, pristine and tranquil. Despite that life was basic and simple, people lived with a singular purpose, that for the common betterment with communal feeling. From some point of view, it was unnatural and regimented through political education.

But around the close of the Vietnam War when anti-war sentiments were high with progressive to radical thinking and movements in the West, some would consider such socialist community as model of a utopian society. George Orwell, on the other hand, would depict it as in his book "Animal Farm" as an authoritarian state.

Today, China has moved, up or down depending on perspective, into a modern society. Similar villages with water canals would be filled with bazaars and tourists. Homes are no longer homes, but becoming a façade of shops and restaurants, with red lantern dangling outside.

/

If regimentation is order of the day, students used outdoor as classroom to instill a sense of patriotism with socialist ideals. This group of students gathered in a park outside of Guangzhou as part of a group study, under the red flag of the communist party of a star with a circle. For ladies, young and old, having their long hair braided into two pony tails was the most popular and prescribed hair style which lasted through the 1970s into the 80s.

/

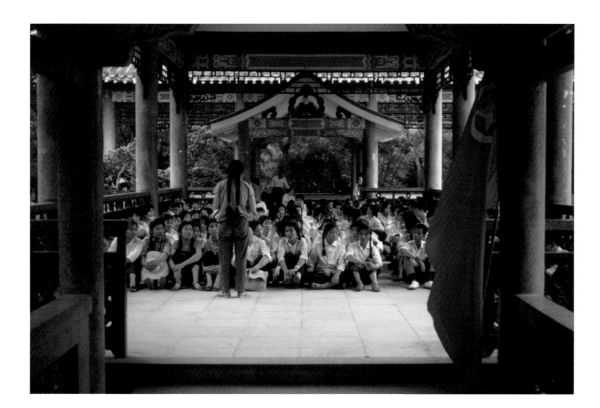

Inside the Imperial Palace, each major hall or pavilion has its own multi-level balustrades, constructed from white marble. It creates a series of progressive layers arriving at a symbolic pedestal for the imposing building to sit upon.

For privacy or secrecy, going from one pavilion to another is partitioned by low walls. Through these walls are doorways into the next courtyard arriving at the next pavilion. Above each door are ceramic tiles to frame the entrance or exit in an elegant fashion. I was often caught by the perfect symmetry of these doors, naturally achieving a framing effect for the view beyond, be it nearby or into the distant hills.

Such view was particularly pristine in the winter of the 1970s, when few visitors obstruct the perfect peacefulness of the scene.

/

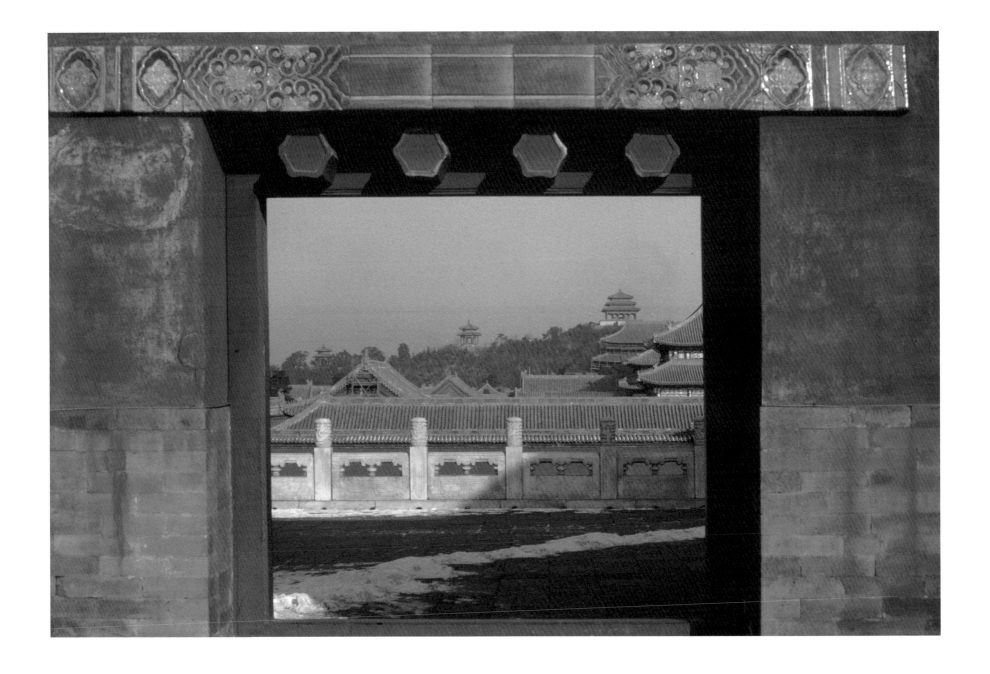

1975 - 1976

North, Central & South America

Between 1975 to 1976, a friend Edward and I did an extended expedition covering the Americas, from Canada, through the United States, to Mexico and Central America, then several countries in South America. My friend sold his Italian sports car in order to purchase a VW camper van with a pop-top bed. We added other outfits and equipment for long-distance travel, before embarking on my 26th birthday on this trans-continental journey, my longest one to date.

Starting from St Catherine in Canada, we drove through North America covering diverse regions, the Great Lakes, Banff and Jasper in Canada, Wisconsin, the Dakotas, Glacier and Yellow Stone National Parks, the US Rockies, Colorado, New Mexico, the Grand Canyon, the entire West Coast, before covering every country in Central America from Mexico to Panama. From there as there was no road beyond the Darren Gap, we flew on to Columbia and backpacked through several more countries before returning to Panama and retraced much of our route back to Berkeley California to try sell a new van which has put on huge mileage within months.

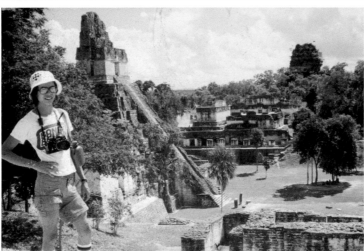

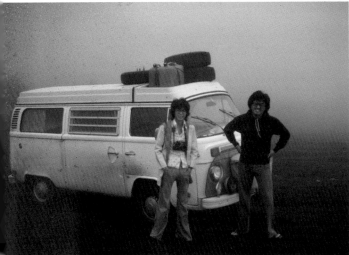

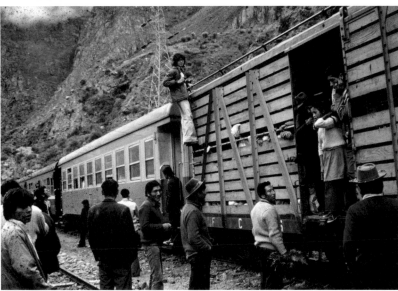

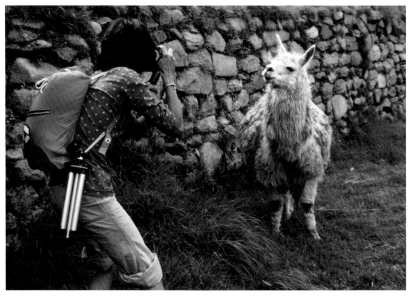

Though always armed with a fisheye lens, I rarely if ever use this angle of view. At Lake Louis, I ventured to cover the entire pristine lake using a Fisheye, creating a curvature over the water. I could not recall having used the lens more than a handful of times, at times for record rather than effect, in confined spaces during my work with architecture. /

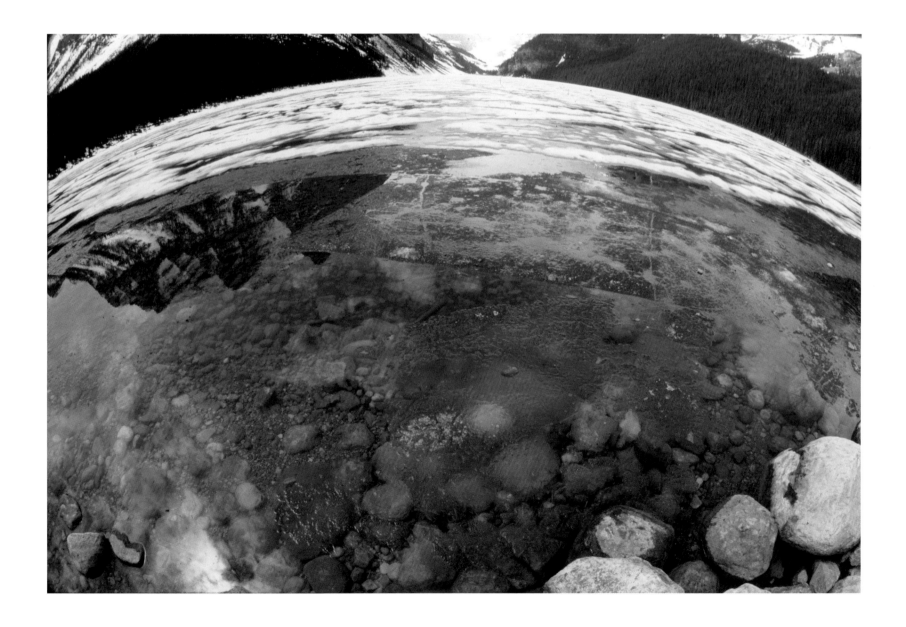

In the Canadian Rockies, I was exposed for the first time to wildlife within their natural surroundings, like in this case a Big Horn Sheep. Such exposure would lead to the setting up of my home in a mountain cabin inside the Angeles National Forest above Pasadena in California, followed by subsequent years of involvement in photographing and conservation to wildlife in the remotest corners of China, as well as other parts of Asia.

/

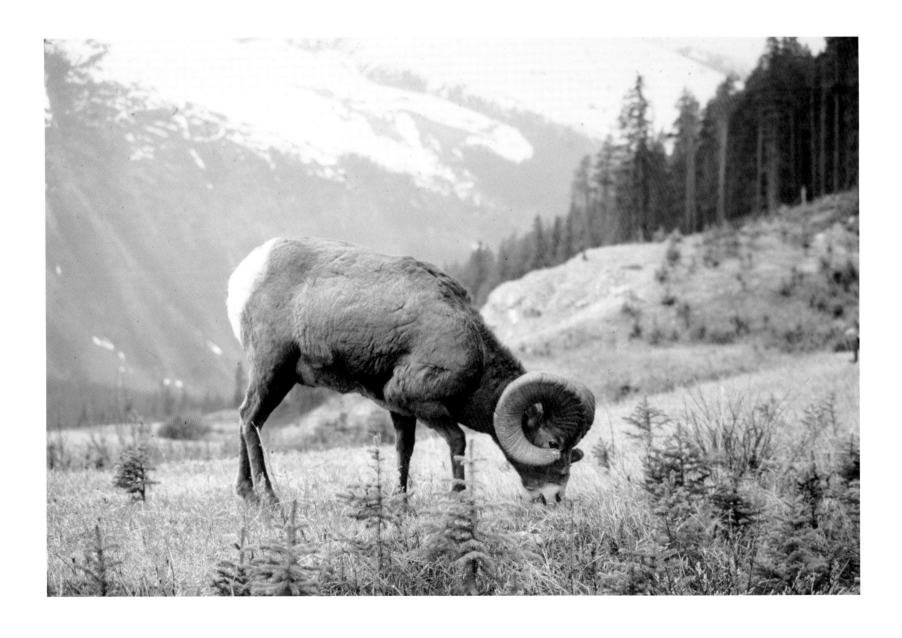

Along Highway One of the West Coast, drift wood were plentiful, enough for gatherers to put together a shed along a beach. The 1970s provided much awakening for the younger generation to get closer to nature, as well as the beginning of many movements about ecology and the protection of our environment.

/

The love of nature went beyond the open field, as in this case an old pick-up truck was transformed into a cabin camper, complete even with a chimney, traveling along the Oregon coast.

/

At Yellow Stone Park, a local cowboy returned from his hunting trip with a Black Bear. While he would keep the skin and eat the meat, the gall would be saved for selling to West Coast Chinatown merchants, for onward passage to Asia as ingredient of Traditional Chinese Medicine.

/

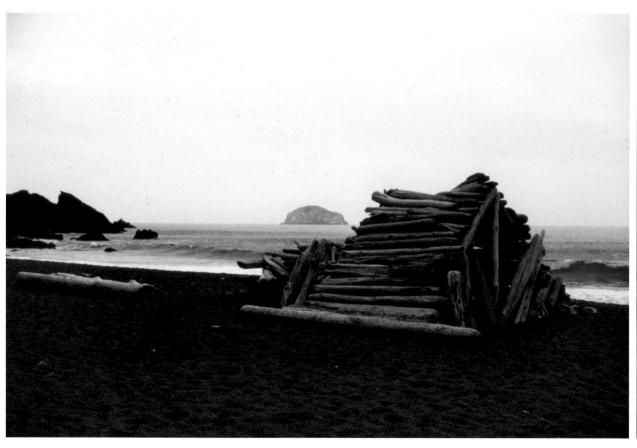

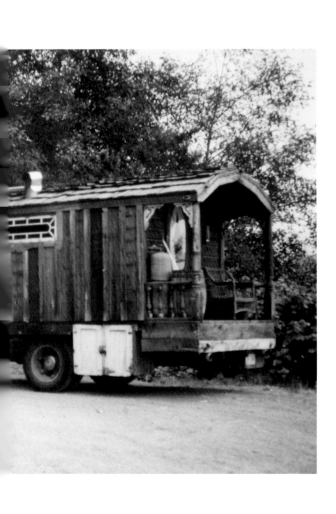

A well-preserved early settlement of the Puebloan Indians at Mesa Verde National Park in Colorado. Using a super-wide- angle lens, I was able to capture the entire archaeological site in a panoramic view, though with some distortion, yet with dramatic effect on the edges.

/

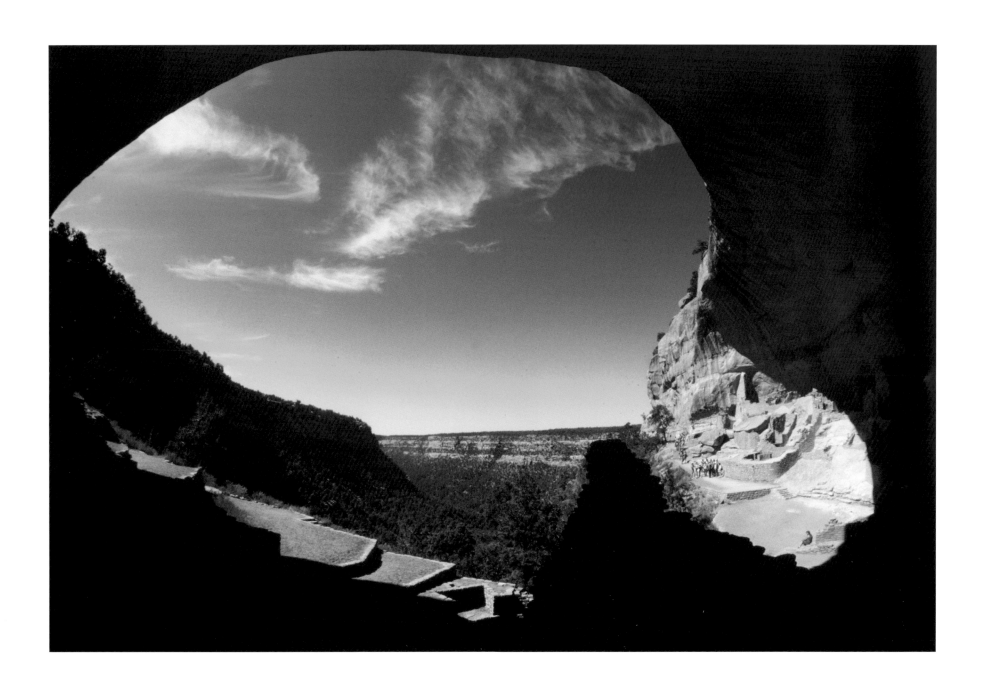

At the Grand Canyon in Arizona, I sat and watched the changing lights as the sun provided a shadow over the Colorado River inside the gorge.

/

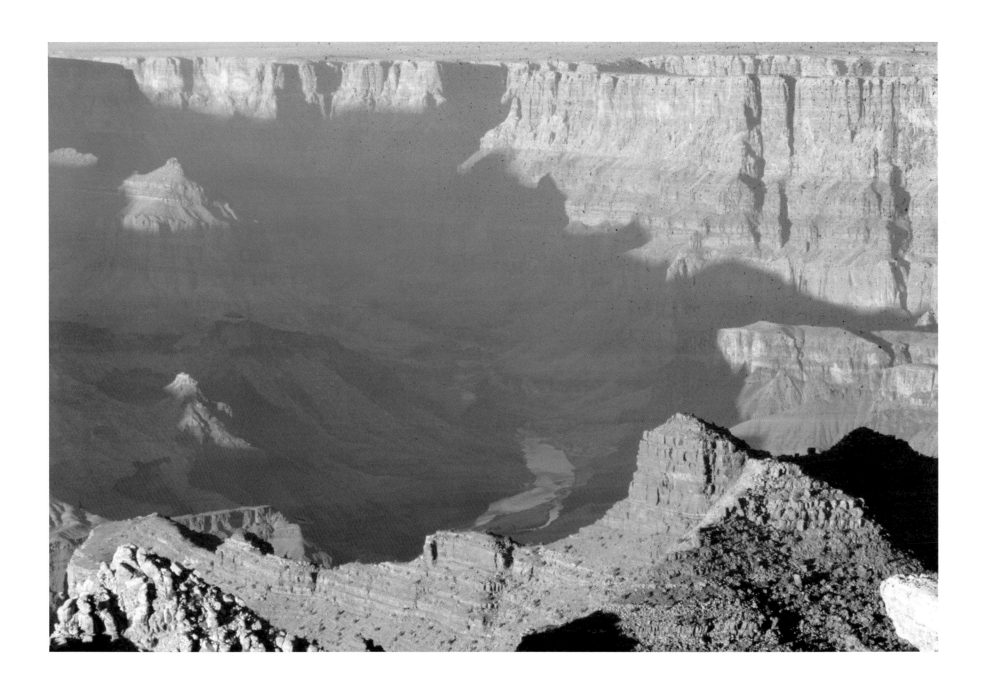

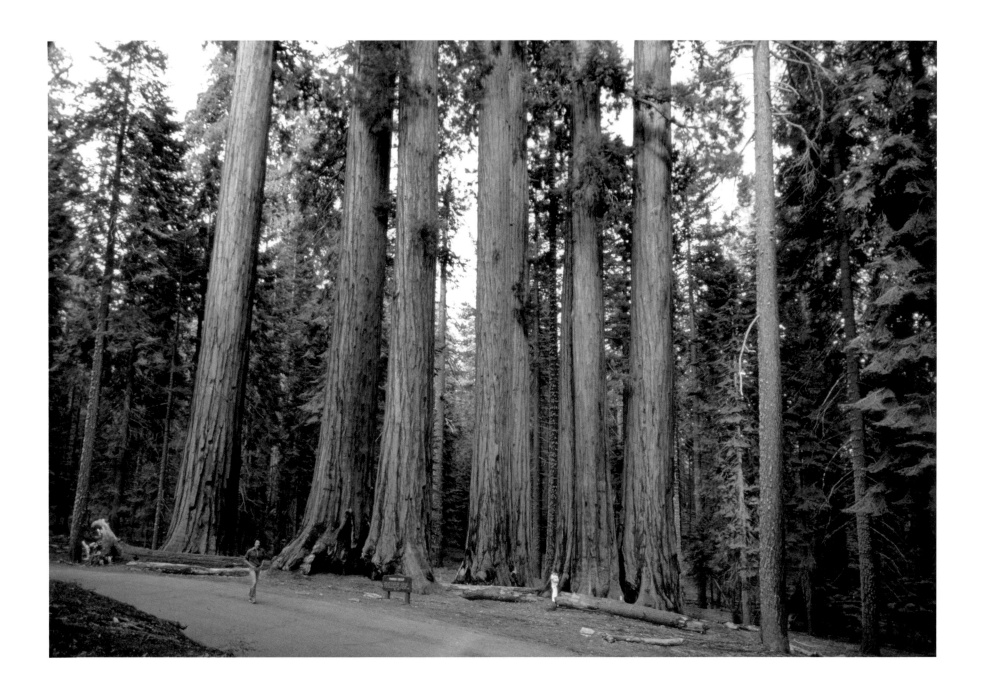

The giant redwood forest of Sequoia National Park became one of my favorite sites to visit after my first trip in 1975. With scale of the tiny human figures at the base of the trees, it first reminded me how little we were in the face of nature.

/

My first visit to Yosemite was in 1972 and later again in 1975 on way to South America. In subsequent years over the next four decades, I went back many times, three times camping out during the winter, including twice during Christmas. Yosemite Valley offers the most spectacular view during autumn and winter, and the frozen river was sandwiched between Half Dome and El Capitan.

/

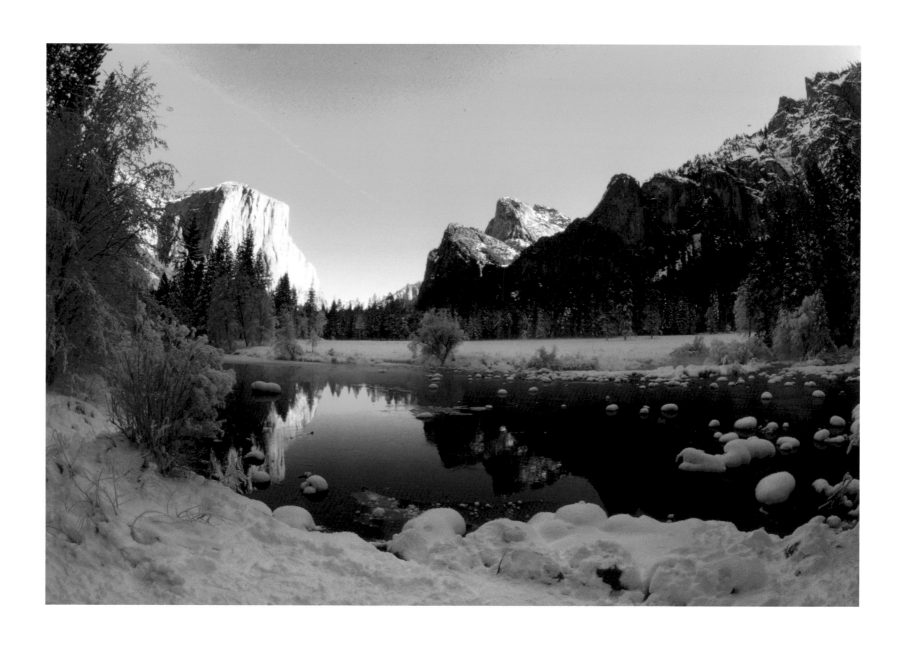

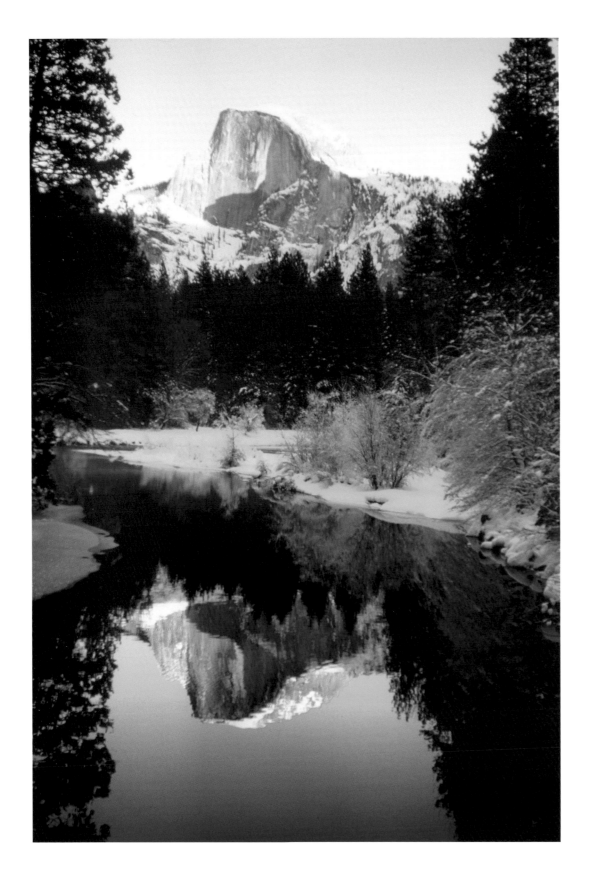

Reflection in water with snow abound made Half Dome stand out even more dramatic as winter sets in at Yosemite.

/

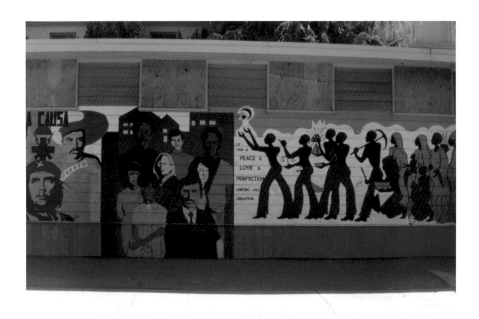

In California, especially around the Bay Area, artistic murals were common sight. In the early to mid-1970s when student rallies on university campuses were frequent, in protest against the Vietnam War or in support of activists of civil rights movement, many of these murals took on political or public issue overtones.

/

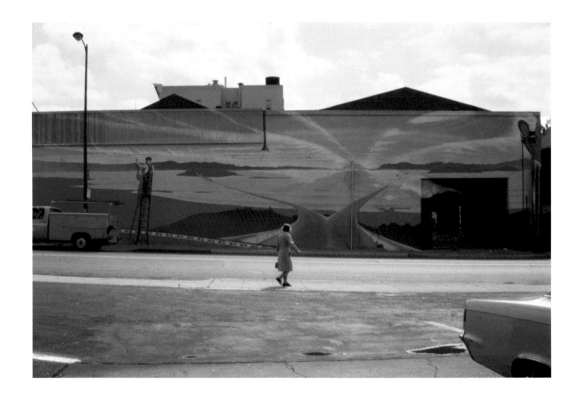

During the 1970s, I spent much time around UC Berkeley, a hot bed for student activities, from progressive to radical. The campus scene as well as the neighborhood surrounding Telegraph Avenue became the daily home of many street artists and performers. This set of pictures were taken during those years in and out of Berkeley, but mostly inside campus. It was upon departing Berkeley that we drove to Los Angeles, then Nevada, and entered Mexico at Nogales of Arizona.

/

At a bay outside Veracruz on the gulf side of Mexico, a family worked the net at sunset, bringing in the catch of the day to a beach. Small fishing communities lived off the ocean in many villages along Mexico's coast.

/

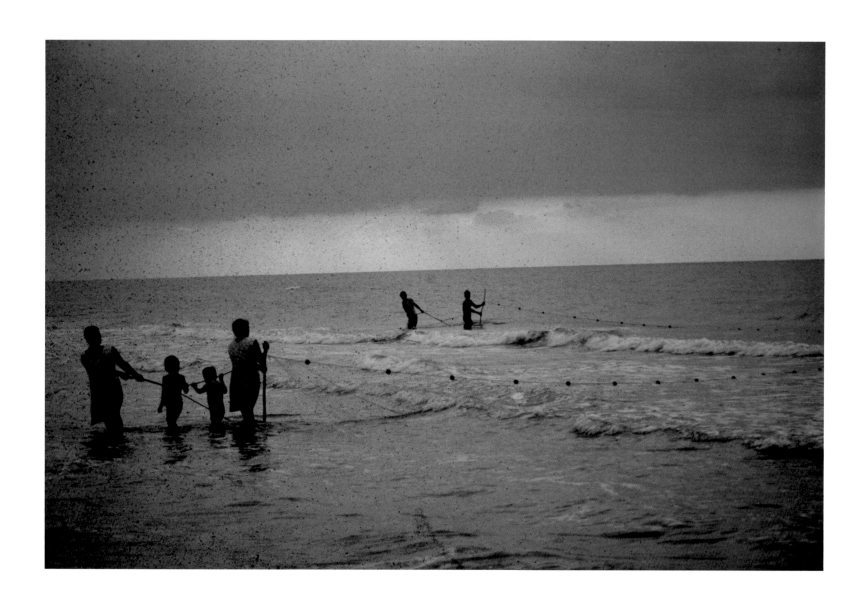

With clouds gathering around the top of a volcano in Costa Rica, it resembled an eruption waiting to explode as the mountain stay momentarily still in the clean air until the next angry burst. Here in this Central American country mecca for retirees, it is supposed to be safest among nearby countries. But our side mirror was stolen on one day and the van broken in the next. Police advised us to park and sleep inside a secured parking lot, or even at university campus.

/

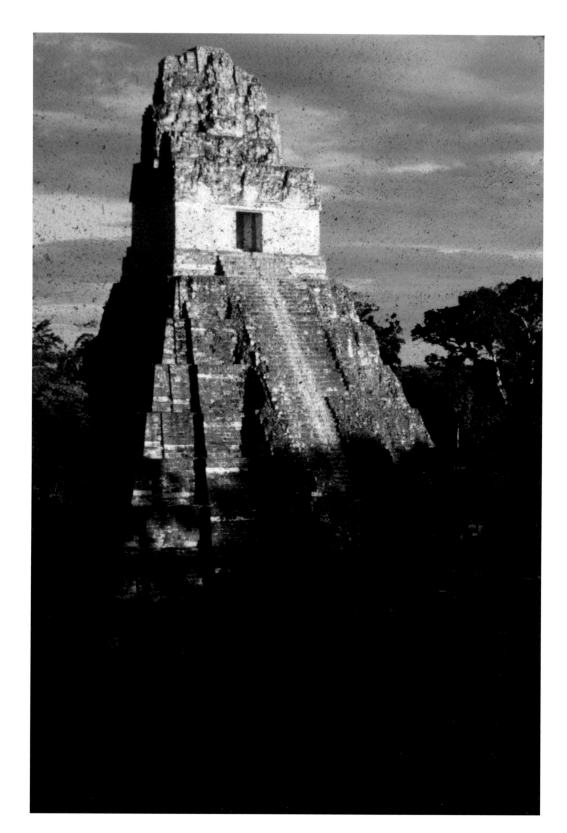

In Guatemala, the pyramid at Tikal epitomizes the temples of the Mayan Indian, an indigenous group that has lived in the region since ancient time. Scholars are still deciphering many of the symbolic motifs of these ancient temples.

In the 1970s, visitors were allowed to scale to the top of the pyramid through steeply inclined steps. A metal chain was anchored in the middle of the stairs in order for guests to hold on to, in case the dizzying height and small steps should incur an accident.

/

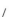

In the street of Guatemala, a fruit vender provided the colors against a dilapidated wall. Political turmoil was frequent in many of the Central American countries in the 1970s. In the jungle, many insurgent groups were active and few visitors would cross from one country to the next in a car. Throughout Central America, we made many new friends, at café or restaurant. But several appointments we made with such friends to meet again turned out to be "no shows", something that seemed common practice.

In asking for directions, another common phenomenon was split opinion, as those asked would end up arguing it out first before delivering a final verdict of the way to take. One incident was also classic. At Cartago Costa Rica, I asked how far the next place is and the answered came as 20 minutes by bus. It turned out to be within walking distance. Later I asked to verify, and the before answer was accurate – it meant 15 minutes waiting for the bus, and five minutes on the bus.

/

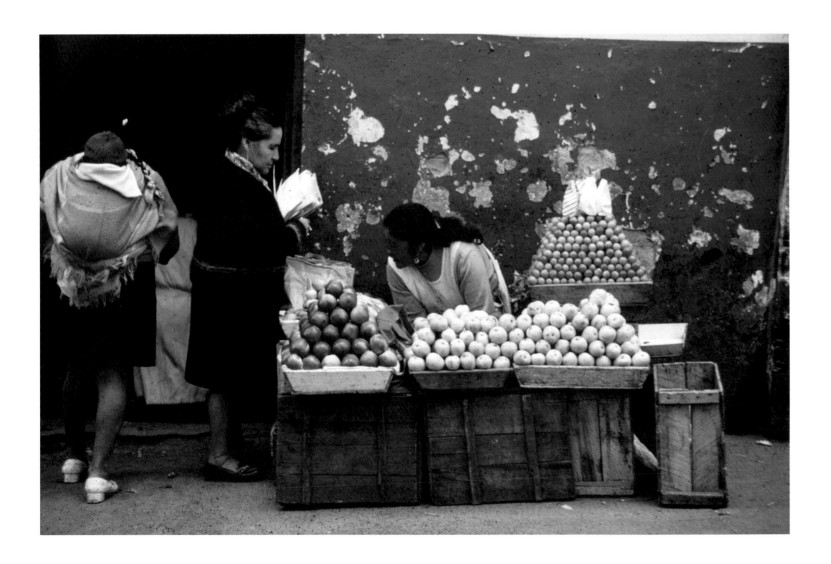

In a side street of Cuzco, two children played by their house. Despite shoeless, their dress was colorful as one girl even had a felt hat as part of her costume. The ancient Inca tradition may have some remaining influence to this day.
/

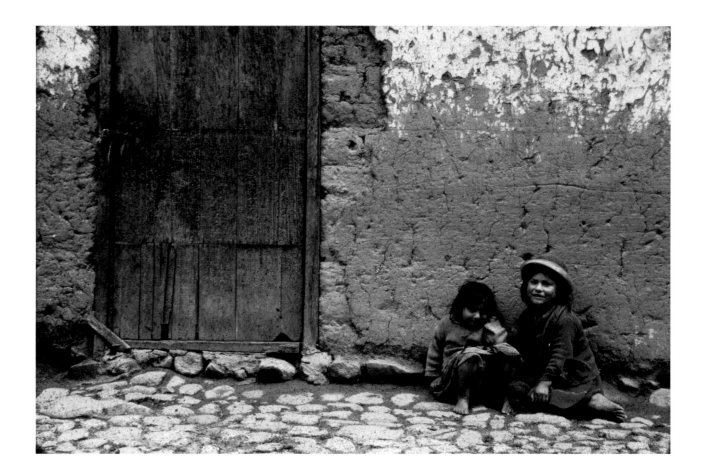

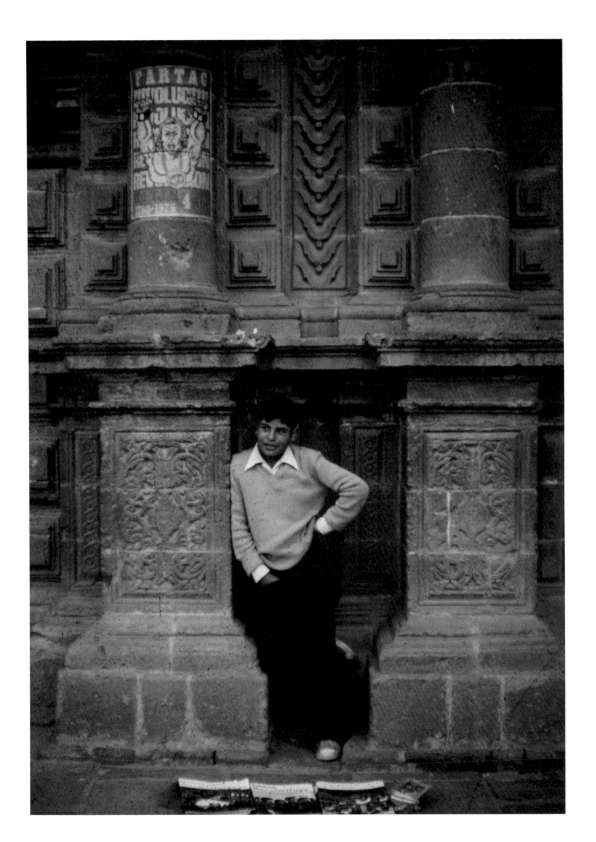

In the street of Cuzco of Peru, I was surprised to see a young man, barely a teenager, laying out a few revolutionary magazines to sell in the street. Those were China Reconstruct journal and China Pictorial. Proletarian movements were certainly openly popular and international in those days.

/

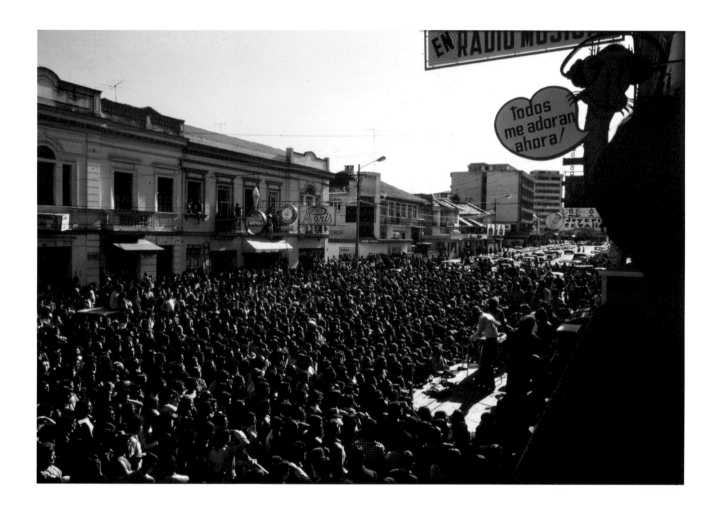

In Quito of Ecuador, a street concert organized by a local radio station attracted a large crowd during the weekend. At the time, I carried also a Press Pass from another radio station, KPFA of Berkeley California. It came with picture of a fuzzy long-hair "hippie".

Ecuador claims to have the highest mountain in the world, Mt Chimborazo. As the earth bulges at the equator, the mountain at 6263 meters elevation, if measured to the center of the earth, would indeed be the highest.

/

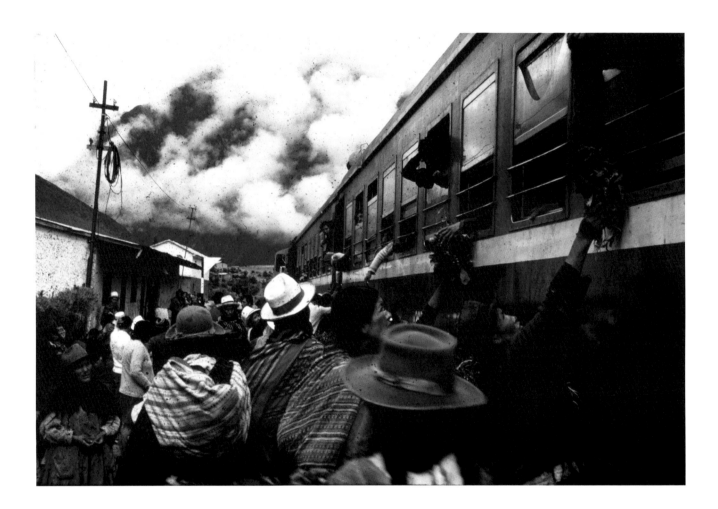

The small and narrow-gauge train ran daily from Cuzco to Machu Pichu, up ahead in the mountains masked by fogs and clouds. Venders stampeded the stopping train at every station to sell their eateries through the windows.

/

Machu Picchu, despite being rediscovered in 1911 by archaeologist Hiram Bingham with support of the National Geographic, was rather distant from the rest of the world even in the 1970s. My visit and this rather wide view photo revealed hardly any visitor, let alone there was no entrance fee or staffing to manage this very pristine ancient site of the Inca people.

/

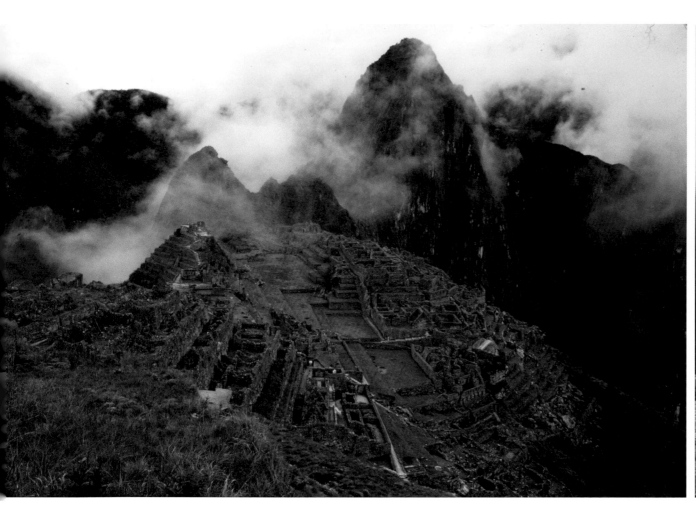
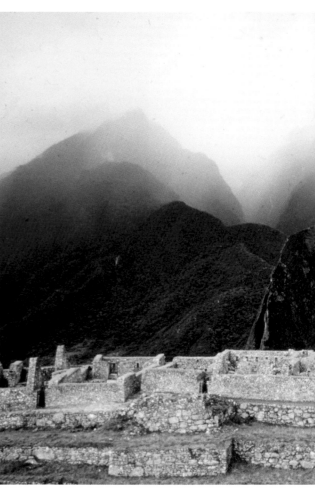

As the jungle awakes in the day, mist and fog often play hide and seek with the mountains at Machu Picchu, giving the stone fortified citadel, now vacated of its residents and former Inca glory, a sense of mystifying feeling. The mountain enclave retains however a special fascination due to its architectural design, layout, and at times massive mosaic of stone walls and structures.
/

A few roaming Alpacas graced the terraces of Machu Picchu with the stone ruins as a backdrop. A few of its slightly larger cousin the Llama were also around grazing the steps of the former city fortress of the Inca. Alpacas are priced for its wool fiber whereas the Llama are occasionally used as pack animal for carry loads in the hill country of South America.
/

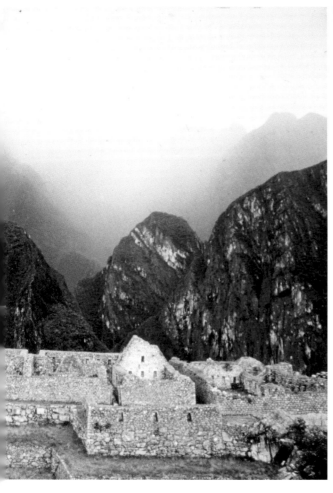
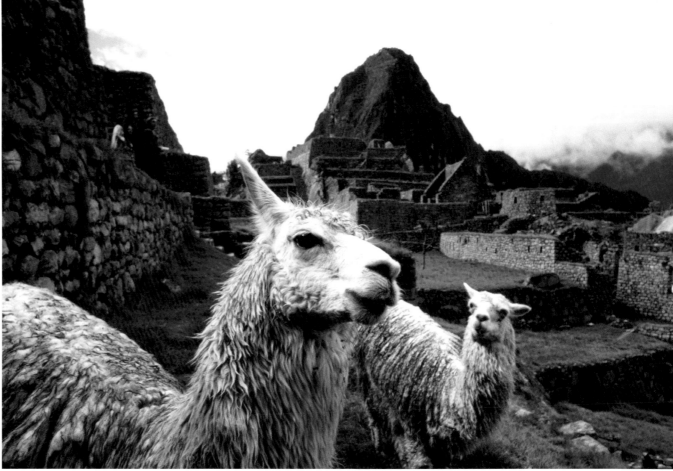

1977-79

While again living in Hong Kong after my long journey through North, Central and South America, I took advantage of some new friends I made in China and went again to Beijing in 1977, followed by a most rewarding trip to Guilin. These trips allowed me to write and photograph for some magazines on a freelance basis.

I finally immigrated to America and was living in Los Angeles beginning in 1978. I tried to make every effort available to go back to China nonetheless. Soon I was able to obtain assignments for the Architectural Digest, focusing my interest on historical Chinese buildings and gardens.

In 1979, I was invited to Beijing for the country's 30th anniversary. It was at a time when China was just beginning to open up to the rest of the world, a time when the country had few friends save those from "Third World" countries.

Following all the banquets and toasting in the Capital, I made a long trip across the width of China from Beijing to Xinjiang, and through the country's length from Inner Mongolia to Yunnan. Finally, I crisscrossed the middle of China by sailing the Yangtze from Chongqing to Shanghai. That was my first foray into a few minority regions of China. From then, I never looked back and made those remote areas of China the focus of my work. 1979 was a watershed. It set the stage for my career in China in the upcoming decades.

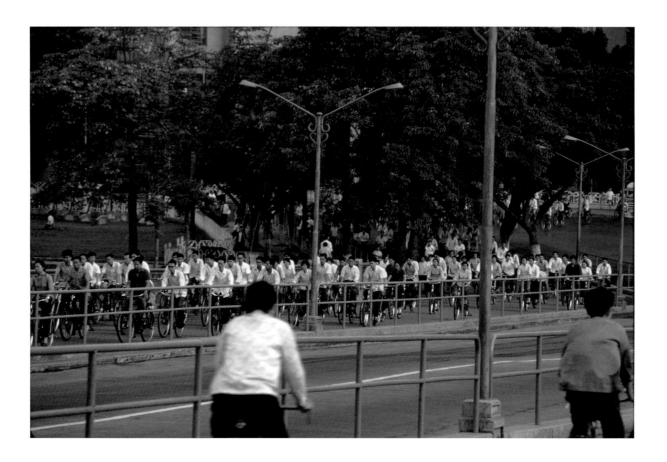

1977 Guangzhou. On the road there were hardly any cars moving around as the morning side lanes were taken over by bicycles with riders in a rather spartan fashion style. Such scene would gradually become obsolete as China moved into the 1990s and the new century.

The sea of bicycles in China prompted me to make a visit in Beijing to the factory of Yong Jiu, one of the two biggest brands of bicycle manufacturers, possibly the largest such factories in the entire world at the time in the number of bicycles it produced. But such a sturdy bicycle, priced at around Rmb 150 apiece, would translate into three or four months of a worker's salary and a luxury requiring special quota or connection in order to procure one.

At the time each dollar in Rmb is converted to three Hong Kong Dollars approximately. A roll of foreign made slide film cost over Rmb 70, a month and a half of one's salary, and only available in big cities like Shanghai,. Local photographers, all professional and hardly any amateurs, generally used the China manufactured Gong Yuan (Era) film. Thus, entering into China as overseas visitor like myself, rolls of film brought in must be written down in my travelling permit booklet, and upon exit same number of films must be carried out. Of course, camera and lenses brought in were even more carefully recorded, likewise, the amount of cash.

/

In 1977, I first visited Hangzhou, then hardly open to even organized friendship groups. Both Chairman Mao and Premier Zhou Enlai had passed away the year before, but the country was still affected by the Cultural Revolution's remnants as regimentation and red banner still ruled the day. Athletes in uniform along the West Lake ran by as part of their morning exercise while the causeway was taken by retirees or youngster eager to catch the fresh morning air.

/

If cars are few and bicycles plenty, the pull and push carts for carrying goods and cargo are in between. The jolly young men here in Hangzhou were captured returning from delivering a load in a most efficient fashion, carrying another two carts, one on top one behind, with his other coolie friends sitting above. In the background, bicyclists looked on while a red banner depicts the new leader and Party Secretary Hua Guofeng, replacing Chairman Mao.

/

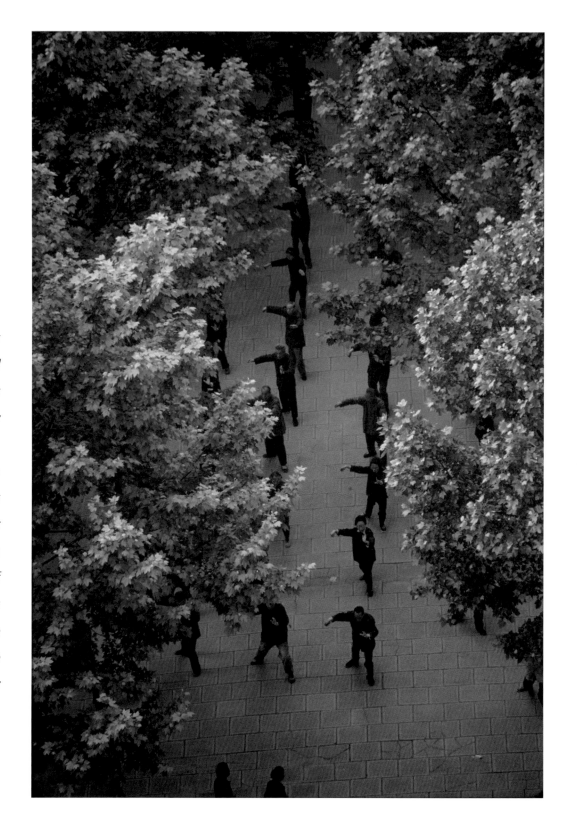

From my hotel room in Shanghai, I could look across to the bell tower of the race track as well as into the park where every morning retirees gathered to perform Tai Chi in a uniform and slow movement.

It always fascinated me that despite the eradication during multiple and successive political movements of the 1950s and 60s, even into the 70s, what was considered ancient and old fashion, such movements of Tai Chi, a millennia-old exercise of the body, breathing and the mind somehow was tolerated and continued to prosper. Perhaps the slow movements was elusive enough to evade attention of a stormy radical reform that blew through the nation.

/

In the early hours of Shanghai in 1977, a public bus went by at 6:15 am before the rush hour began when streets would be filled with bicycles and workers heading to work. The clock to the left is that of the tower of the Shanghai Race Course, a landmark for a century standing high among low-rise buildings.

/

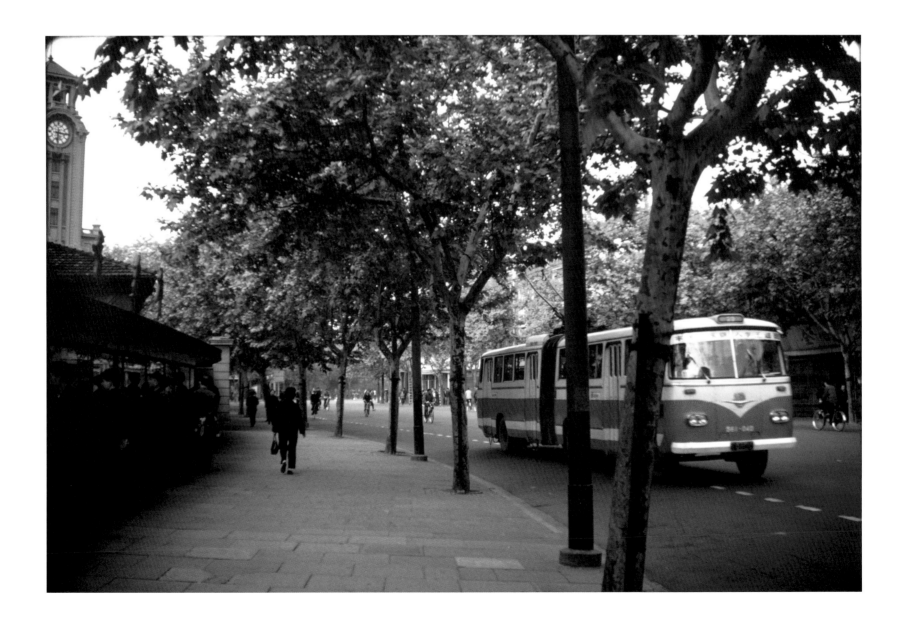

As the day rolled on, bicycles ruled the largest city in the Orient, the former Paris of the East. Here as cyclists stopped for a red light, one apparent offender pleaded to the police as his bicycle was set to the side. Oblivious to the offender with an apologizing smile on his face, the traffic police simply looked away with little to no interest.

Capturing such moments have always been a photographer's dream. Remember before the age of digital photography, film is a priced commodity, especially a rather limited supply was allowed to be brought into the country. Despite always having a motor-drive to my Nikons, I have never, not once, used multiple exposures as the full stock of my photography would reveal. However, I do use it as a fast winder to bring up the next frame.

/

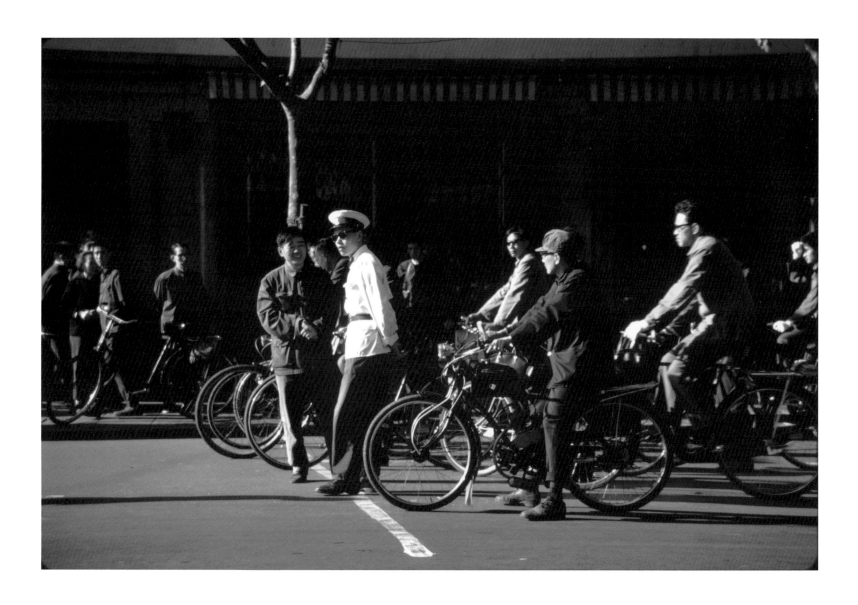

"Long live Mao Tse-tung thoughts" as the political slogan and banner said above the Shanghai Race Track tower building. The Club was started in 1850 whereas the towered Club House began construction in 1933 and was completed a year later. The grandstand in front of the finish line is attached to the main building.

Looking beyond to Shanghai's skyline in 1977, there was not one high-rise building within the line of sight. There was however a line-up of high-rise, generally less than fifteen story tall architecture of Art Deco design of the 1920s and 30s, along the Bund and the bank of the Huangpu River.

/

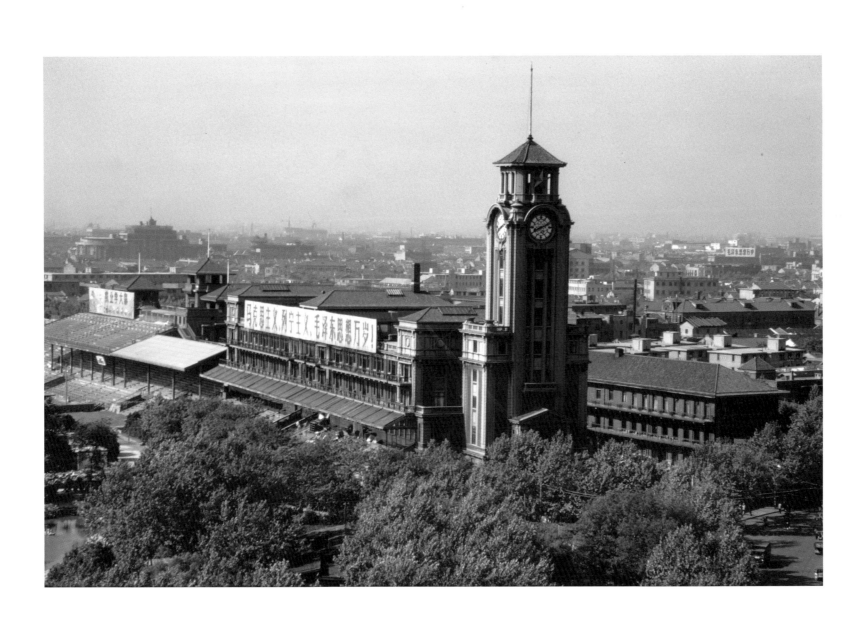

In the 1970s, visitors going to school including kindergarten was a must-do on the itinerary, likewise a trip to a commune. While schools of higher grades may be regimented, those to kindergarten was always a joy. Small children were the most innocent and always ready with a smile, despite the program may be choreographed to the finest detail. The color diversity of young children apparently was spared from the monotone tunic and dresses of the older age group.

/

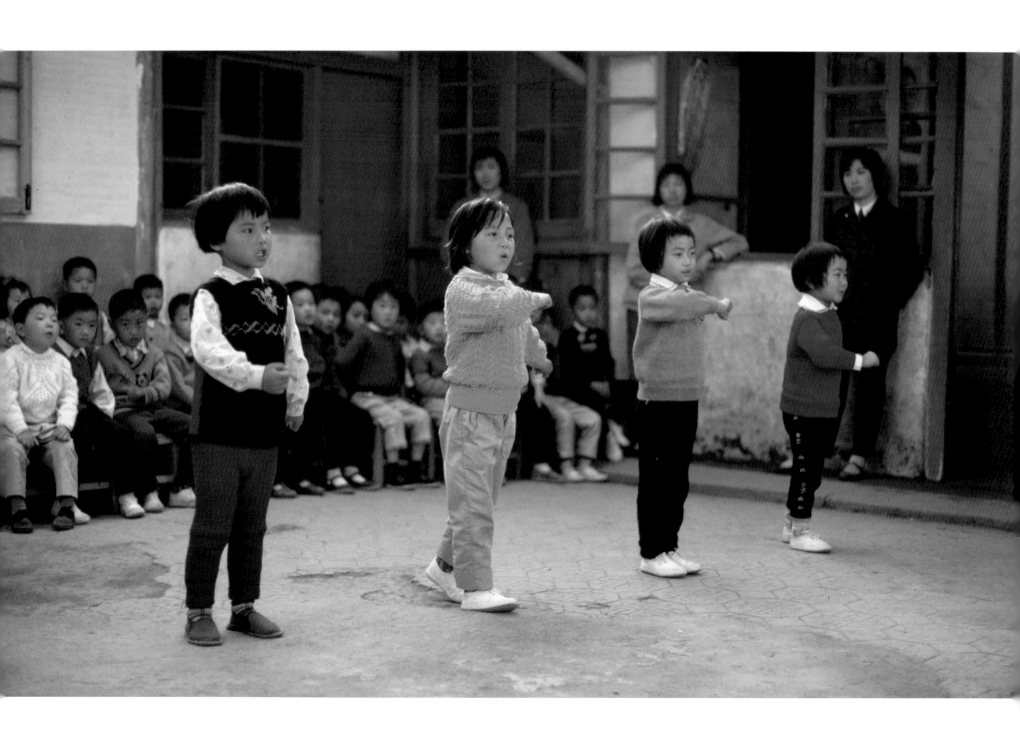

At school students besides studying in class, must perform some functional duties. Here at a Shanghai school, students help in making soda caps by setting the cork inside the cap, readying them for the factory to produce the next step for a beverage. Such manual labor was common before mechanization arrived.

/

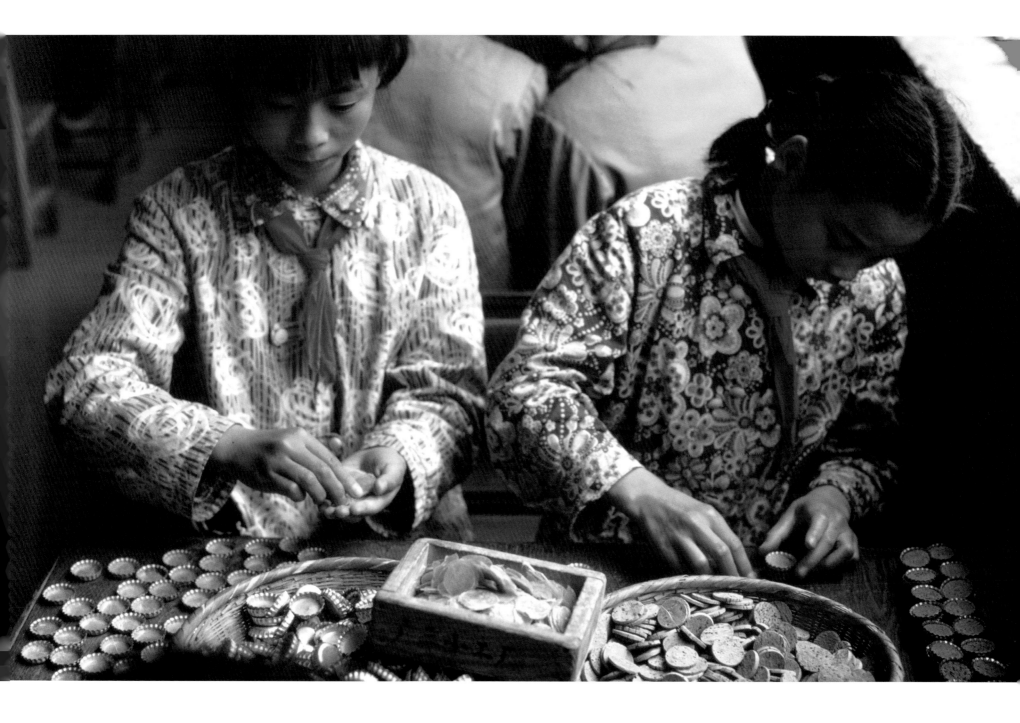

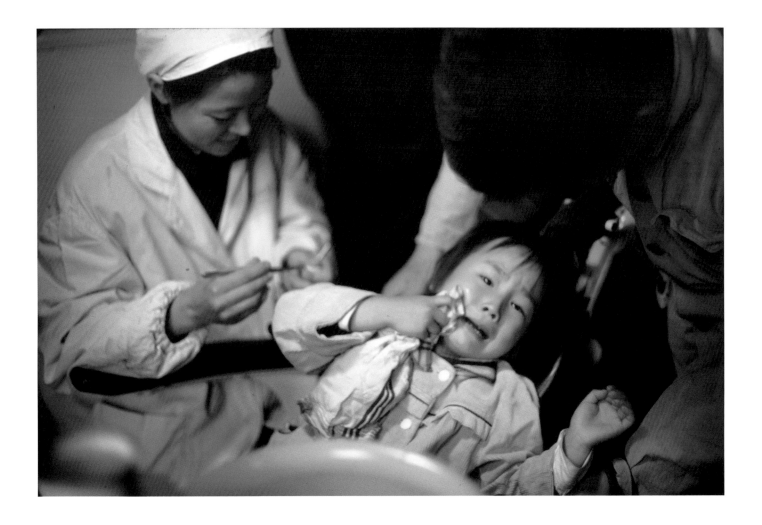

I visited a dentist's clinic when a young girl was obviously a little traumatized with the pulling of a tooth with cavity.

Besides schools and communes, hospital visit was always included. As part of the pride in traditional Chinese medicine, an exception spared from eradication of the old in multiple political movements, acupuncture demonstration was routine. In another instance, I observed needles inserted to serve the function of anesthetics while the patient laid conscious during a surgery operation.

/

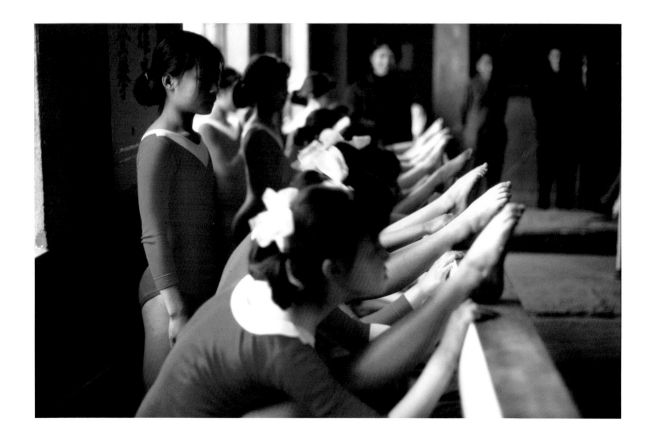

At the same school, high school students perform gymnastic classes. The elite for such sport were identified at an early age and trained for regional, provincial, or national team. These types of activities began early and for a long time the sport was dominated by the Eastern bloc countries. China exceled in such programs and had produced world champions in the process.

/

Despite rudimentary and old equipment, China produced some of the best gymnasts in the world, often taking the podium at international competitions. /

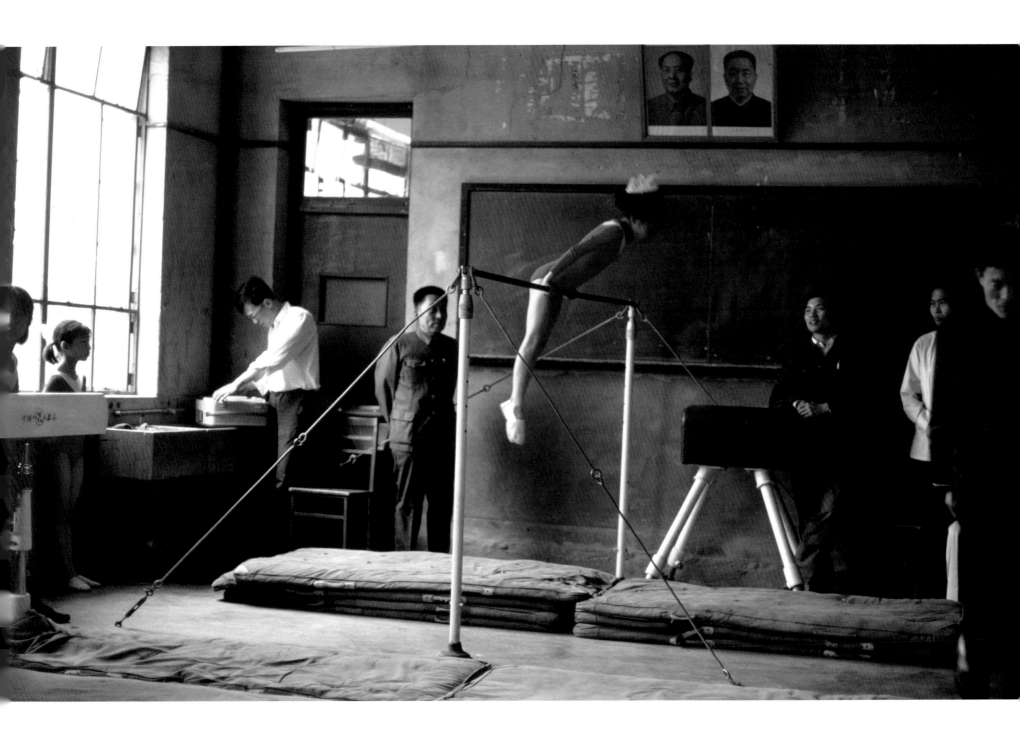

Suzhou garden is an exquisite part of Chinese architectural heritage. I was attracted to this garden city three times during the 1970s, always finding additional design details that fascinated me. Art being one of my majors in university, soon I began writing for magazines, including the Architectural Digest, regarding Chinese gardens, in particular those in Suzhou. Today, such gardens that used to be private domains, are filled with tourists from the world over.

/

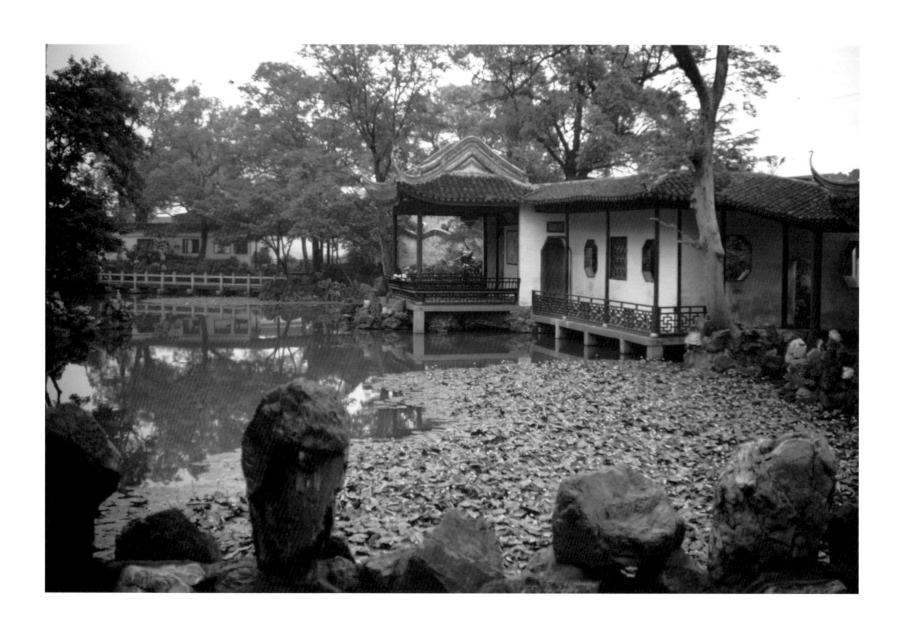

During the 1970s, bath houses in major cities were common site as few homes had individual bathrooms. In larger houses, they were often divided into many families and households, sharing kitchen and bathroom if any. Here in Shanghai, the bathhouse was used daily by many residents of the city.

/

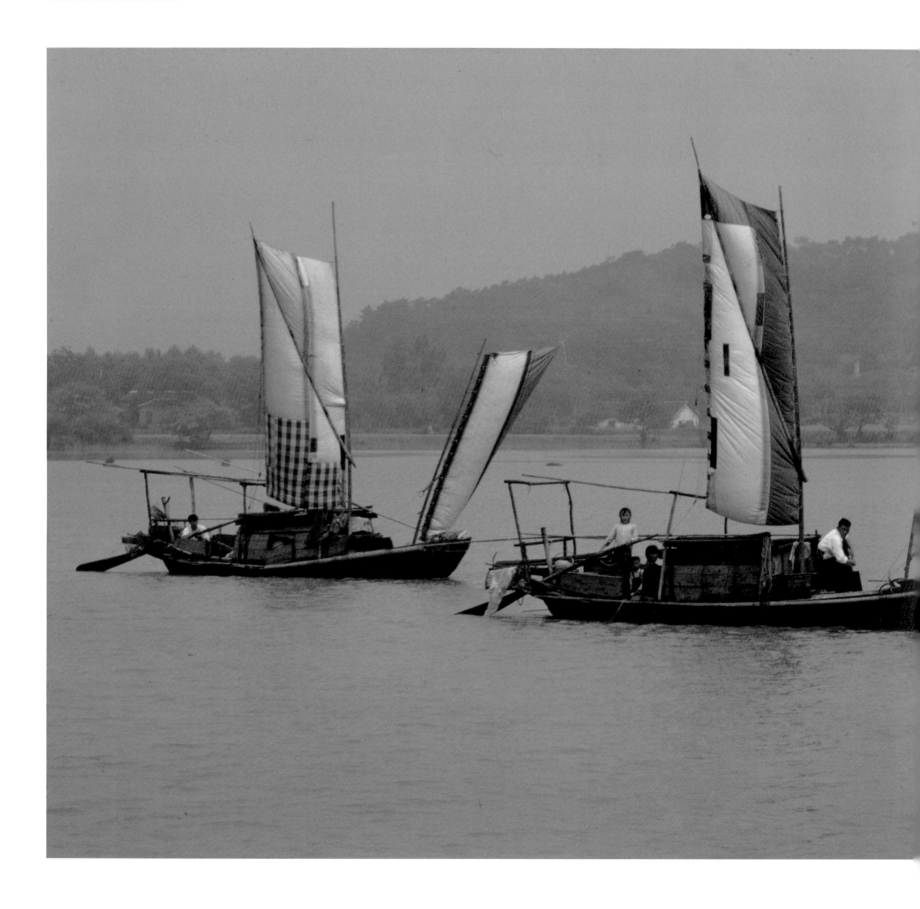

Boats with rag sail in the West Lake was common sight in the 1970s. Today even wooden boats have long become obsolete and replaced by metal or cement boats. The saturation of tourist boats also obliterated the once civil fishing boat on the lake.
I had long avoided going back to Hangzhou and the West Lake for fear of the pristine memory being wiped out.

/

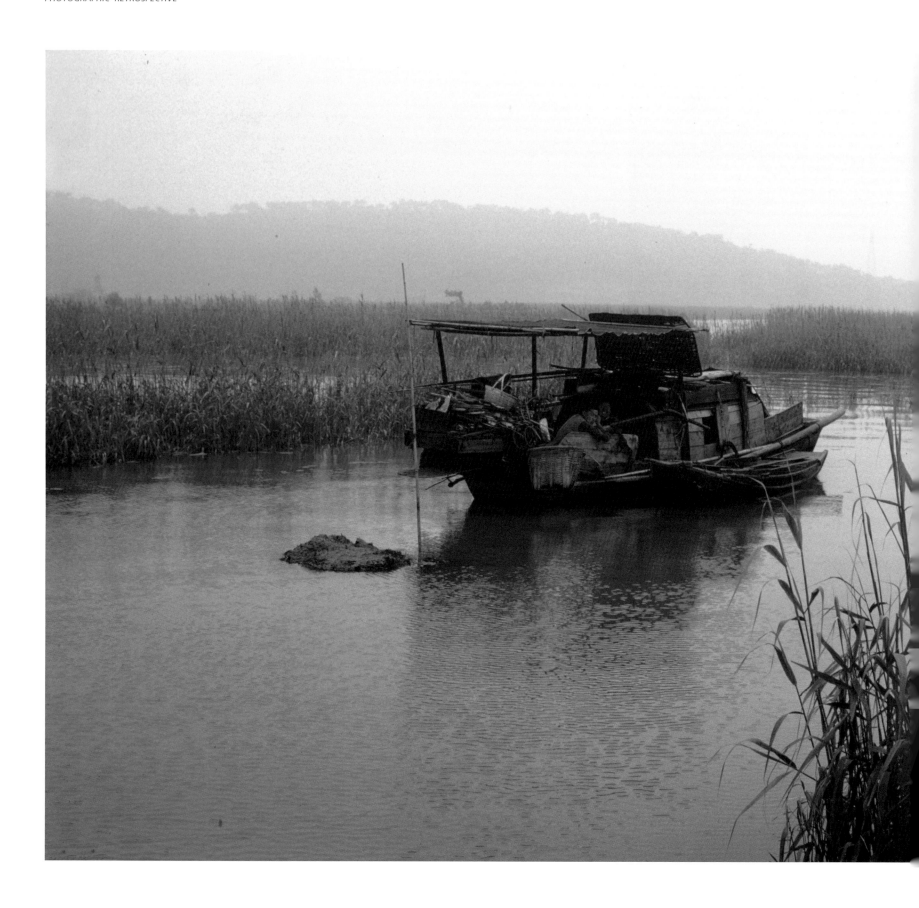

Indeed the wooden boat is a sight of the past. This scene of a family living on a boat anchored among the high reeds of the West Lake is no longer to be seen. Fishing community has disintegrated and today practically all family has a home on land. Without strict government regulations, the overflowing population and waste can also easily exceed beyond the capacity of the lake with pollutants.

/

Chongqing has always been known as the hill city, though deep in the interior hosting a population rivaling that of Shanghai. It has become the fourth municipality of China which has the same status of a province. The others are Beijing, Tianjin and Shanghai.

In the 1970s, not too many visitors would go to Chongqing despite it was China's Wartime capital under the Nationalist government of Chiang Kai-shek. But as tourism picked up speed in the 1990s, Chongqing became the upper departure point of many who wanted to cruise down the Yangtze River to see the grandiose of the Three Gorges. This photo taken in 1979 showed the monotonous yellow color tone and black roof tiles of the city's dwellings with deep and inclined streets of steps descending from the hill to the bank of the Yangtze below.

/

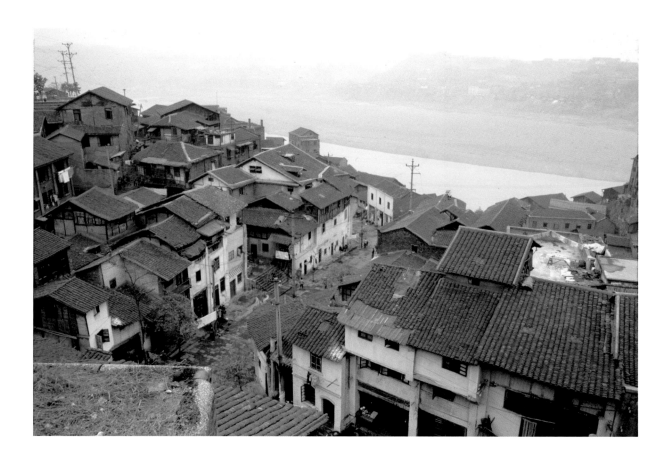

Bamboo and log rafts used to frequent the Yangtze, floated downriver to market further east. Here one raft of small log went through the Three Gorges with a tug boat steering it from in front, as well as powering it. The journey could take a couple weeks, or much longer if left to power by the current, thus the rafters would be housed in temporary sheds built on a raft. Whereas a cruise on the regular ferry from Chongqing to Shanghai would take generally five days.

/

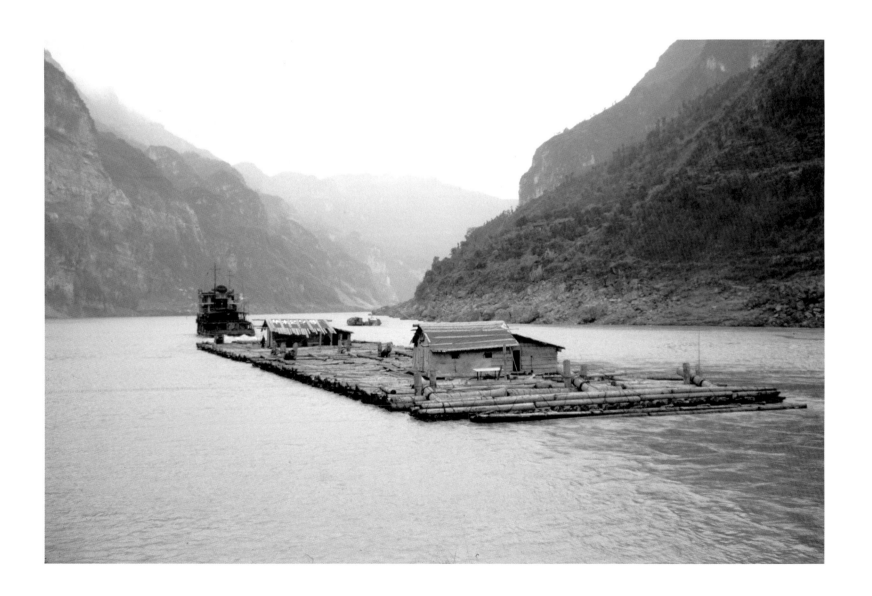

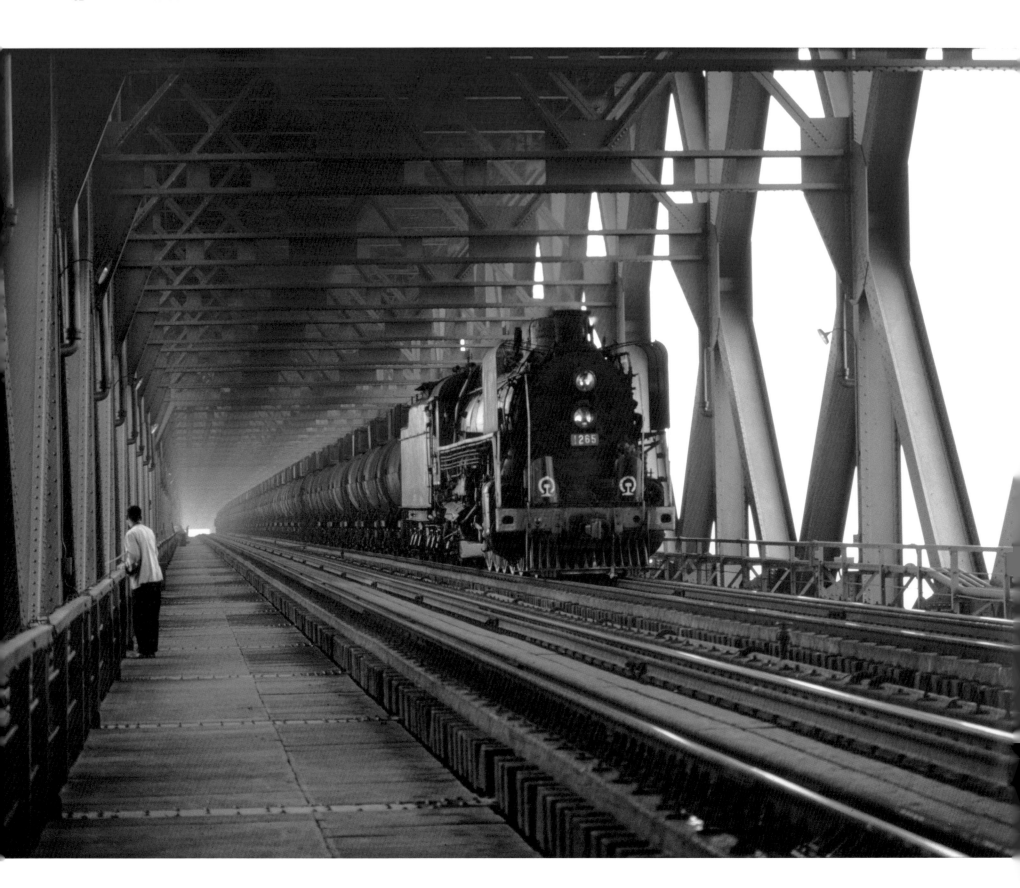

In the 1970s, the majority of China's trains were still operated with steam engines. It is not unusual to see a steam train pulling up to one hundred carriages for cargo transport, including gas, oil or other dry goods. The regular passenger train however would generally have up to twelve carriages, divided into three classes, hard seat, hard bed, and soft bed. The last is actually a cabin usually with two bunks for four passengers. Here a steam engine pulled its load across the underdeck of the Yangtze bridge at Nanjing. During that time, to procure a permit to go underdeck to the train tracks required finesse and determination, not least the right connection.

/

In the 1970s, the Great Wall, despite fame and history, did not have a fraction of today's tourist numbers. Only a short section was restored for benefit of visitors. Slightly beyond the first tower, one could see the extension into the distance with much of the Wall in a dilapidated state. However, the meandering serpentine Wall into the undulating hills was still a very special sight to behold, bringing a mental memory back to two thousand years ago when the Qin Emperor finally united China into one whole and expansive country.

By the late 1970s, I realized I hardly ever have pictures of myself taken when traveling. There was not one picture of myself at the Great Wall, nor Tien An Men, or the Imperial Palace, despite having been to these places three times in the first decade. From then on, I occasionally added myself into the pictures, but still extremely rare and far apart, unlike today's "selfie" craze all over the world. But then, film was a limited and valued resource in those days.

/

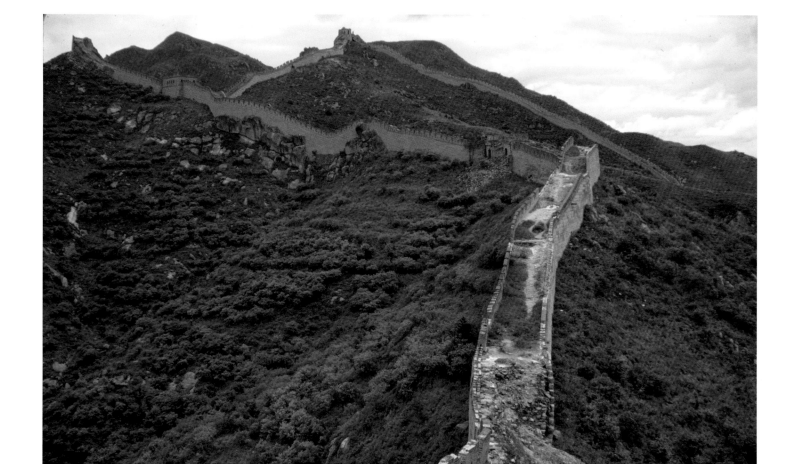

It is not difficult to frame the Great Wall with it snaking up the hills to end at one of the defense towers. But it certainly is difficult to do so with so few visitors on the Wall under bright daylight. That was the case throughout the 1970s when a few blue jackets or white shirts were all one could see as tourists at the Great Wall.

I visited the Great Wall in 1974, 1977 and again in 1979. Since then I did not recall going back for the next forty years. Once the backdoor of China was open in 1979, I never turned back, and charged ahead to the remotest corners of the country. That was precisely what the Great Wall was built for, to defend the Han and sedentary Chinese from the marauding and nomadic Mongols, as well as other tribes and minor kingdoms which now is considered minority nationalities within the boundaries of China.

/

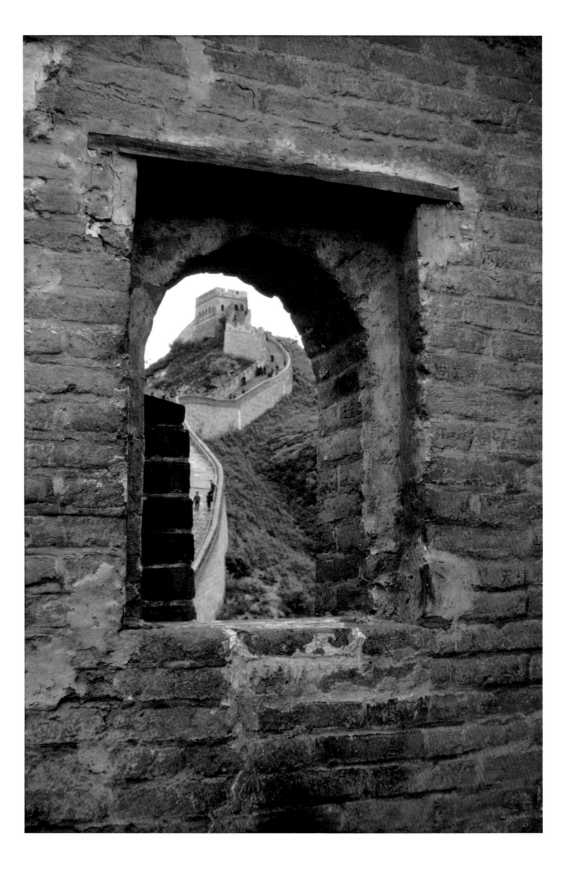

Beijing train station was first built in 1959 and situated on the southern end of Tien An Men Square. Before the arrival of long-distance buses and highways, the train was the preferred and more affordable transportation means, compared to air travels was rather minimal and expensive in the 1970s.

In those days, both air and train travels had two rates, one for Chinese nationals and another for foreigners who are considered more well to do. As all transportation were subsidized hugely by the government, it seemed reasonable that foreign guests were sold tickets at a higher price. I, coming from either the U.S. or Hong Kong at the time, was considered foreign, at least in price paying category.

/

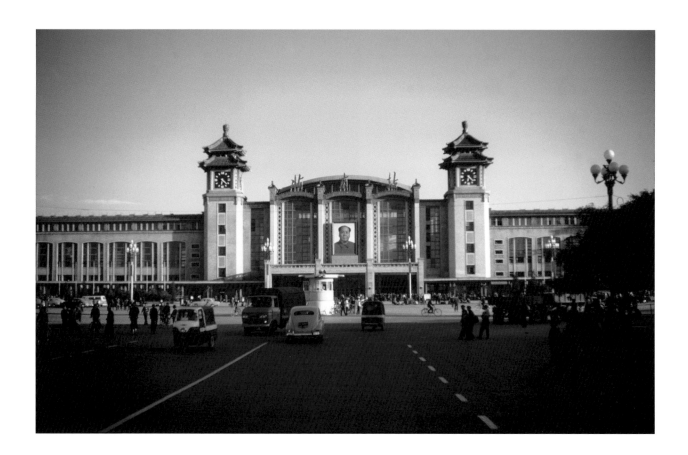

Like Beijing Train Station, the Great Hall of the People was also completed in 1959 at the height of the Great Leap Forward Movement in China. Though much used for national meetings, conferences and performances, it is also where China's leaders meet with other international dignitaries, including hosting of state dinner.

Today, much of the Square in front are filled with tourists yet well-guarded, in the 1970s, the open space was considered one of the largest city Square in the world. The national flag as seen in the picture is hoisted every morning at dawn and lowered down at sunset. The act is performed twice daily ceremoniously by a military troop as a solemn marching routine and observed by many Chinese who visit Beijing.

/

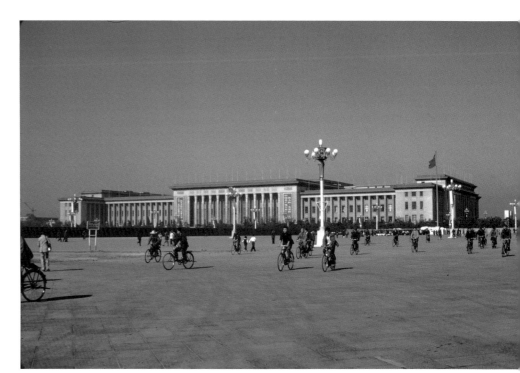

Tien An Men Square derived its name from Tien An Men Gate, the first and most imposing gateway for entrance into the Imperial Palace. It is also here that in some years the country's leaders stood above the gate as military parade marched pass this grandstand. I was a guest during the country's 30th anniversary celebration in 1979, and attended state dinner at the Great Hall of the People.

Today Chang An Boulevard in this picture has become a multi-lane car thorough way. But in the 1970s, pedestrians, bicycles and cars all shared the same passage orderly without overcrowded traffic or other control for security or diplomatic protocol functions. A leisure walk in the morning and evening was a great pass-time.

/

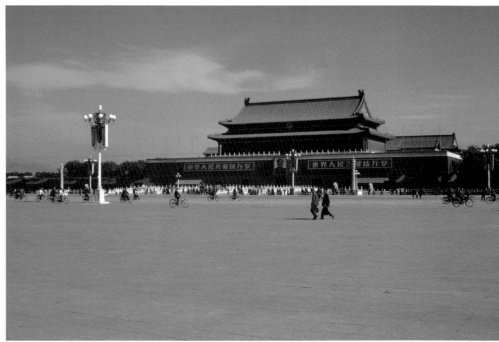

As an aftermath of the closing of the Cultural Revolution in 1976, the "Gang of Four" was detained and a nationwide political campaign was unleashed. Portrayed as the head of the Gang was Jiang Qing, wife of Chairman Mao. This major movement lasted for a couple years until after Teng Xiaoping took over leadership and China moved into a new open-door policy to the West.

In this wall poster caricature, Jiang was portrayed as a self-ordained empress and a grabber of all credits for the cultural and political theater performances and activities of the country.

/

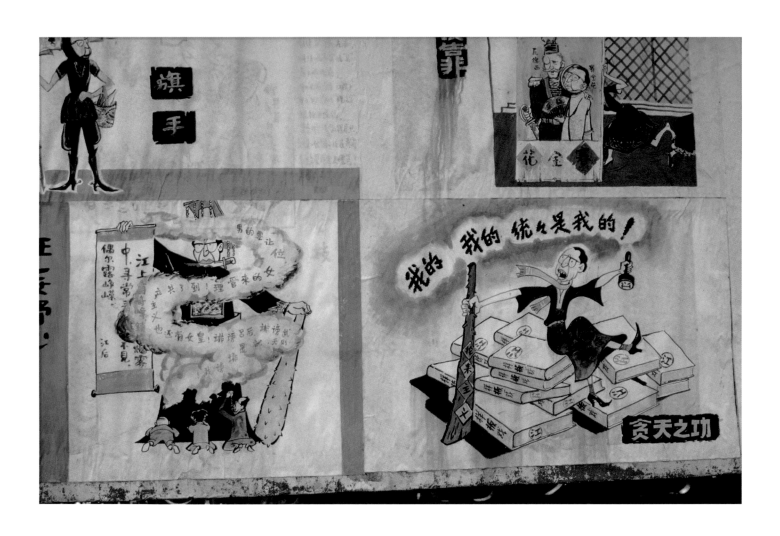

A political mural at a major intersection of Shenzhen depicts the core mission of 1977 being to uncover all the ill remnants of the Gang of Four. In those days before Teng Xiaoping's reform of the economy starting in 1979, Shenzhen across from Hong Kong was a backwater rarely visited by anyone. Compared to today, the city has become a modern metropolis hosting a large number of world class companies and start-ups.

The tall tower in a distance is a defense fortress-like architecture, usually housing a pawn shop which in ancient days operate much like a local bank.

/

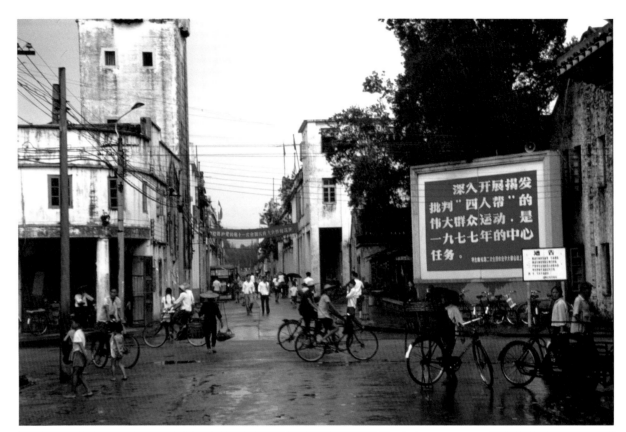

The Main road of Shenzhen in 1977 was nothing more than a village street and even a mud-stained tractor could be parked along the side of the road. Today, none of these traditional houses remain in a city that is now full of new and young people migrating into the municipality from all provinces of China.

/

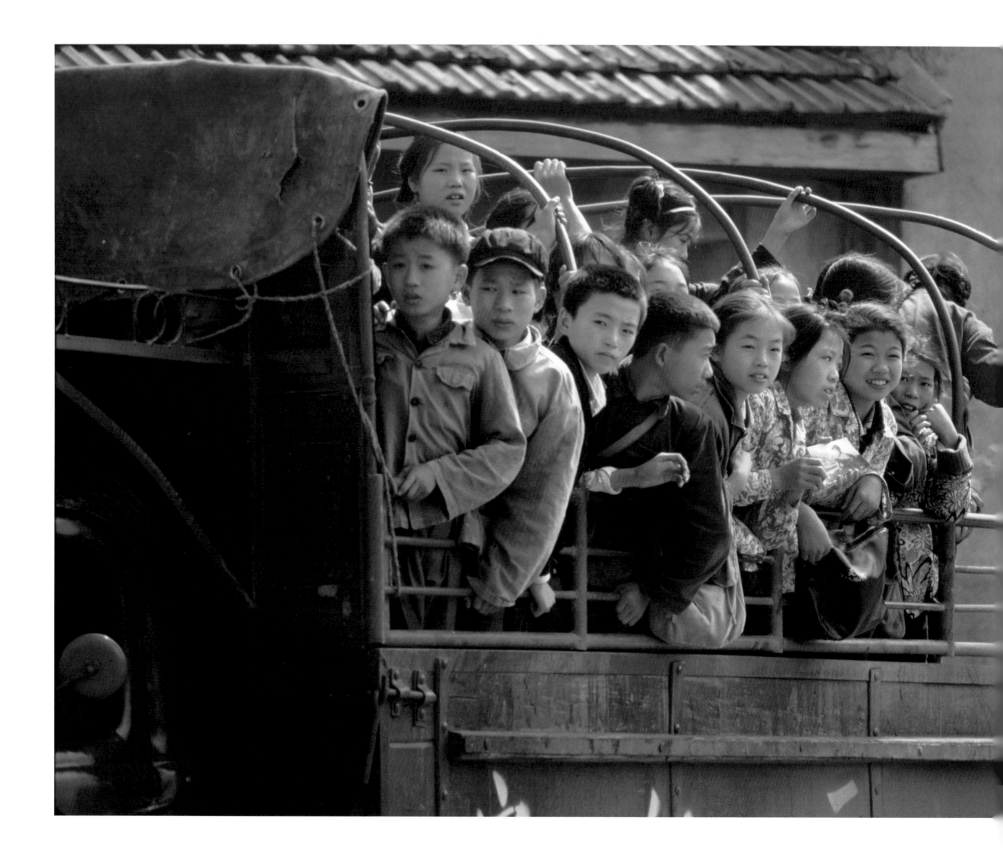

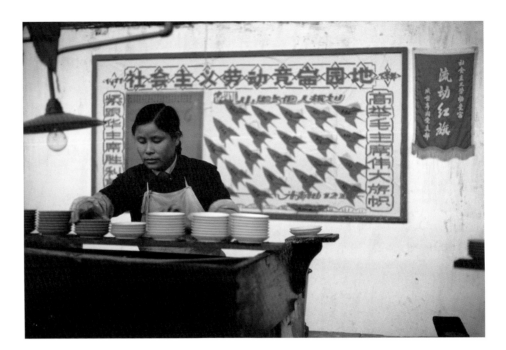

As students get out of class in Changsha, Hunan Province, they were taken in a truck that served as a school bus to be dropped off at the other side of the city closer to their respective homes.

/

At a ceramic factory of Changsha, a woman worker hurried along in her work to best her own performance with a board behind expressing the socialist production enthusiasm like rockets hitting the sky. The red banner on the wall, named revolving red flag, signified that she was awarded the title of high, or highest, performer within the factory.

/

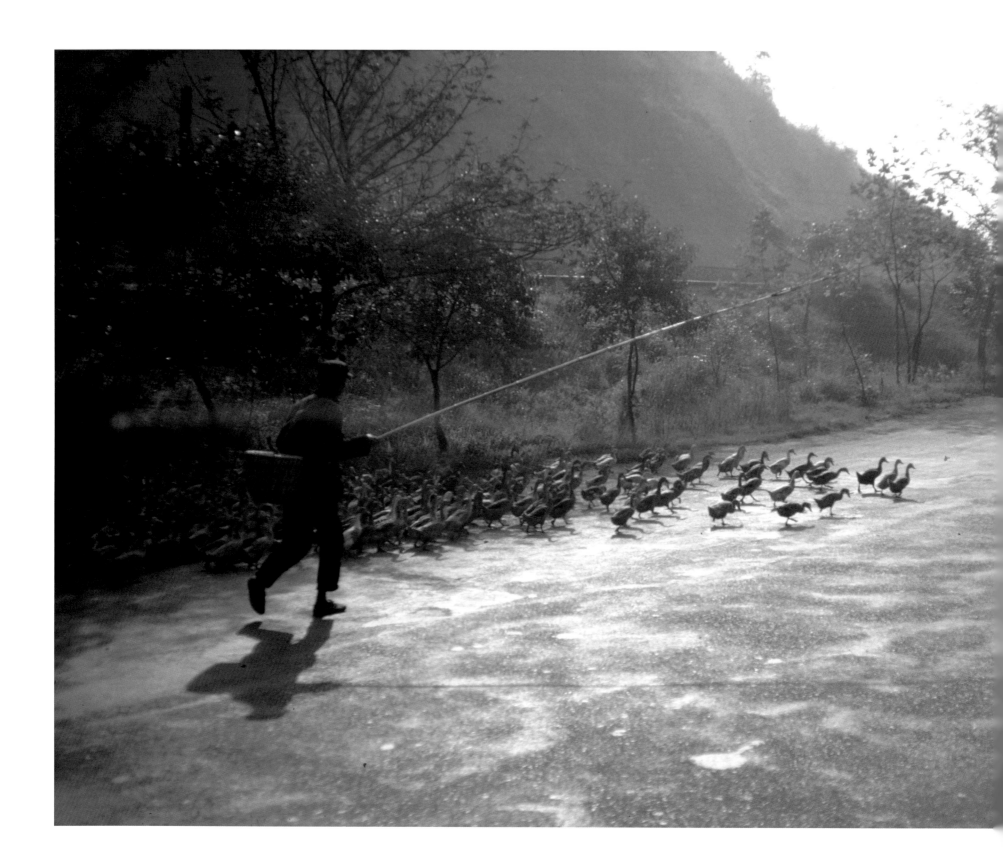

In rural countryside of Hunan, a farmer drove his flock of duck homeward. Back in 1977, the commune was the standard structure of the countryside. Individual farming has not been restored and considered a capitalist trend, to be frowned upon.

/

Like another flock of ducklings, Chinese from the entire nation made pilgrimage to the home in Hunan Xiangtan County in a house where Chairman Mao grew up. Even before the advent of tourism, such study tour organized usually by the local government was considered proper in promoting high political conscience.

/

A house also at Xiangtan where Mao had gone to as student of traditional learning was also considered a revolutionary pilgrimage site in the 1970s. Aspiring communists would make such a visit as adding merit to their communist conviction. Foreign groups found such places were often included in their travel itinerary. Fortunately, these places occasionally are also quite scenic, being in the rural countryside of China.

/

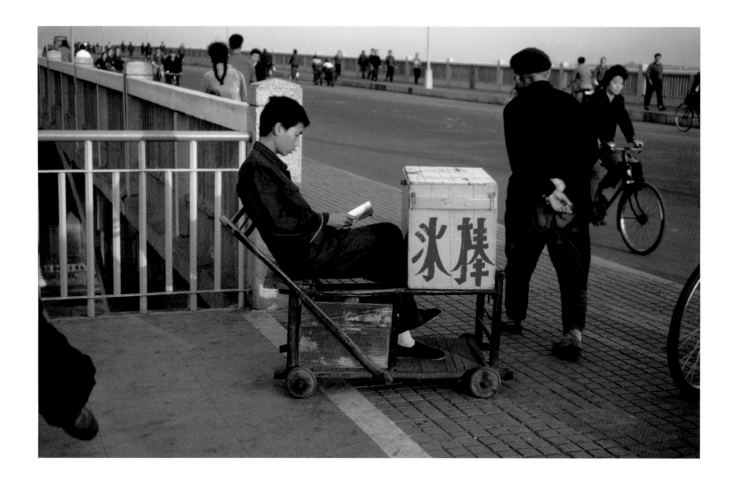

Morning hour over the bridge across the Xiang Jiang at Changsha, capital city of Hunan Province. As others headed to work and retirees took a stroll, a young man read his book while attending to his home-made ice popsicle cart.
/

Before the build-up of the 1990s, Guilin in 1977 was a pristine and sleepy small community, hardly a city by scale. The buildings were sandwiched between spectacular lime-stone karst hills. Through a friend and then manager of the hotel, I was able to borrow his bicycle for an early morning ride to Dushou Hill and climbed it before dawn, only to capture a sunrise scene as well as the first ray to hit the valley pocket below.
/

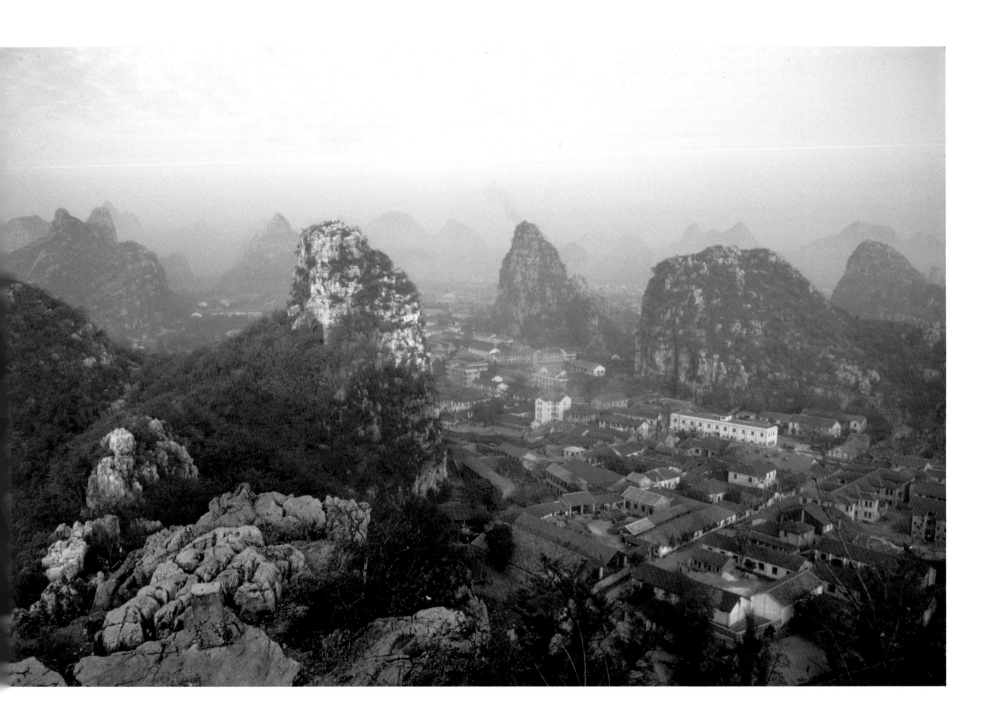

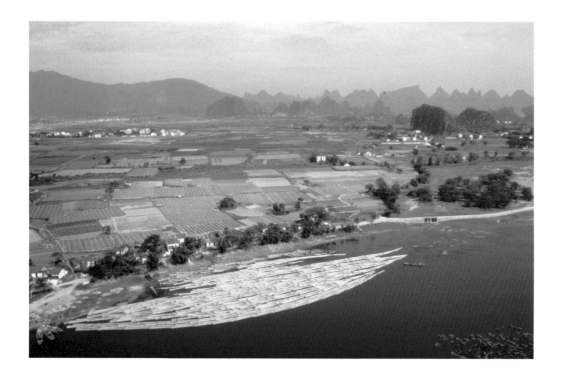

Along the Li River in Guilin, the distant karst hill sets a backdrop to a huge array of bamboo harvested and ready for binding and to be floated downriver to market. Though Guilin was historically a tourist mecca in southern China, back in the 1970s, visitors were few and far in between. There was only one main hotel that was capable of hosting foreign visitors.

/

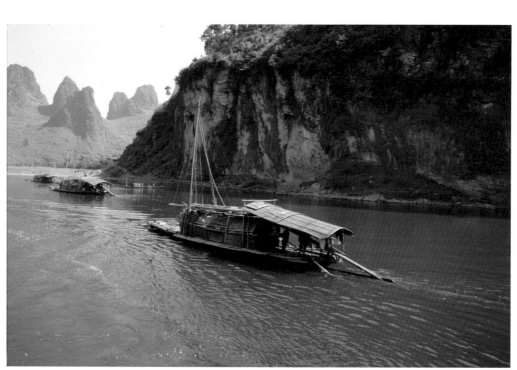

The Li River cruise to nearby Yangshuo town was a joy and must-do for anyone to Guilin. In the 1970s, there were many wooden boats plying the river as regular transport of goods and farm produce. When the wind picked up, sail would be set, whereas other times, manual labor was used to negotiate the relatively slow running river.

/

Without motor, fuel power is substituted by human power as this loaded boat was being pulled upriver through the use of a circular manual winch in the front of the boat. At slower rapids, one could see boatmen walking along side of the boat's outer edge in a direction against the flow of the river while poling a long bamboo stick to the bottom and pushed the boat upriver.

/

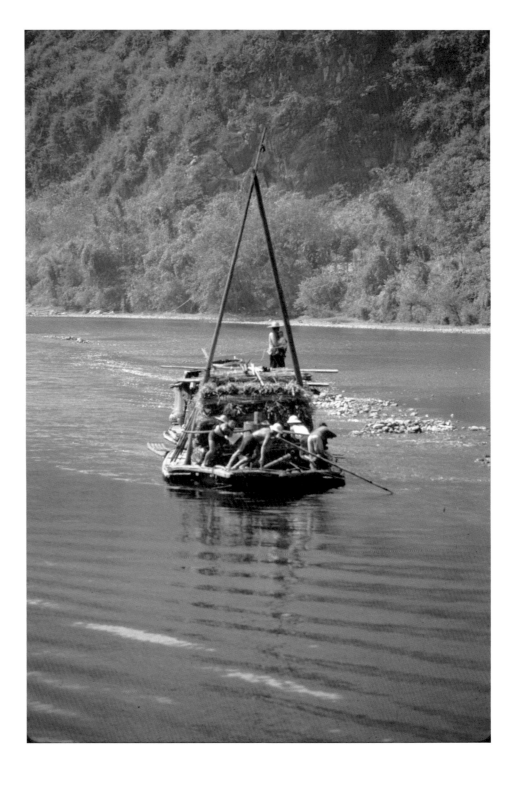

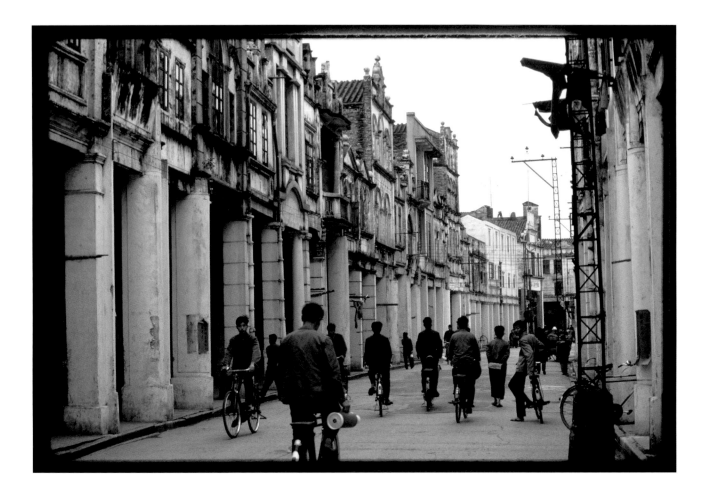

The main street of Taishan of Guangdong Province had many old-style pseudo western architecture. This was where East meet West as the county boasted the largest number of immigrant workers to the U.S. in the old days. Money remitted home from these overseas workers contributed to the old Taishan becoming a semi modern town compared to many other village towns of the province.

The high ceiling ground floor often came with a loft, making the shop houses a unique feature of the main street. /

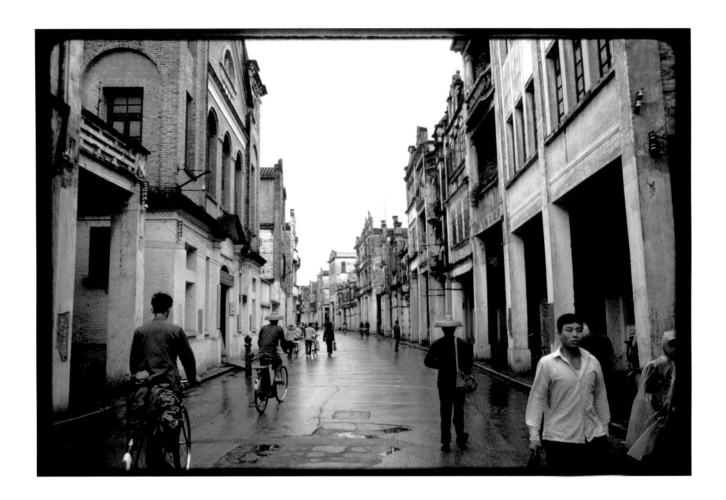

In Taishan, though the houses were old, the streets were immaculately clean. In the 1970s, it required taking four ferry crossings at branches of the West River, tributaries of the Pearl River, in order to get from Guangzhou to Taishan. Today, it can be accomplished within an hour through highways connecting the two places. /

Mass meeting of students in a park was routine for political studies, memorializing the early days of the communist's peasant movements. Here outside of Taishan, a group of students listened on as their teachers took turn in giving historical and political lectures, reminding youngsters the hardship of their forefathers.

/

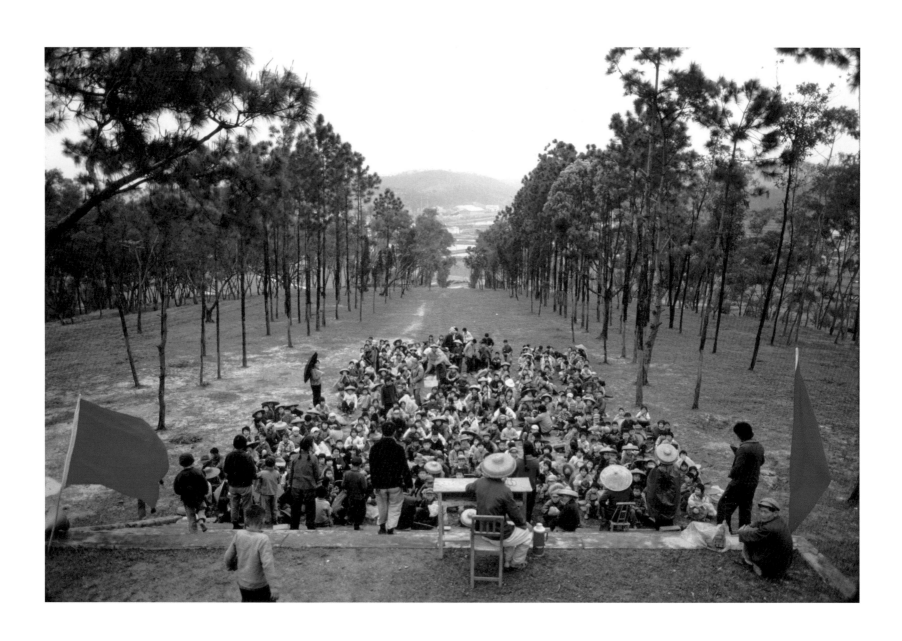

Even after the Cultural Revolution, by 1978, production was still slow until after Deng Xiaoping open the country to the West. In a shop at Taishan, considered with better stock than other towns and cities due to remittance from overseas relatives, the merchandise were few and basic. However, in those days of socialist enthusiasm, shopkeepers were always serving with a genuine smile, as everyone was equal, given the few commodities available. Radical changes were soon to follow in the 1980s.

/

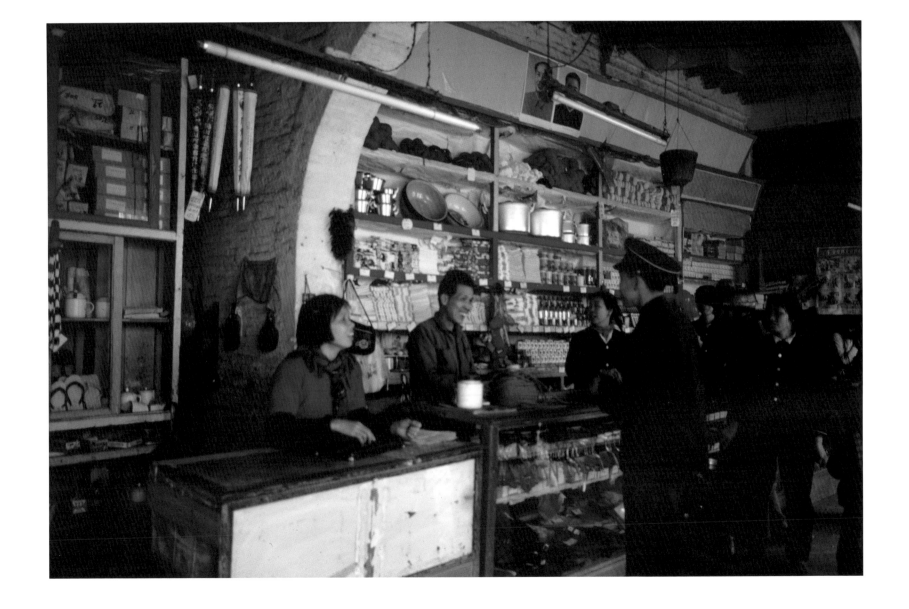

Hong Kong & Macau in the 1970s

In the 1970s, Hong Kong was going through major transformation times. The boom and bust of the stock market, from home-call and customized tailoring shops, to ready-to-wear garment factories and mushrooming of small boutiques, the society was undergoing a shift from the traditional old Chinese culture to embracing a modernized western one.

I had a hiatus from the US after college and entered advertising profession in Hong Kong, first as a copywriter but soon promoted to become Creative Director, handling some big international accounts like Mobil, Celine, KLM, and even introduction of new cigarette brand which I felt obliged to taste before designing its campaign. Every chance I had, I took time to roam the more remote parts of Hong Kong, including a few trips to nearby Macau, and enjoyed my new love for photography. For my China trip, I would take leave without pay in order to satisfy my quest to see the country. My first Nikon FTN was bought during that time in 1974.

By 1978, I moved back to the US "permanently", but continued to make occasional trips to Hong Kong to visit my parents. Looking back, I am glad I took time to record a few worthy images of Hong Kong and Macau in transition, though for Macau that change was not as apparent and came more slowly.

In the mid to late 1970s, Hong Kong still had the old street food stall in many of the island's side streets. Here, even with a sloping alley, a restaurant for rice and egg noodles was able to establish its stand. The old trick of how to squat and sat on a tiny non-fixed stool over a long bench took some balance and finesse just to enjoy a hot bowl of freshly cooked noodles.

/

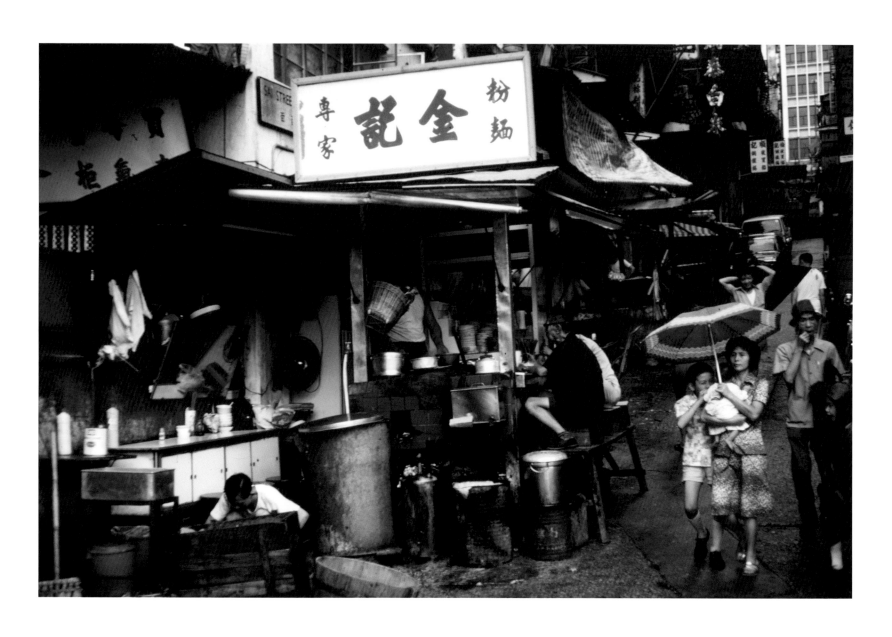

Wala Wala was a common sight of Hong Kong harbor while I was growing up. I had to cross by ferry every day from our home in Hong Kong Causeway Bay mid-level to Kowloon, where my Jesuit school was located. This went on for six years until I graduated from high school. Today, not a single Wala Wala boat remains to be seen, not even in the maritime museum. In this sense, Hong Kong seems adamant in eradicating its past completely in the name of advancement, somewhat similar to radical revolutionary addicts of Mainland China destroying their tradition and heritage during the Cultural Revolution.

/

Aberdeen was already a sizable fishing village when the British took Hong Kong in 1841. In the 1970s, the festival of Tian Hau, sea goddess for all Chinese fishermen, was celebrated with all seriousness and pomp. As all boats returned to port, the entire harbor and typhoon shelter of Aberdeen became a sea of flags as canvas canopy was spread over the fishing boat's deck for hosting of family banquets, and making of special offerings to the goddess.

/

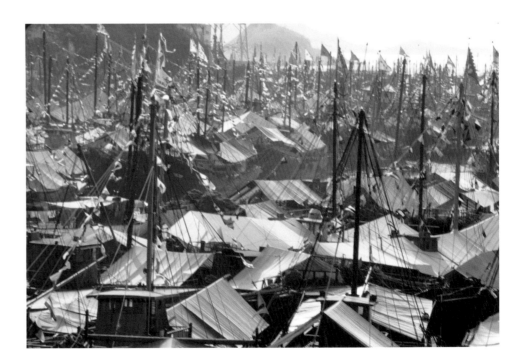

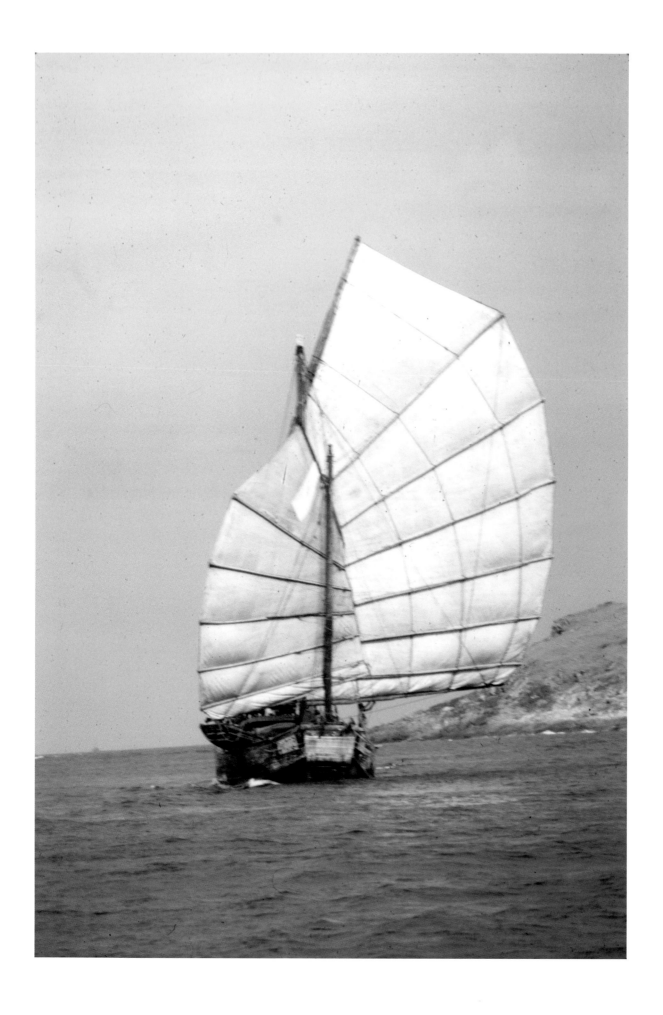

Wooden fishing junk with sail was still prevalent in Hong Kong during the mid-1970s but disappeared thereafter suddenly and very quickly as all fishing vessels were replaced by motorized ones made with steel as wood become harder to come by and expensive. Today, only a couple of not so authentic replicas are operated in the harbor for the benefit of tourists.

/

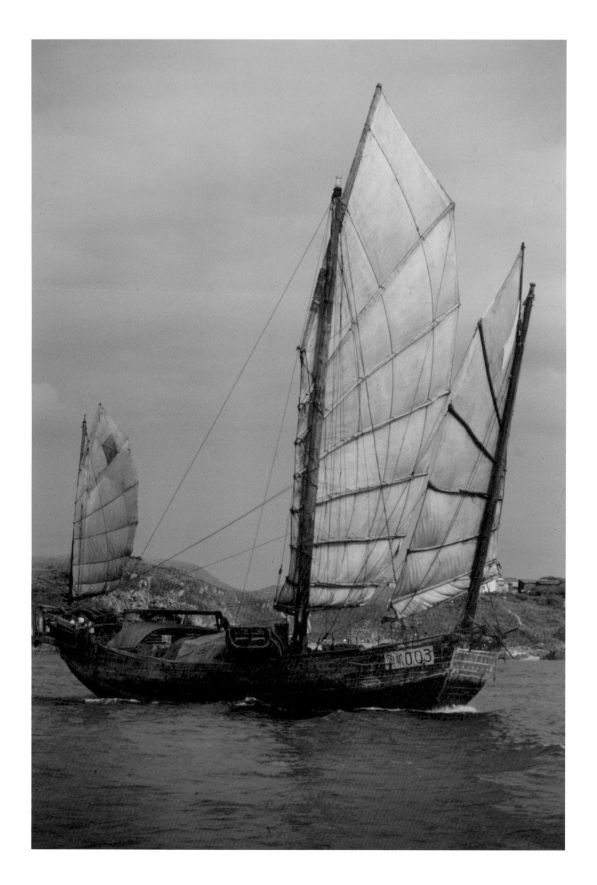

Back then, the traditional fishing junk with multiple sails was still prevalent in the harbor and outer sea of Hong Kong. Rivaling western sailors as well as those who reached China during its dynastic reign, boatmen of the South China Sea sailed through the coast of China into distant islands, be it for trade or for fishing occupation. It was around the 1960s to the 1970s that such boats began to become mechanized with motor, but soon to be replaced altogether by modern metal or fiberglass boats.

/

Before the arrival of container ship of gigantic sizes, goods and cargoes reached Hong Kong by sea in ocean-going ships. The multi-armed cranes would lift the crates from its cargo hold and drop onto smaller vessels converging around it for delivery to shore. The hydrofoil was a novel high-speed boat for passenger, ferrying gamblers to the casinos in nearby Portuguese Macau where the dreamers head to the Morocco of the East, and often returning a little poorer with their dreams unfulfilled.

/

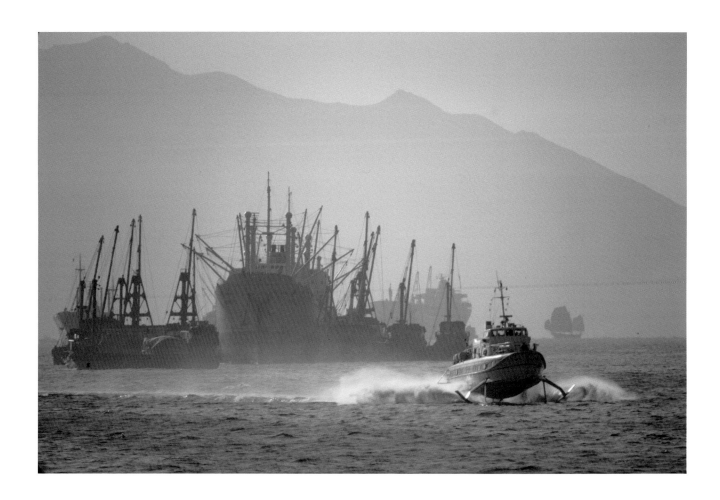

Hong Kong was a more leisurely place with slower speed in the 1970s. A road side worker relaxed with a cigarette in hand while napping over a dug-up ditch as other traffic passed by. The stock market crash in the mid-1970s sent the colony into its lowest ebb as white-collar and factory workers lost their shirts. But resilience soon overcame the doom's day attitude and Hong Kong revived itself once again into a bustling metropolis of the East.

/

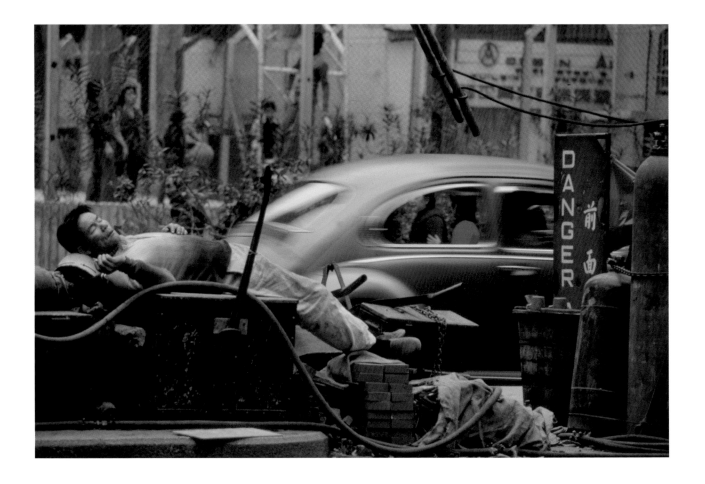

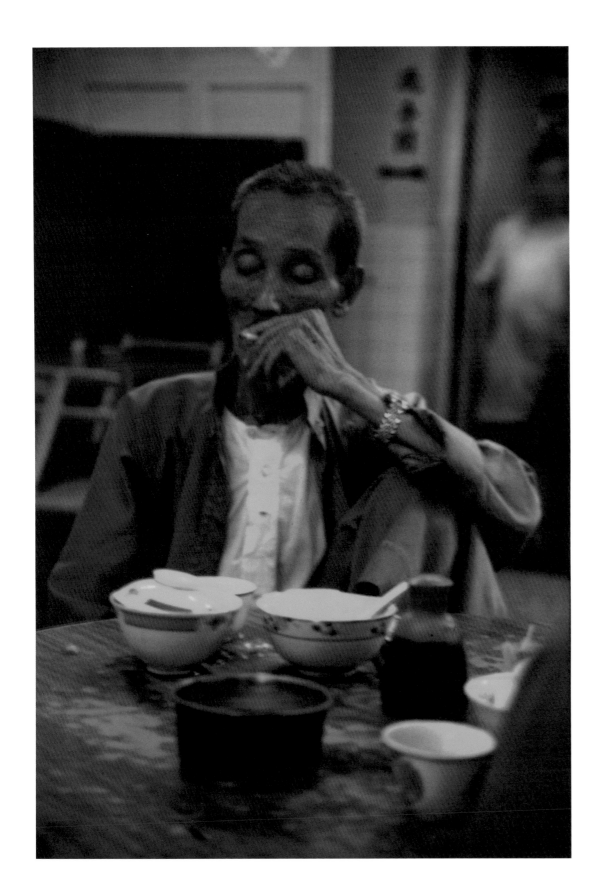

Enjoying a cigarette over a covered cup of fragrance tea, Chinese tunic was still worn by many of those more senior in age. Local teahouses dot the main and side streets of both Hong Kong and Kowloon. In a relaxed posture, resting his arm over one foot on top of a chair, this was a common sight in teahouses of the time.

/

At the waterfront of the harbor, a dog took refuge inside an empty box next to a stack of beverage delivered from the dock. At the time, canned soda has yet to arrive in Hong Kong and the various brands popular among the locals came in bottles. Green Spot was the preferred non-fizz drink of the time.

/

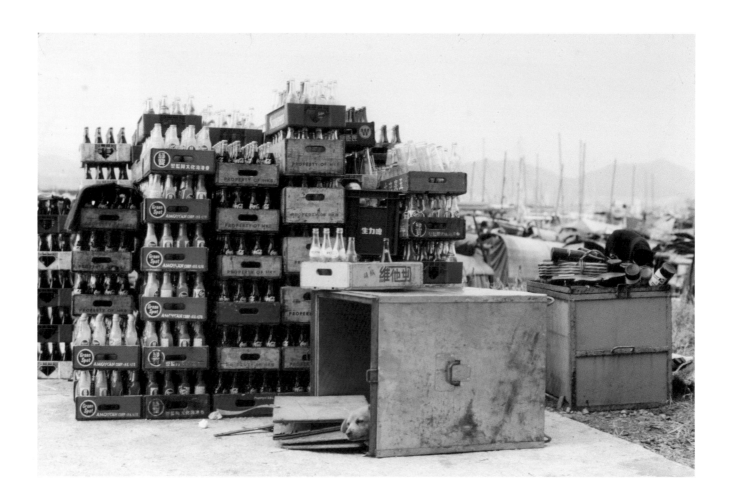

My home was a three-story pre-War house in mid-level Causeway Bay in Hong Kong, half a block from the Christian "girls" school I attended as a child, where elementary did accept some boys. At home, a balcony connects the living area to the kitchen and servant quarters. This remain the only image I took of Yasmin, our Russian Blue Persian Cat, with yellow shining eyes.

/

It may seem strange that even a factory making coffins would catch my eyes. Another photo was a coffin shop in the heart of town. Perhaps that explains my ultimate research and conservation work to Hanging Coffins of the Bo people in Sichuan. Later I was also attracted to similar burial practice of a tribe in the northern Philippines.

/

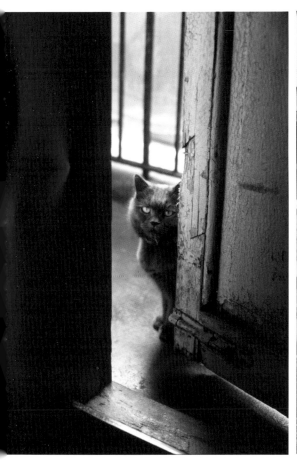

Always using slide film, my preference had always been Kodachrome X, later converted to Kodachrome 64 as referred to its slow ASA rating. It is known to have more saturated color as well as claiming to stay vivid with little fading up to 100 years. At the time, high-speed film up to ASA400 were grainy and not acceptable for enlargement. Thus, trying night photography necessitated using of a steady tripod, and a fast lens. My first Linhof portable tripod performed as expected, allowing me to capture this Christmas scene in Central before the old Hong Kong Bank was demolished and rebuilt.

/

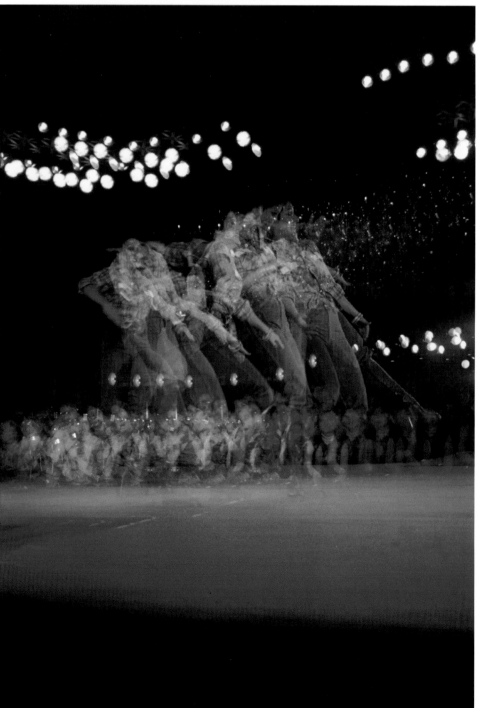

Photography for me was self-taught, as I did not sign up for any photo classes despite graduating from college with a double major in Journalism and Art. In the 1970s, I experimented with photographing motion, though film was too expensive to repeat such trials with many frames.

My Nikon FTN allowed for both slow shutter speed as well as even multiple images on the same frame by carefully rewinding the film after one exposure, using a red dot as a guide to reverse the positive film exactly for one frame. In this instance, the multiple image of a dancer on stage was accomplished strictly through a slower shutter choice.

/

In the 1960s in Hong Kong, television was the possession of a select few, from the upper or upper middle class. But by the 1970s, it has become a common form of entertainment even for an average home. The mushrooming of television antennas, like fishbones mounted on rooftops, dot all private and public residential buildings. These were gradually replaced by joint communal antennas later on.

/

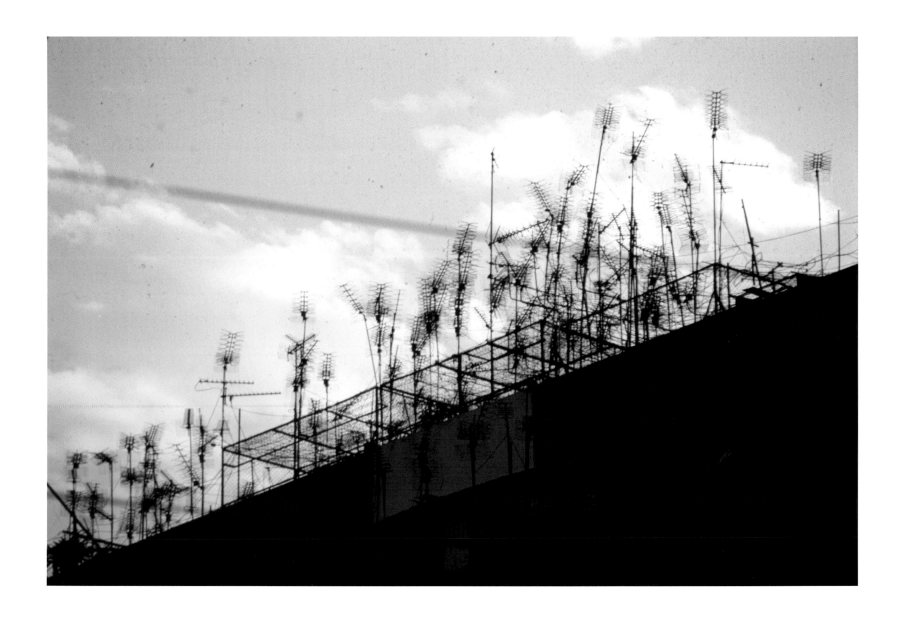

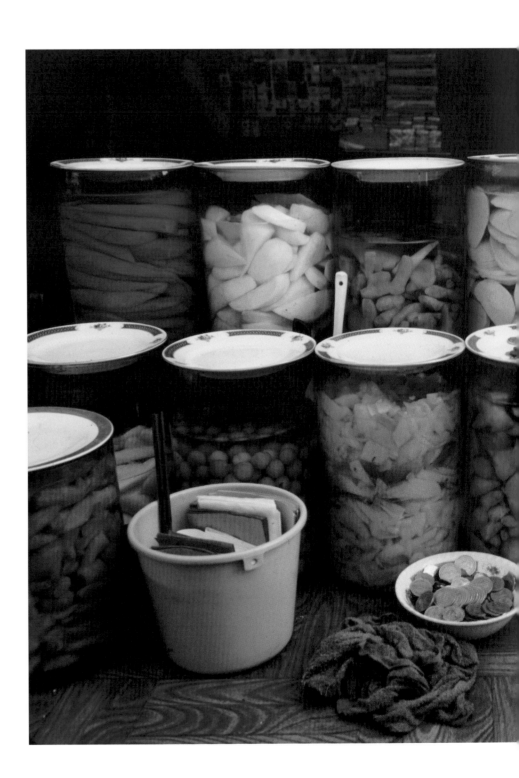

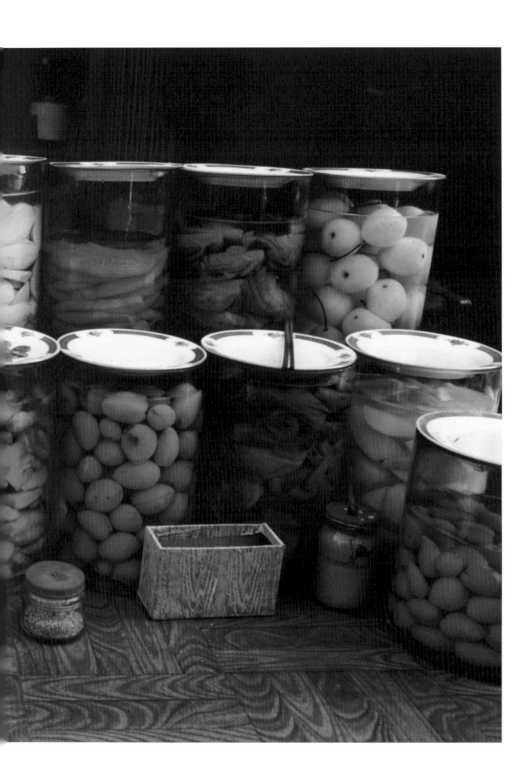

Street stalls and even push cart stands used to provide an array of pickled snacks catering to any class segment of the community. These were preserved in jars with seasoned vinegar and other condiments of fluid or sauce. They are made from vegetable to turnip, and from fruit to ginger roots, making the contents very colorful to the eyes.

/

At the bay of Macau, the traditional large hand-pulled fishing net were common sight. Here is one last remaining one silhouetted against a rising sun. A somewhat similar picture was my one and only entry ever into a photo contest, in the Los Angeles Times in 1979. It took the Grand Prize among over 12,000 entries, and that was the last time I would consider entering any contests, quitting while I was ahead.

/

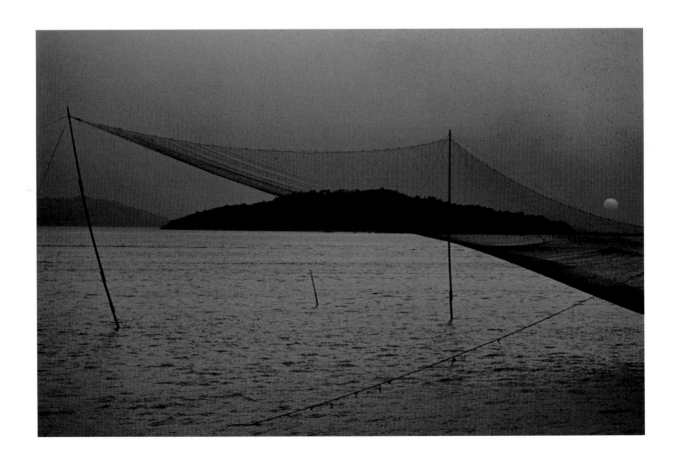

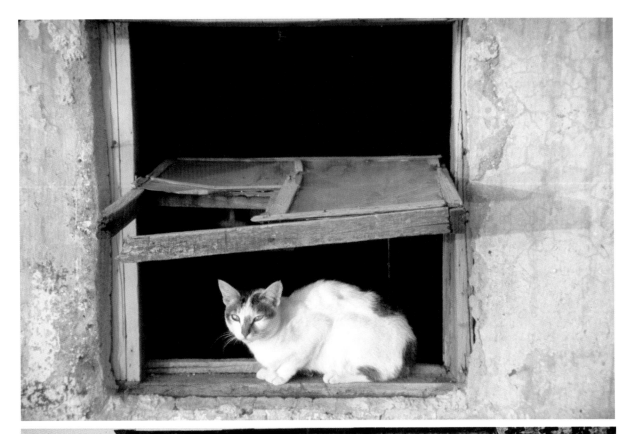

A cat is simply a cat, but not so for a cat lover. As I lived on and off in Hong Kong during the mid-1970s, I took time to visit outer islands and this feline caught my eyes and imagination as it sat to catch the last ray of the sun. By then, I already had the tendency to focus my attention and lenses on dilapidated houses, something overtime would trigger my desire to make a difference by restoring or preserving old broken buildings.

/

The façade of an old pre-war mansion at the main square of Macau provided a fusion of East and West. The wooden louvre window blinds were common sight in old Hong Kong and Macau before the War and well into the 1960s.

/

1979-1981

In 1979 as China opened its deep interior to my visit,
I grabbed the opportunity and began exploring minority regions
of remote China.
I have never looked back since.

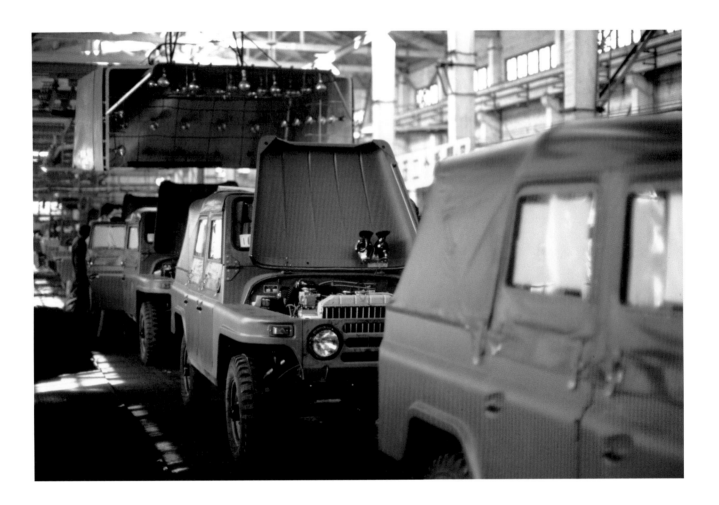

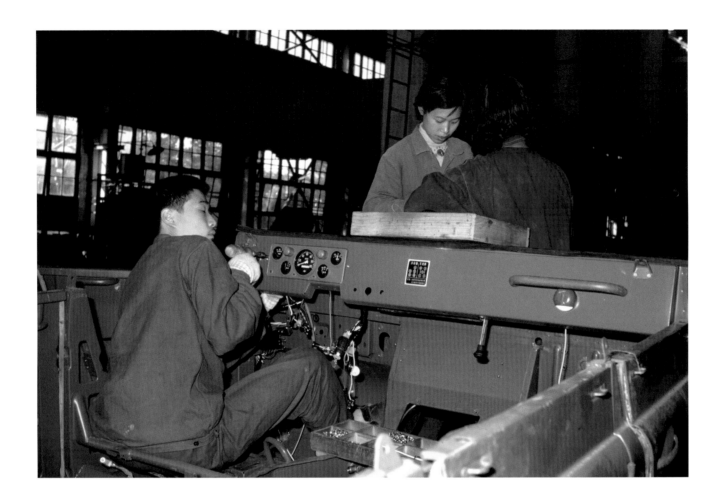

In Beijing, I visited the Beijing Motor Company where the sturdy workhorse Beijing Jeep were made. Everything was hand-built and the assembly line was filled with workers in blue work clothes. Soon I would be using such vehicles as my choice for exploration. After all, it was the only choice available in China at the time.

/

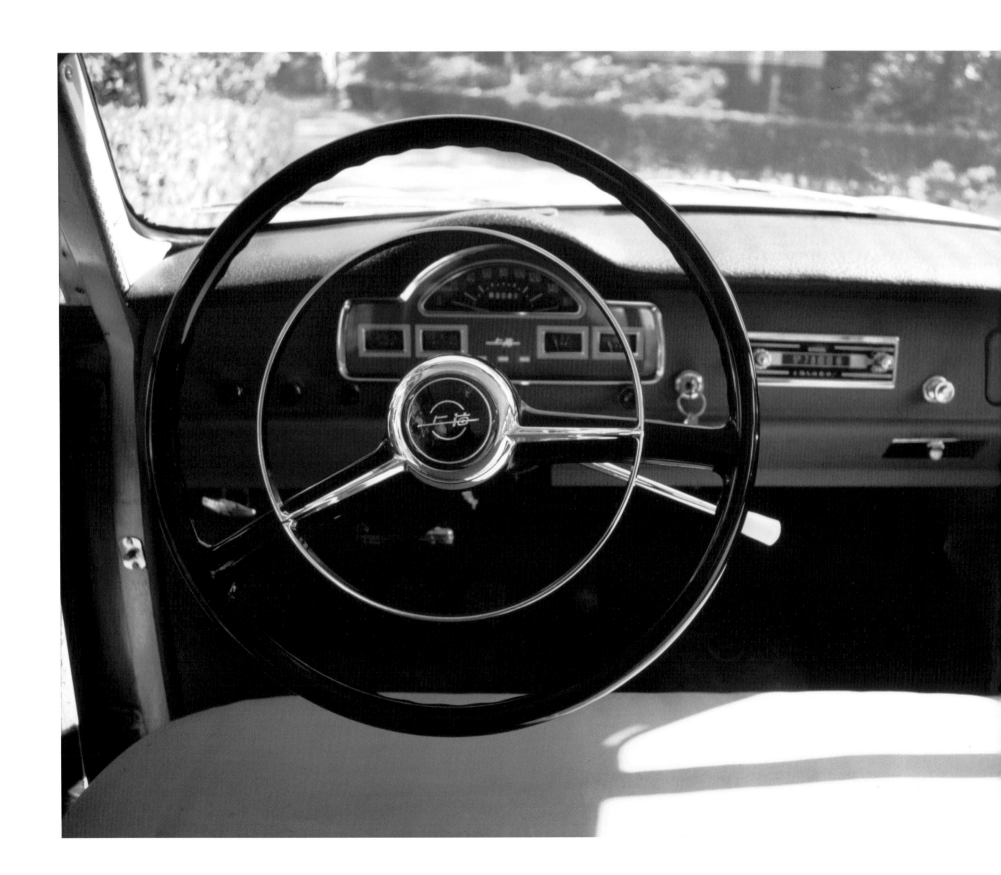

In Shanghai, I visited the Shanghai Car Factory where the best known sedan by the same brand name Shanghai was manufactured. The classic looking model lasted for over a decade and the interior dash board, while simple, is somewhat reflective of Art Deco made popular in Shanghai during the 1930s.

/

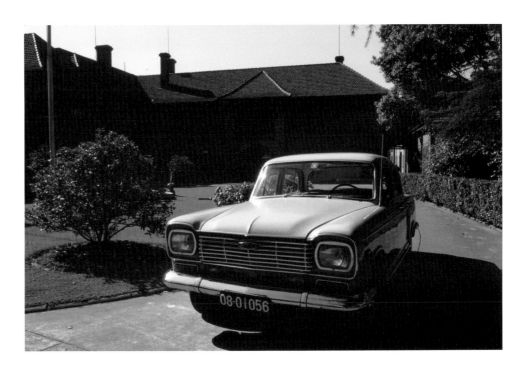

The Bund at the bank of the Huangpu River of Shanghai still retained much of its old look up till the 1980s. There was no modern high-rise in sight. The few that surpassed ten story were all built during the heydays of the pre-War years. Even ocean-going ships were steamship type of the past.

/

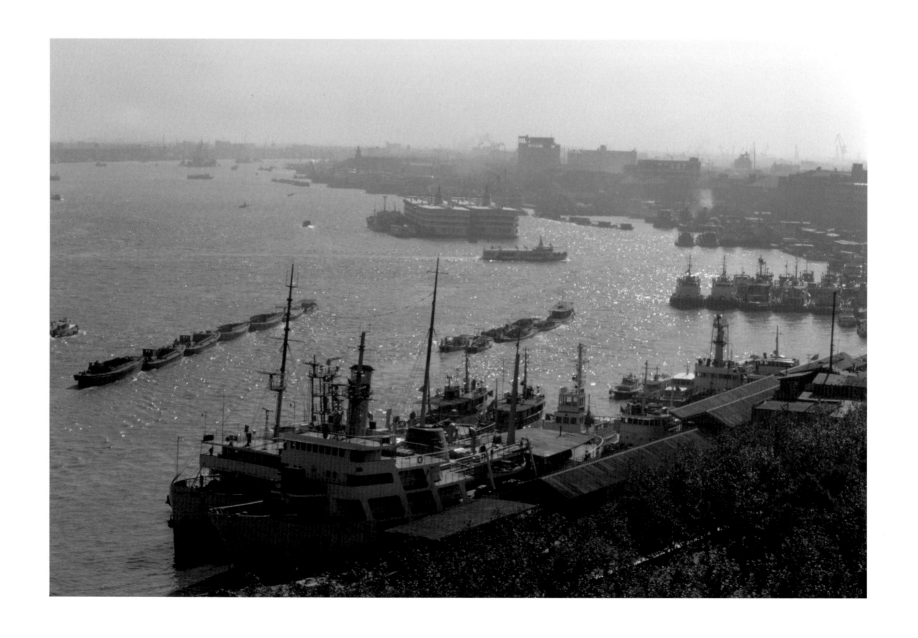

Junk with sail on the Huangpu River at Shanghai lasted through the 1970s and into the early 1980s. Like in Hong Kong, such boats would soon be obsolete, replaced by more modern fishing fleet and cargo boats.

/

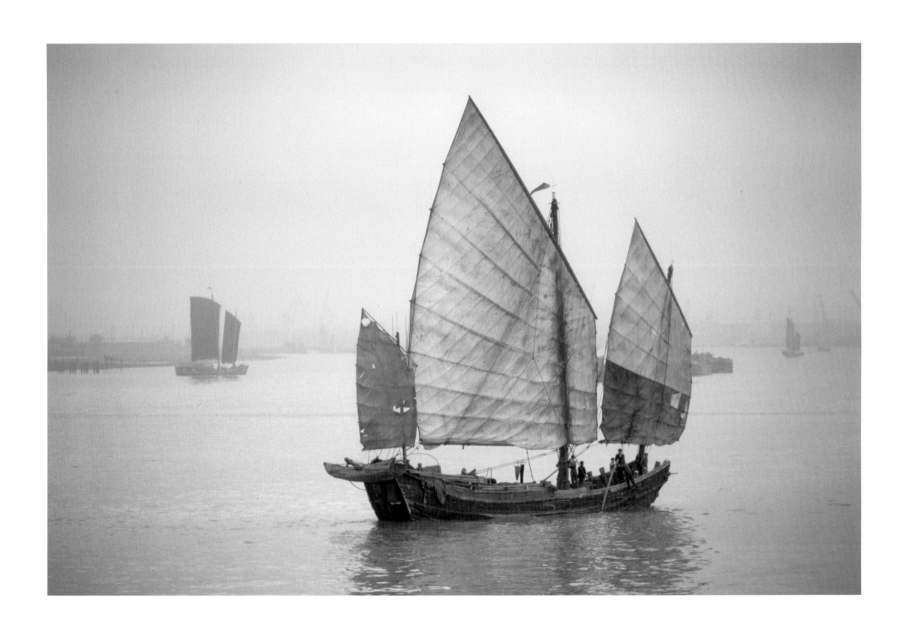

Along the lower Yangtze in Anhui Province, one can still see steam ship plying the river or going up and down stream.

The Yangtze remains the main artery of transportation of both passenger and cargo.

/

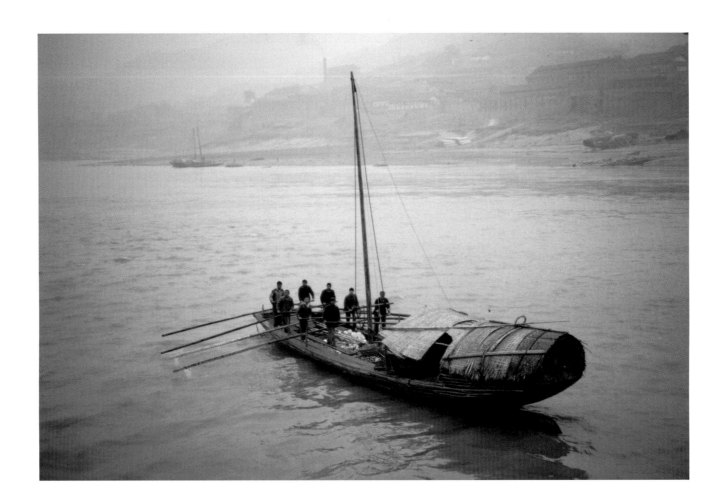

In the upper reaches of the Yangtze beyond the Three Gorges, human power using oars to navigate the river can still be seen. However, these would be the last vestiges of days past as China modernize and move into the last part of the 20th Century.

/

In Datong of Shanxi Province, a train factory continues to manufacture engines for steam trains when much of the world has turned to diesel or electric instead.

/

Along train tracks, at every station village venders flocked to the window, hoping to sell just a bit of local produce to receive additional money, formerly prohibited under the commune system of the past.

/

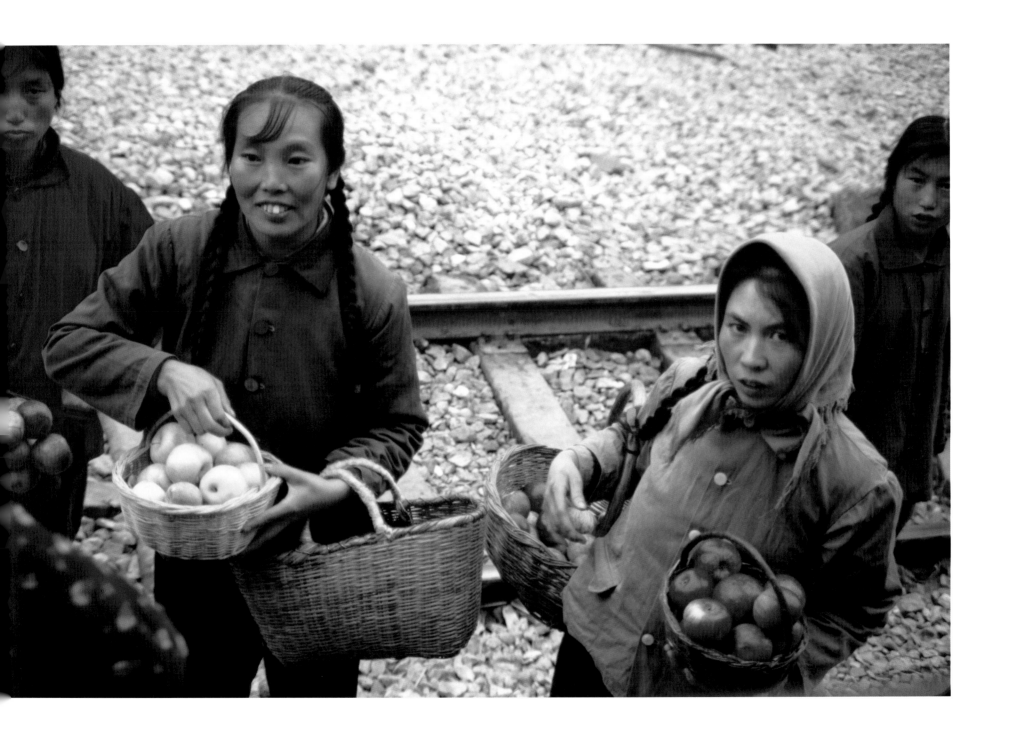

East of the bend of the Yellow River in Shenxi is Hua Shan, one of the four Daoist sacred mountains of China. The path and gate leading up the mountain can be quite hazardous.

/

In the 1970s very few visitors had the leisure to scale the mountain, and only a handful of Daoist monks and nuns were allowed to return to the few temples dotted along the way in very precarious locations

/

At a very unlikely site, a temple perched near the edge of a perpendicular cliff with only a single and narrow path chiseled out of the rock face.

/

自 古 華 山 路 一 條 ，
我 今 攀 登 費 兩 朝 ，
迴 心 石 旁 三 思 後 ，
長 空 棧 盡 四 肢 搖 。

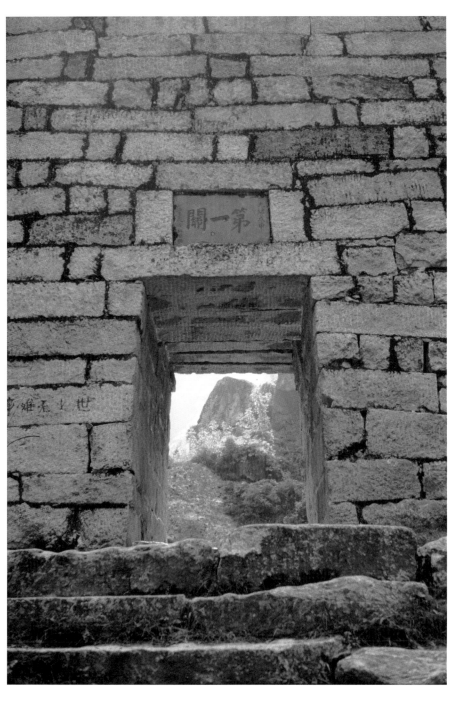

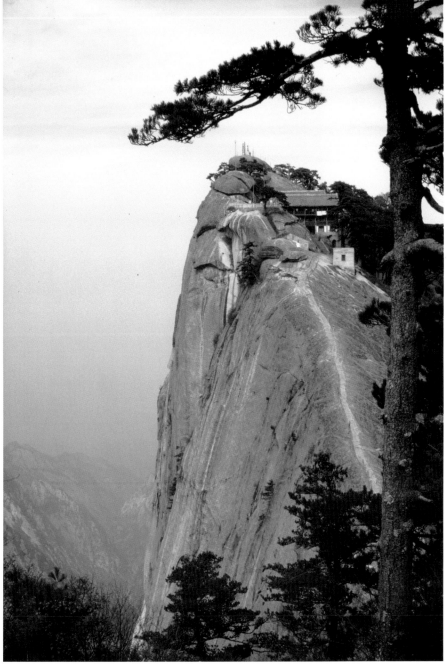

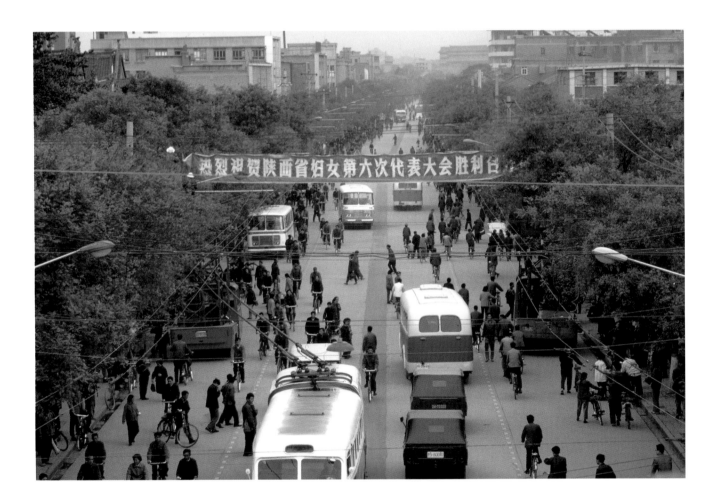

In the main street of Xian, an ancient capital of China, electric buses, bicycles and pedestrians shared the road.

/

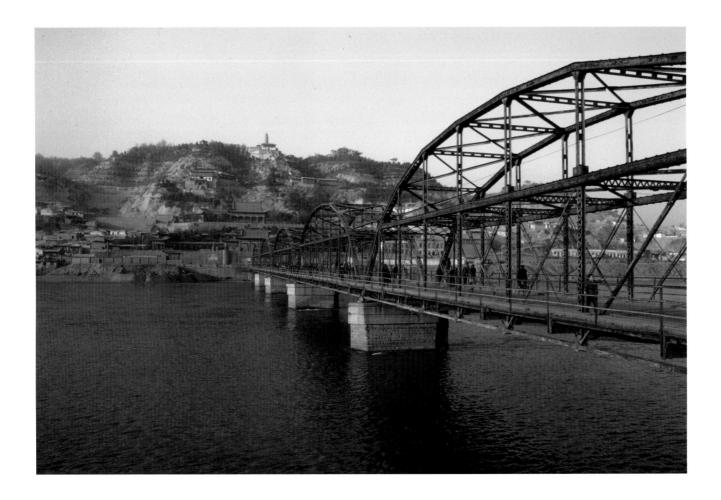

The iron bridge, named Zhongshan Bridge spanning the Yellow River at Lanzhou was built in 1907 by German engineers as the first bridge across the river.

/

A Mongol yurt is warm and easy to assemble or disassemble, ideal for a nomadic lifestyle as the herders move their flocks from place to place in search of new grazing grounds. Here one such yurt, a felt tent, is used outside of Hohhot in Inner Mongolia.
/

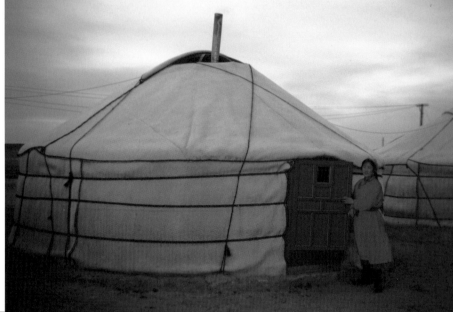

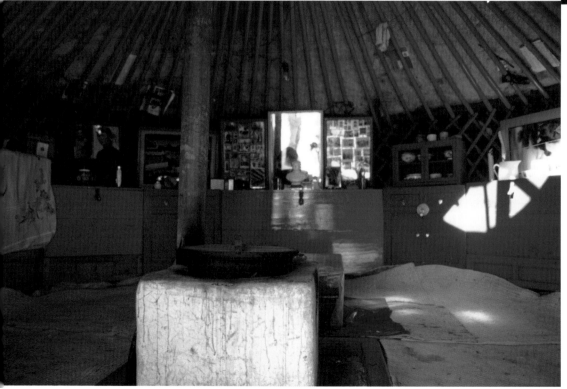

Inside a yurt, the interior can be decorated lavishly, even with a shrine that Chairman Mao was set in the middle, where in the past a Tibetan Buddhist deity would take this place. Crates and closets ringed the outer circle whereas an earthen stove would be placed in the middle, serving cooking as well as for heating.
/

Though a Mongol would prefer to wear their traditional robe, many would sport the army cap popular among old and young alike.
/

In more remote parts of the steppe country of Inner Mongolia, the yurts were more worn from use. I wrote an article illustrated with pictures for the Architectural Digest after my study of these nomadic tents.
/

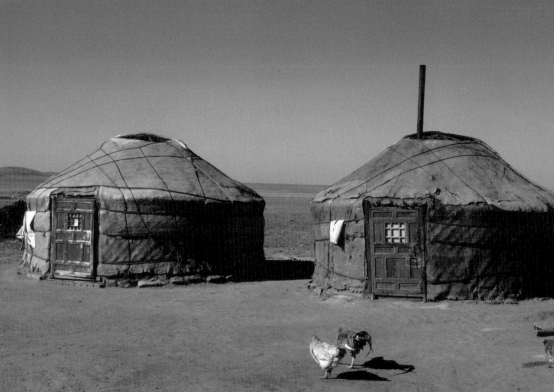

For some of the Mongols who had taken a more sedentary lives, they lived in houses where the bed was connected to the kitchen through a heated channel underneath. That is the "kang", common to many homes in northern China. Here a few children sat on a Kang bed to warm themselves.

/

In the upper Yellow River near Lanzhou, loess hills provide a most scenic setting as the calm water was created by nearby Liujiaxia dam, one of the modern dams of China.
/

The Binglingsi monastery is considered one of the five most important Buddhist grottoes of China. It is situated within the Ji Shi Shan, a loess mountain by the Yellow River near Lanzhou. I wrote an article for Architectural Digest and described the most important cave grotto Number 169 from the Norther Wei Dynasty during the 5th Century.
/

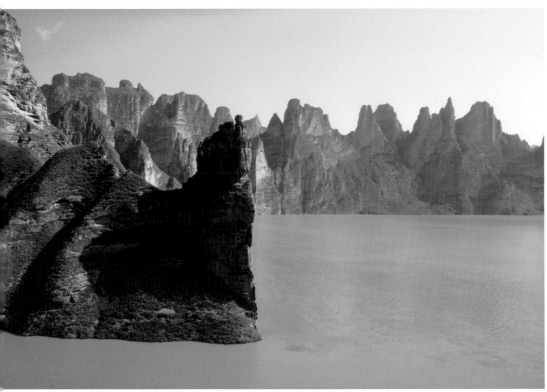
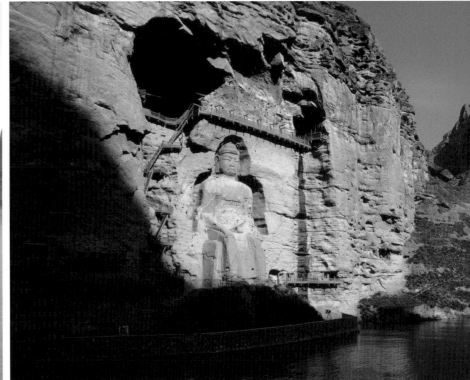

These twin eagle owls perched on the window of a village house along the Old Silk Road in Gansu Province. My interest in wildlife came rather late as my work was largely focused on the minority nationalities of China, usually living along China fringe areas, thus closer to nature. In time, I've learned that both nature and culture go hand in hand in many of these remote regions.
/

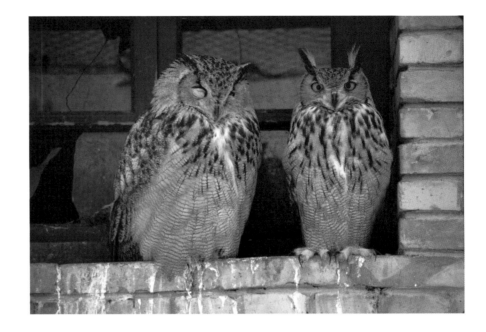

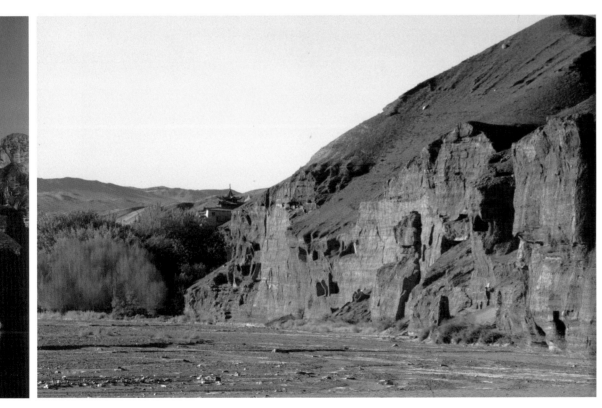

Even by the late 1970s, Dunhuang, the most famous of grottoes along the Silk Road, had few visitors except some artists and scholars in Art History. Much of the caves were in disrepair and not guarded. Erosion from the desert did much damage to both the caves and the contents, including Buddhist murals and statues, adding to the harm incurred by early western explorers/orientalists pilfering from the caves.
/

At the time, photographing inside the grottoes were largely allowed, though locals would have very limited film supply or good enough camera equipment to do so. I was able to study these statues and murals complemented by my background in Chinese art history I studied during my college years, thus able to write articles on Dunhuang both for Asia Magazine of New York and for Reader's Digest.

/

The sand dunes adjacent to Dunhuang provides much of the sand that encroached on the neighboring oasis. Here a section of the Mingshashan carved a serpent-like hill along the desert.

/

While today the Crescent Lake is a hot spot for tourists, back in 1979 it was truly an empty quarter with only one mud house ringed by a roll of tamarisks and poplar.

/

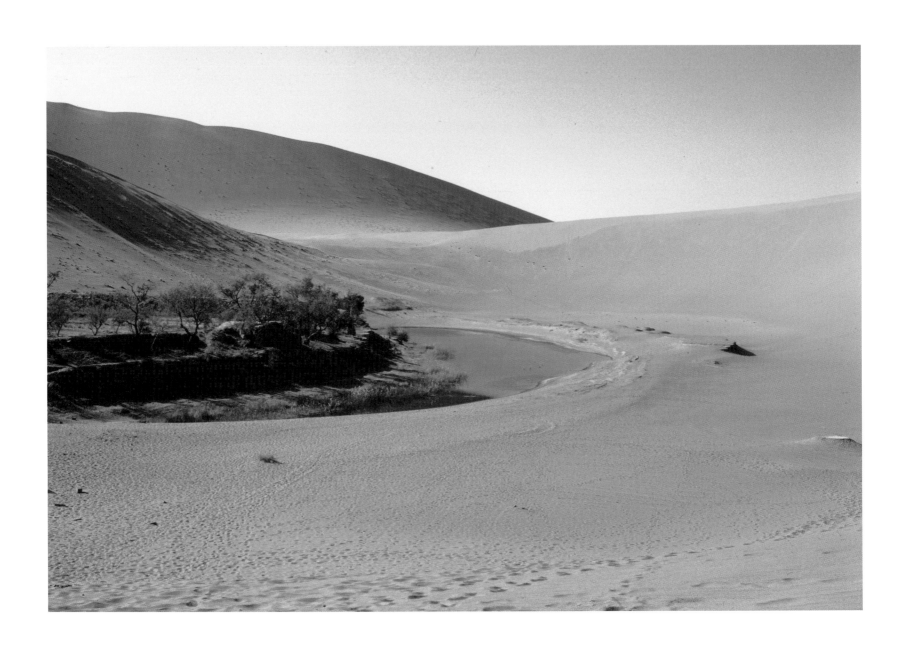

Kunming in the late 1970s were filled with old wooden houses painted in green. Today such relics are but all gone except in old pictures.

/

By 1981,
I began making more serious expedition into minority region
as the area opened up.
I would use a local Beijing Jeep and explore the eastern
part of the Tibetan plateau,
but at the same time covering a little of coastal China
to freelance for other magazines.

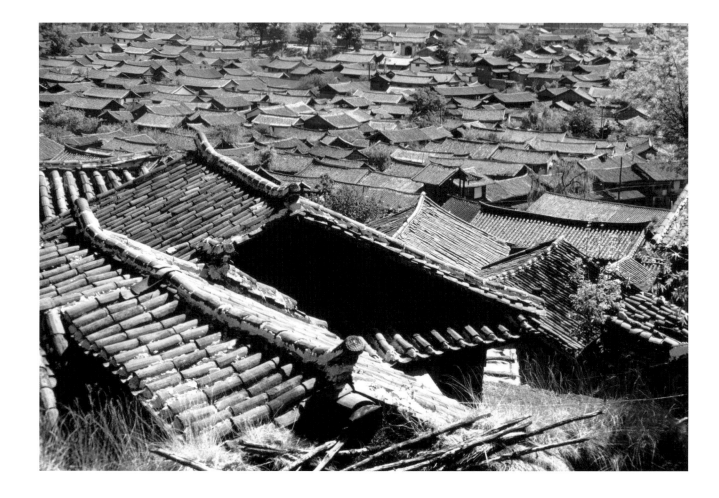

Lijiang in 1981 was a sleepy quiet town. Literally all the buildings were simple brick houses with tiled roof. From a nearby hill, I could look down on these rooflines which still reflect days of the past. Back then, even tiled roof in rural area was considered wealthier, even a luxury, as many village houses were still using thatched roof. Thus, Lijiang was considered rather prosperous when compared to neighboring villages and towns.

/

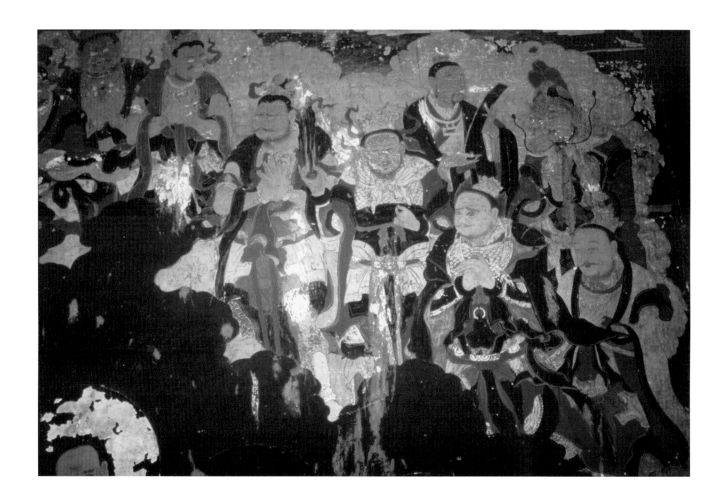

The Ming Dynasty religious mural of Lijiang is one of its prized relics. Though somewhat dilapidated, the paint was still vivid and distinct, depicting both court and religious life of time past. Today, photographing such artistic wall mural is restrictive. But at the time of my visit before tourism became popular, I was fortunate to retain record of such art before they were restored, at times in rather crude fashion.

/

A lone man staggered up the hill through the cobbled street in Lijiang. Much of the town was along a sloping hill, and water canals crisscrossed the town bringing clear glacial water from the nearby Jade Dragon Mountain.

/

In country stores, the variety of consumer goods were sparse and with very limited choices. This shop in Lijiang had much of its shelves empty and cigarette seemed to be the only item in abundance.

/

At Huangshan Commune Baihua Brigade outside of Lijiang, I observed an impromptu performance, or "jam session", of a local orchestra of the Naxi nationalities. They were all senior in age and carried the old tradition of their music into present day. Today there are many such orchestra, big or small, at many performance locations in Lijiang catering to a large horde of year-round tourists stampeding to this former quiet mountain enclave of Lijiang. /

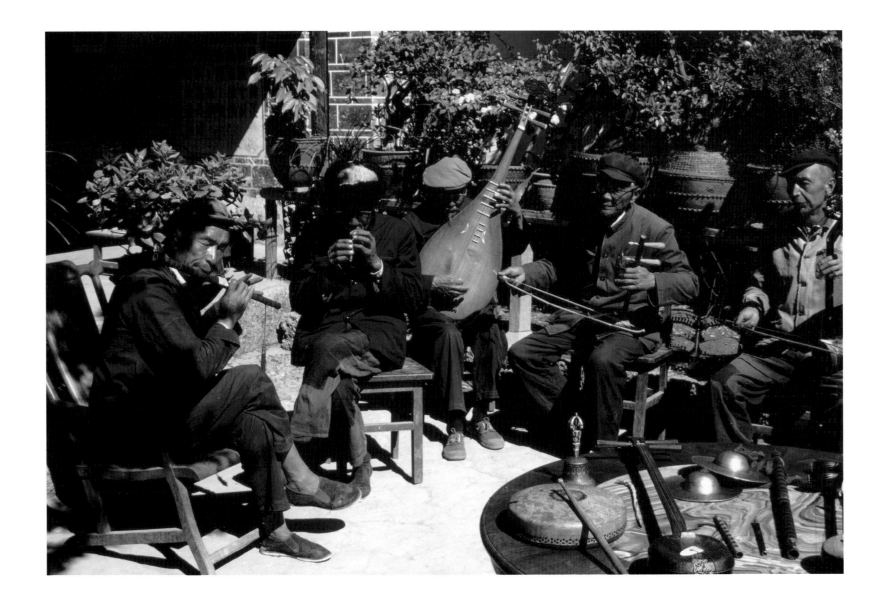

The Tiger Leaping Gorge of the upper Yangtze, here known as the River of Golden Sand, was at the time prohibited to foreign travelers. It wasn't until the mid-1990s before the region was open to foreign tourists. Here the Yangtze narrows to less than 30 meters as it went through a series of over ten rapids within a river length of 16 kilometers. The gorge is formed by two high mountains, both over 5,000 meters. To the west is Harba Snow Mountain and to the east the Yulong, or Jade Dragon Mountain. This image was first used in the National Geographic coffee table book "Journey into China". /

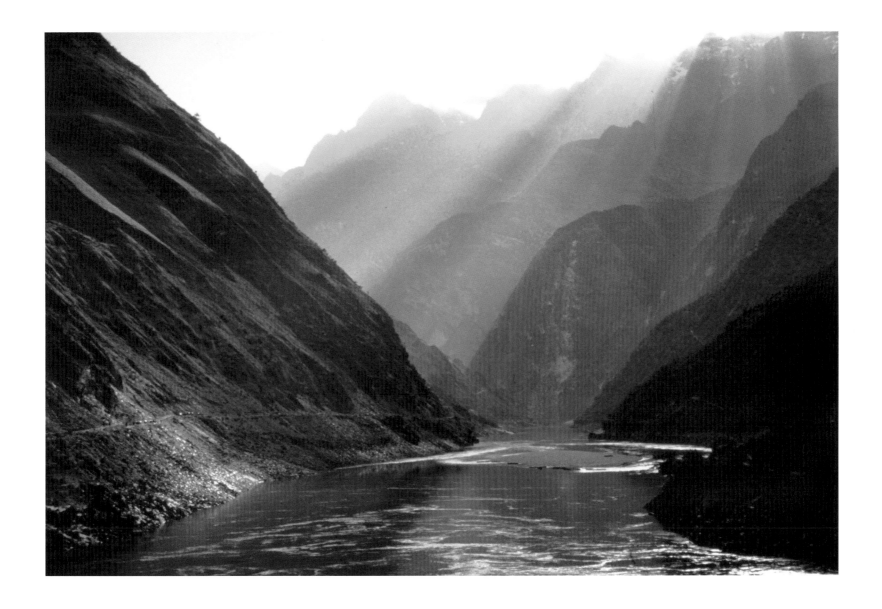

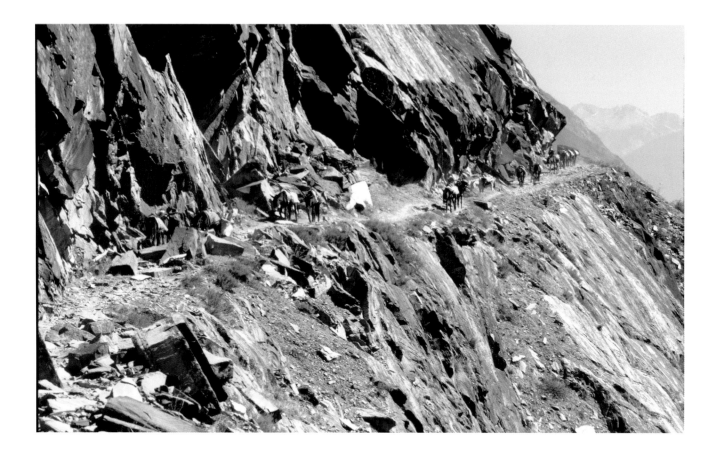

A narrow caravan and foot path was cut into the marble rock face as mules carrying tungsten mined high up the mountain would descend the hill and be transported to the outside. At the time, there was also marble being quarried along this stretch of the Tiger Leaping Gorge. /

Zhongdian, historically called Gyalthang by Tibetans, and later changed its name to Shangri-la, as coined by the 1933 novel Lost Horizon by James Hilton, was a waystation for caravan from Lijiang to the high plateau and onward to Tibet. The ancient monastery Guihua in Chinese and Songtsenling in Tibetan, used to have upward of 1,000 monks, considered one of thirteen most important Buddhist monasteries in Kham, or eastern Tibet. During the mid-1960s, it was raided to its ground and not one building remained intact. It took me over an hour to walk from town to the monastery. Today, it has been totally restored, far surpassing its former glory in architecture glamor, though not in its religious significance as in the past. The monastery would become highly commercialized as a tourist destination, contributing to both the income of the monks as well as corrupting much of their religious zeal. /

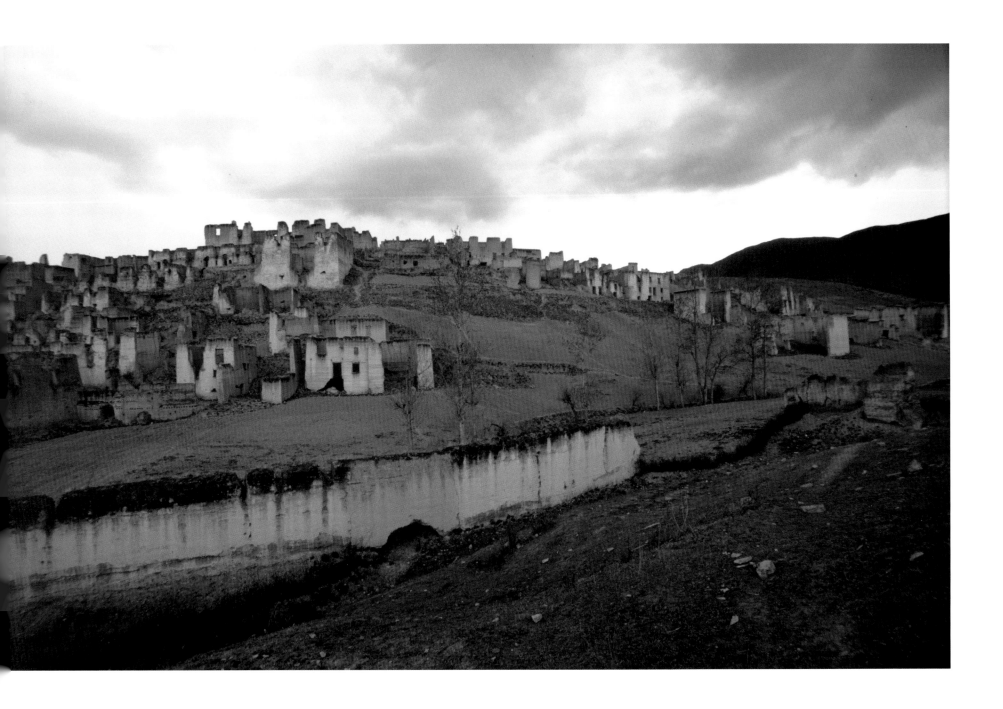

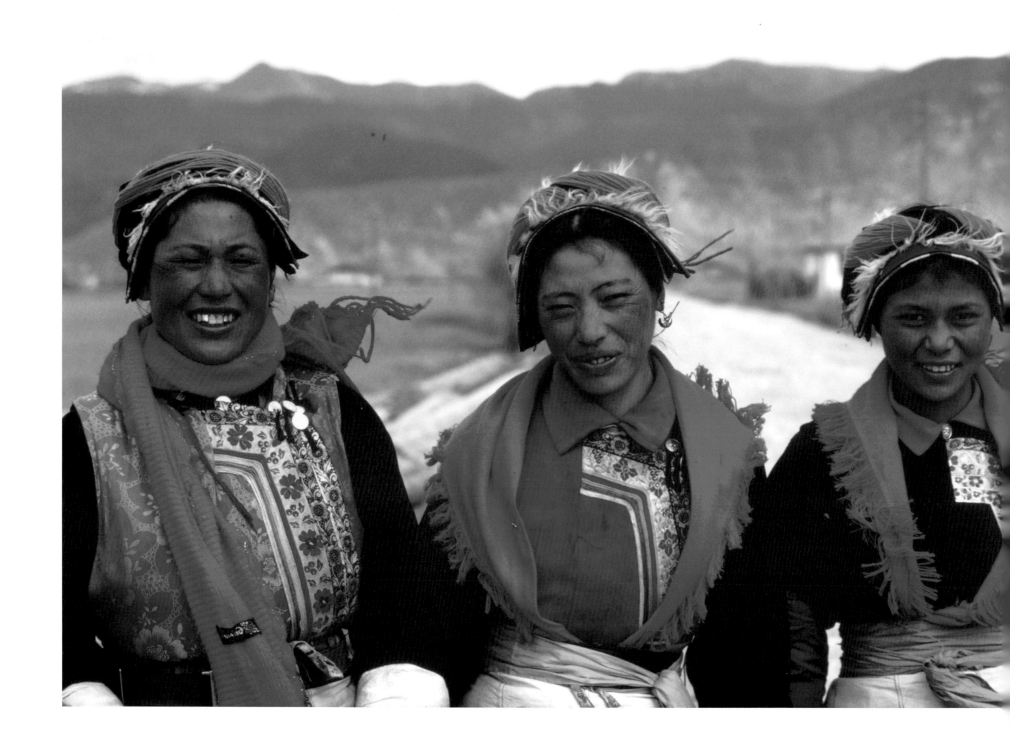

In 1981, local Tibetans of Zhongdian, especially female, almost exclusively wear their national costume on a daily basis. These three ladies along the road stopped to wonder why a photographer would be in town, a rarity in those days when travel was highly restrictive. It was on May 1, 1981 that I met my first Tibetan friend, who would in time become the Tibetan Director of CERS, a organization that I founded. Qiju Qilin was an artist attached to the prefecture culture bureau, and I enjoyed my very first bowl of buttered tea in his home. Such tea would become my regular beverage among Tibetans in the subsequent almost 40 years of roaming through the plateau.

/

The first yak I saw was in Zhongdian and these animals continue to fascinate me, leading to later years of our pioneering yak cheese production in the region, with the cheese winning a gold award from France. This first encounter was at Xiao Zhongdian when for the first time I reached the Tibetan plateau beyond 3,000 meters in the spring of 1981. A local Tibetan with his loaded yak was on his way heading home. There are over 12 million yaks on the high plateau, over twice as many as there are in the population of Tibetans.

/

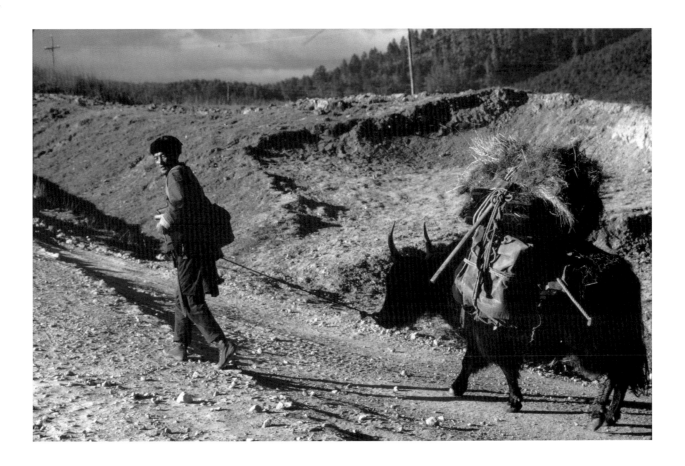

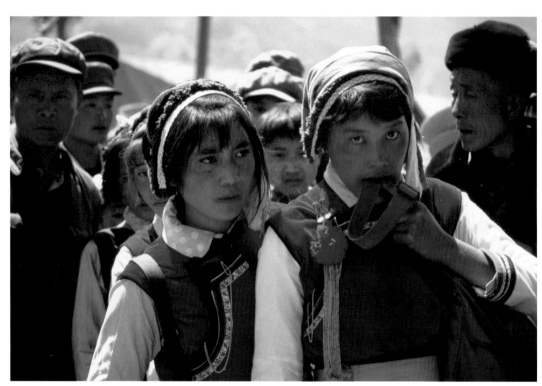

At the Third Moon Fair, members of the Bai nationality proudly dress in their costume, though perhaps still a bit shy in front of the camera.
/

That spring of 1981, I arrived at Dali and participated in the Third Moon Fair, first revival of the event after long years of suspension throughout the Cultural Revolution and beyond. The original gate of Dali was a simple fare, whereas today it is much more elaborate with pavilion standing above it.
/

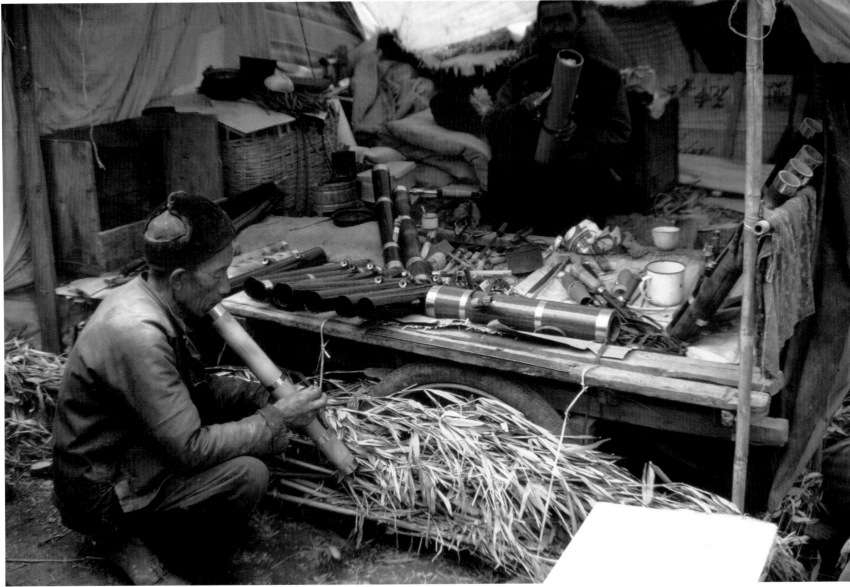

Many temporary stalls were set up at the Third Moon Fair, among them was one that sell water pipes made from bamboo. Tobacco were grown locally, Yunnan being the most famous tobacco growing province in the country.

/

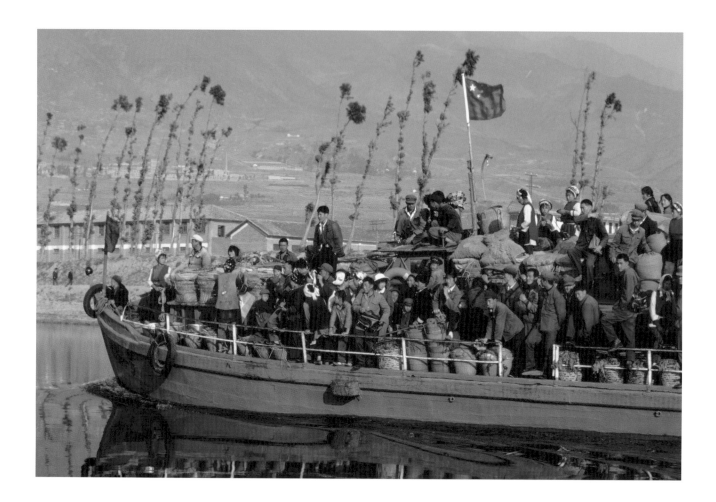

Along the lake front of Dali, villagers crowded a motorboat bringing their farm vegetable and livestock to market as China began to allow farmers to buy and sell their own produce, gradually breaking down the commune system. In those days, the lake water of Er Hai was still clean and unpolluted. Today, the entire lakefront is highly developed with vacation homes, hotels and villas.

/

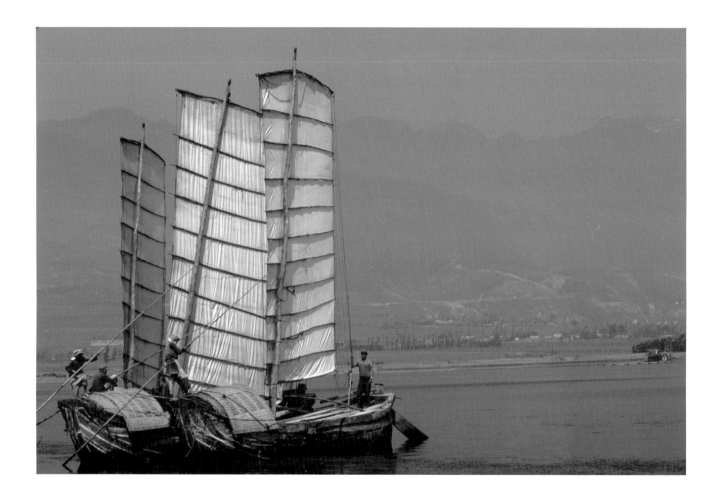

The twin-sail wooden boat was the more common means of transport on Er Hai lake at the fringe of Dali. However, when wind does not pick up, the boat has to be poled in order to move forward.

/

The railroad from Chengdu to Kunming was considered one of the proudest engineering achievements of China in those days. Countless bridges and tunnels had to be built to harness the mountain fastness between the two provinces. Here a section went through remote villages in southern Sichuan.

/

The iron bridge at Luding, first completed in 1706 of the Qing Dynasty, span the Dadu River, a tributary of the Yangtze. It was made famous by the Red Army crossing during its historic Long March in 1935. Today it becomes a popular destination for tourists in China to memorialize the revolutionary heroes.

/

The frontier town of Luding was where the Han majority fringes on the Tibetan minority. Since ancient time, mule caravan and coolies on foot would carry loads of brick tea in bales from the plain of Sichuan across the mountain through this town and onward into Tibet. Today, such old wooden houses along the street has become obsolete as modern non-descript buildings lined the road, a failure in urban planning to safeguard its past and cultural heritage.

/

The town of Kanding, sat at an elevation of 2700 meters, in the old days called Dajedo by Tibetans, in the early 1980s was small and quiet. The Jedo River flows through the middle of down before cascading through continuous rapids to the Dadu River at the foot of the mountain. This is considered the first Tibetan town and gateway to the plateau. Yak caravan would stop here without going further down to lower elevation. One of the most famous Chinese songs, "Mountain with Galloping Horse", is derived from the yearly mountain festival behind Kanding. I happened to be here during the festival in the spring of 1981.

/

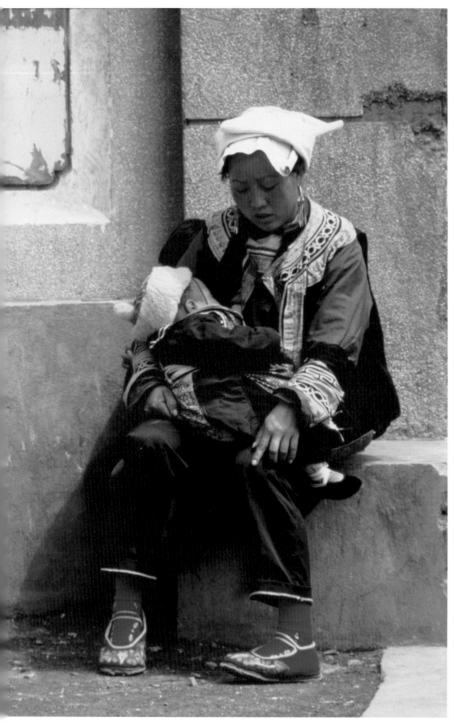

A Chiang mother nursing her baby near a market. In days past, both women and children adhere to wearing their traditional costume, which are fast disappearing as city life encroaches into the countryside.
/

Western Sichuan is Tibetan country. However, another nationality, the Chiang people, also inhabit some of the lower hills northwest of the Chengdu plain. Here, a Chiang lady in traditional costume went into the town of Wenchuan for shopping.
/

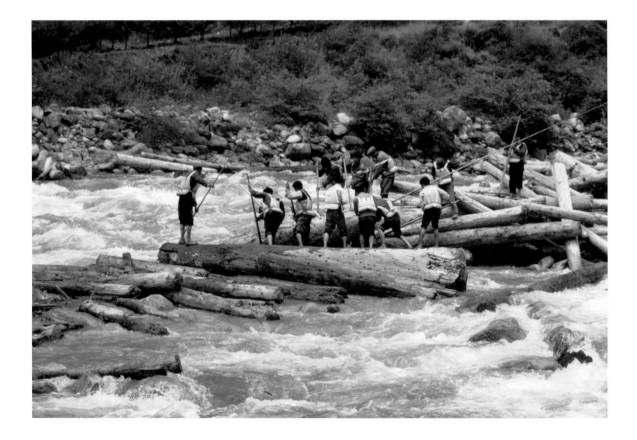

Along the Min River of northern Sichuan are huge old growth forest of pine, cedar and fir. Much logging went on during the 1970s and into the 1990s. Felled log would be floated down the river for collecting and be sold in the market. Where logs are jammed, workers with life vests would get into precarious position with long poles to try clear the log, a very hazardous preoccupation.

/

Jiuzhaigou in 1981 was pristine and without any tourist. Few had seen its many turquoise lakes, except local Tibetans. Much of its periphery was still forest station used for logging. It was at a time before the area was turned into a protected area, later a national park and then a tourist mecca. By the 1990s, photographers began flocking here, especially during autumn for its famous foliage scenery.

/

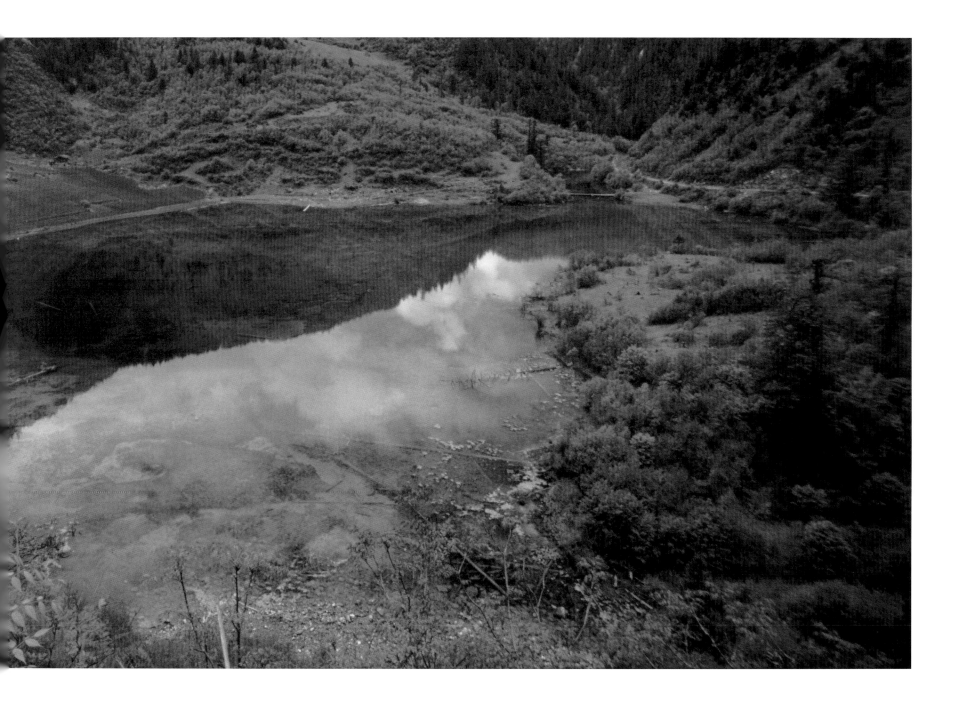

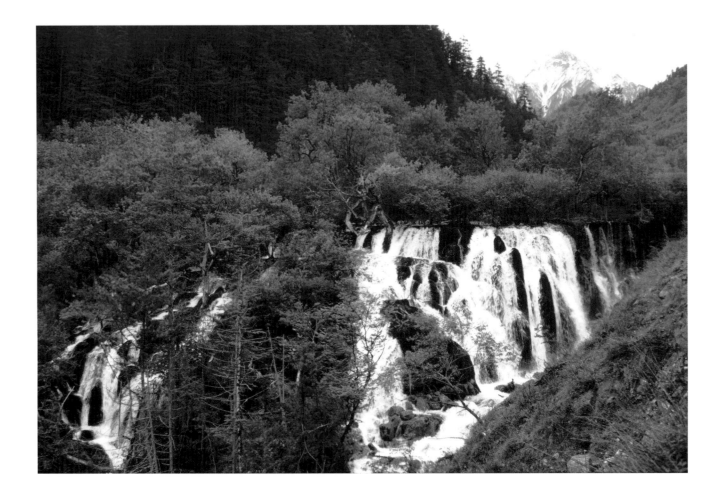

The waterfall through trees rooted in the stream is a special feature of Jiuzhaigou. My first of many subsequent trips in the 1980s provided lasting memory of the place before later it being overrun by visitors. By the late 1990s, motor cars were not allowed inside the site after it was made into a park. Only electric trolleys take tourists in and out, and more lately under a quota of how many were allowed in per day.

/

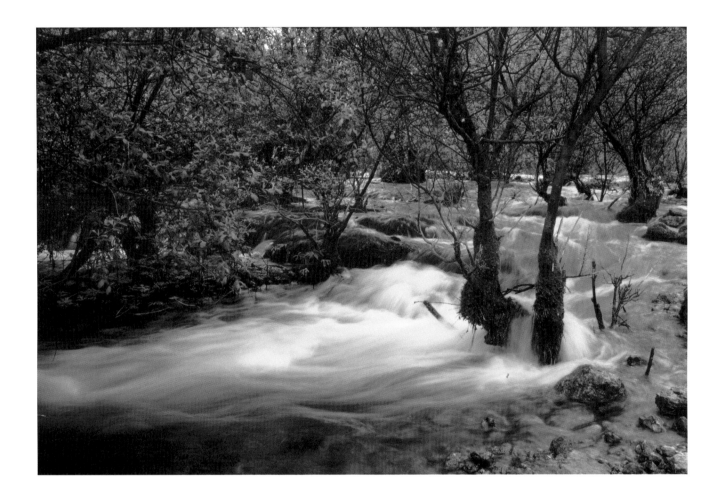

At Jiuzhaigou, I began making a series of photographs of its fast running stream, allowing motion to take its course to create a sense of movement through the low trees and shrub.

/

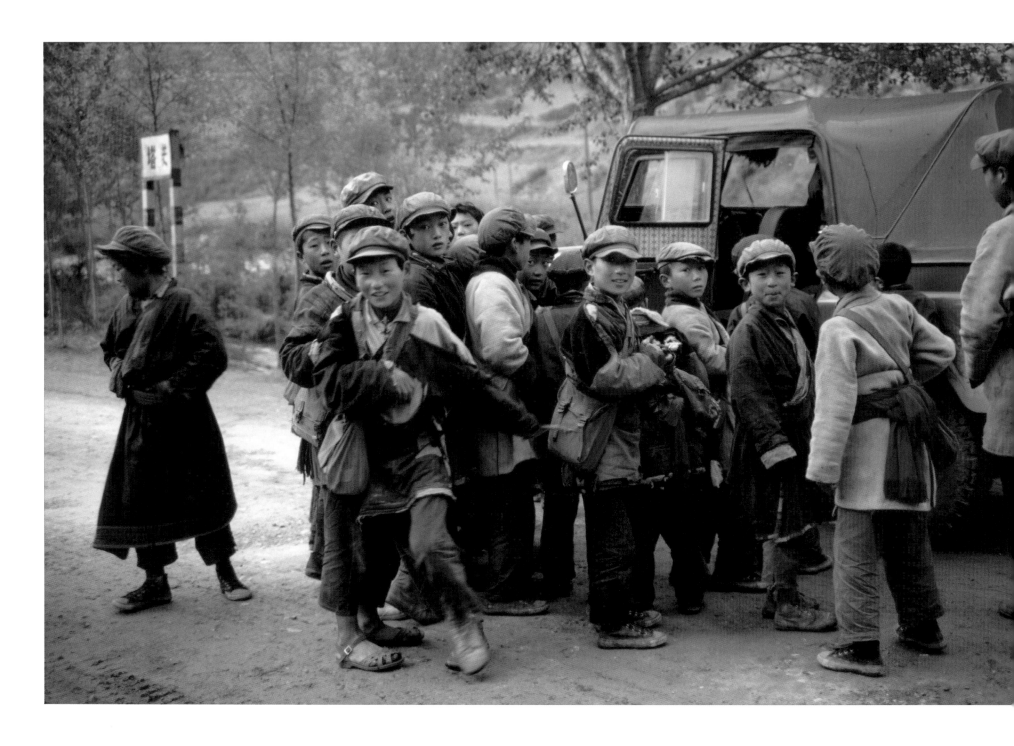

As our jeep stopped for photography, Tibetan children would swarm the car curiously looking at this Chinese dressed in western outfit that they had never seen in their mountain fastness.

/

In norther Sichuan, Tibetans are partly considered Amdo nomadic tribe, as well as the one featured here, who is a Jarong Tibetan of Songpan area, an important caravan stopover of the former tea-horse trade going in a northern and western direction from the plain of Chengdu. The amber setting, as part of her headdress, is common worn in the region by ladies while go to market, or to local festivals.

/

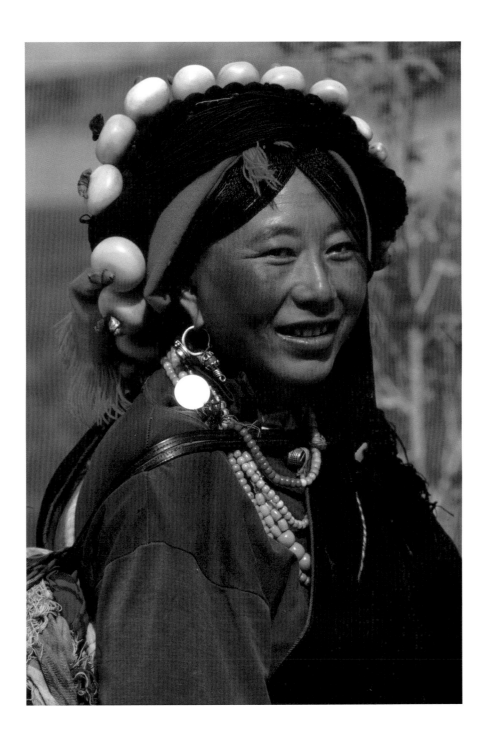

As part of my continued freelance work
on Chinese architecture and gardens,
I continued to visit coastal China to feature imperial buildings of Beijing
and houses south of the Yangtze.

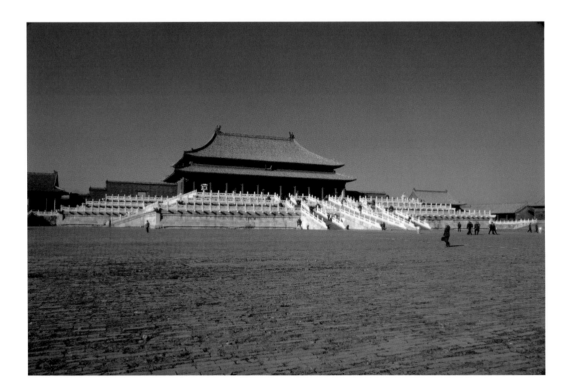

Even by 1979, the Imperial Palace in Beijing had few visitors. The courtyard leading to some of the most prominent halls and pavilions remained in disrepair, like in this case the Zhonghe Hall.

/

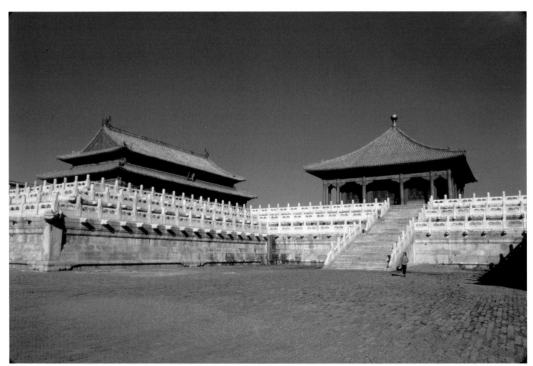

Despite I was photographing and writing for Architectural Digest, there was little need to wait around for the ground to be cleared to feature a largely empty courtyard inside the Forbidden City. It was as if the palace was still largely forbidden.

/

As in the 1970s China did not have too many friends except those from Third World countries. Outside journalists like myself was treated with pomp and respect. It was for this reason I was given access inside the Forbidden City and was able to photograph many of the halls and even private quarters of the former Emperor of China. This chamber was where the Emperor would sit and preside in front in the golden-padded seat, whereas the seat behind, with even a higher back, was saved for the Dowager Empress, mother of the Emperor. She would sit behind a silk screen that could be lowered or be lifted, listening to reports by courtiers. The Dowager would then give opinion as advice, approval or concurrence, to the Emperor in deciding matter of state, or of importance to the nation.

/

Photographing inside the Imperial Palace, also known as the Forbidden City, a friend, a long-time museum scholar of the Palace provided me with a tall ladder to get into a high vantage point so as to photograph the grand hall the Emperor use for his daily audience of court officials. Given so many daily visitors now, such privilege in photography is unheard of and impossible to obtain.

/

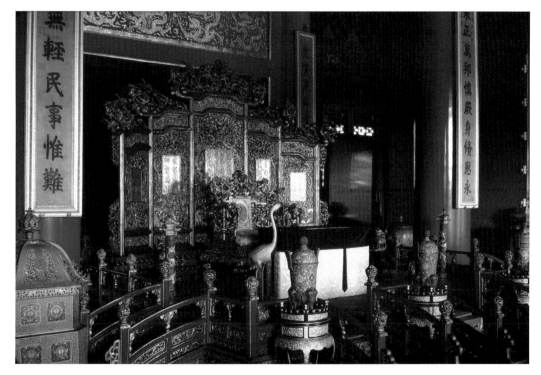

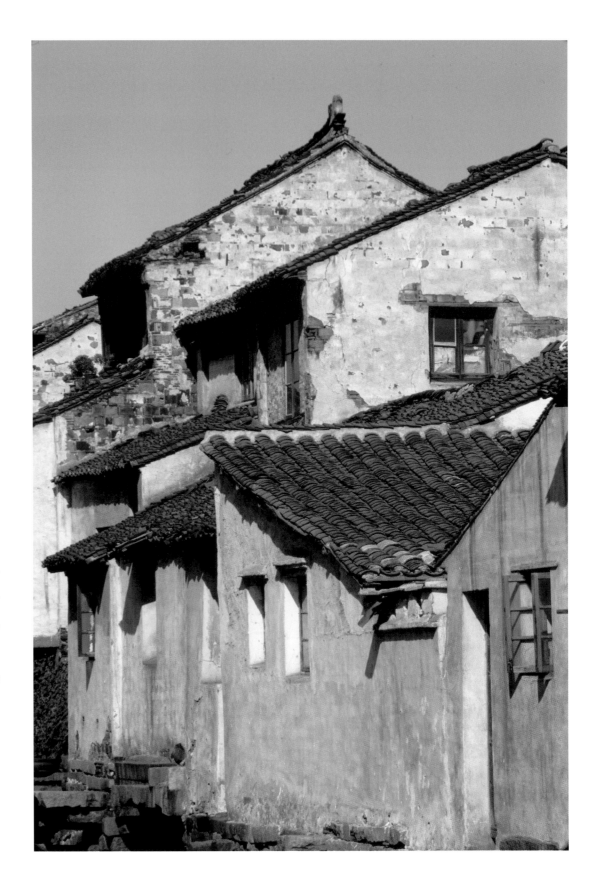

The architecture of Suzhou, though simple, is the most appealing and reminiscent of days of the past. Unfortunately, today such pristine places have become highly commercialized, decorated with red lanterns and advertising signs throughout villages and towns.

/

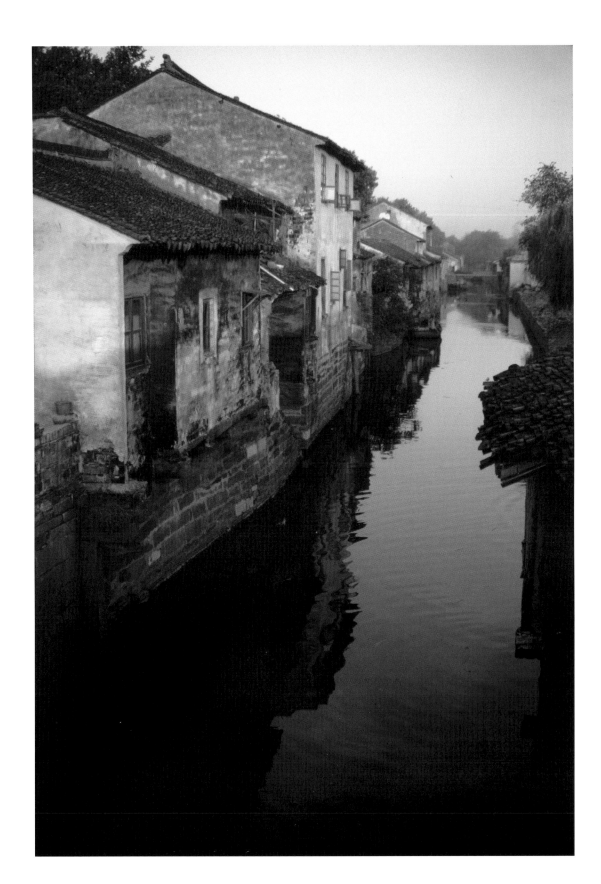

Suzhou was famous for its labyrinth of canals and countless bridges. Here the picturesque reflection perhaps highlights what inspire poets and painters of China for over a millennium.

/

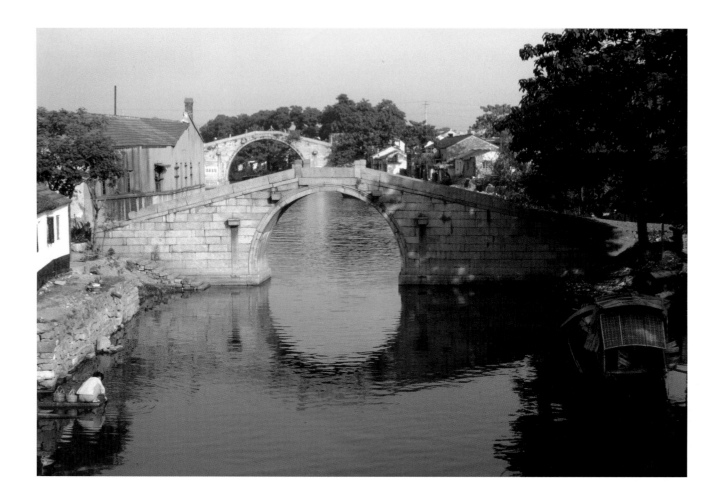

The many curved and half-moon bridges made the canals and waterways of Suzhou most attractive. The reflection on the calm water also create a timelessness unsurpassed by other modern cities of China today.

/

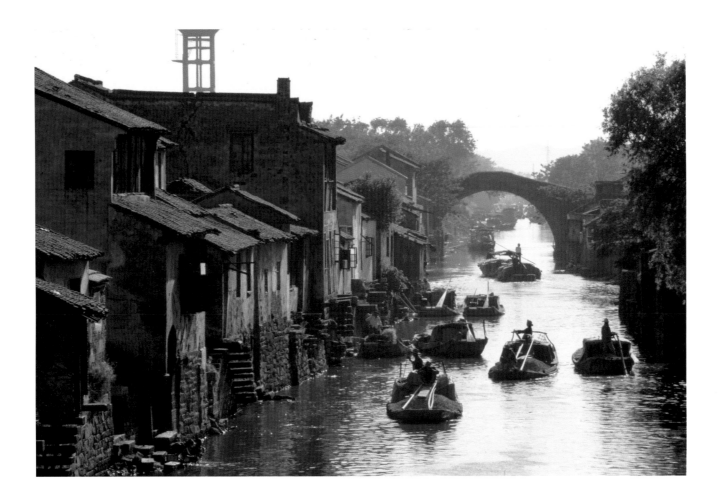

Even during the busiest of time when canal traffic was heavy, it did not create much disruption to the calmness of the river and canal. In those days, literally all boats were powered by human, rowing in slow motion rather than motorized vessels which would create more waves and disturbances.

/

In Guangzhou, the morning was filled with bicyclist on way to work. It was common to see few cars whereas bicycles were in abundance.

/

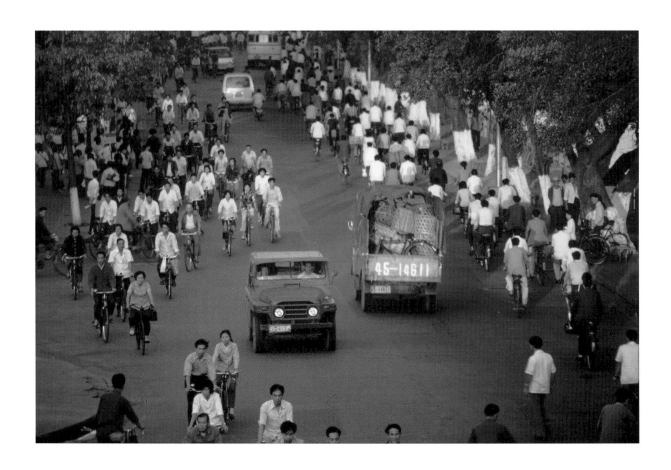

A second expedition in 1981

took me through Guizhou, Yunnan and into the border of Sichuan

where the matrilineal Moso people live.

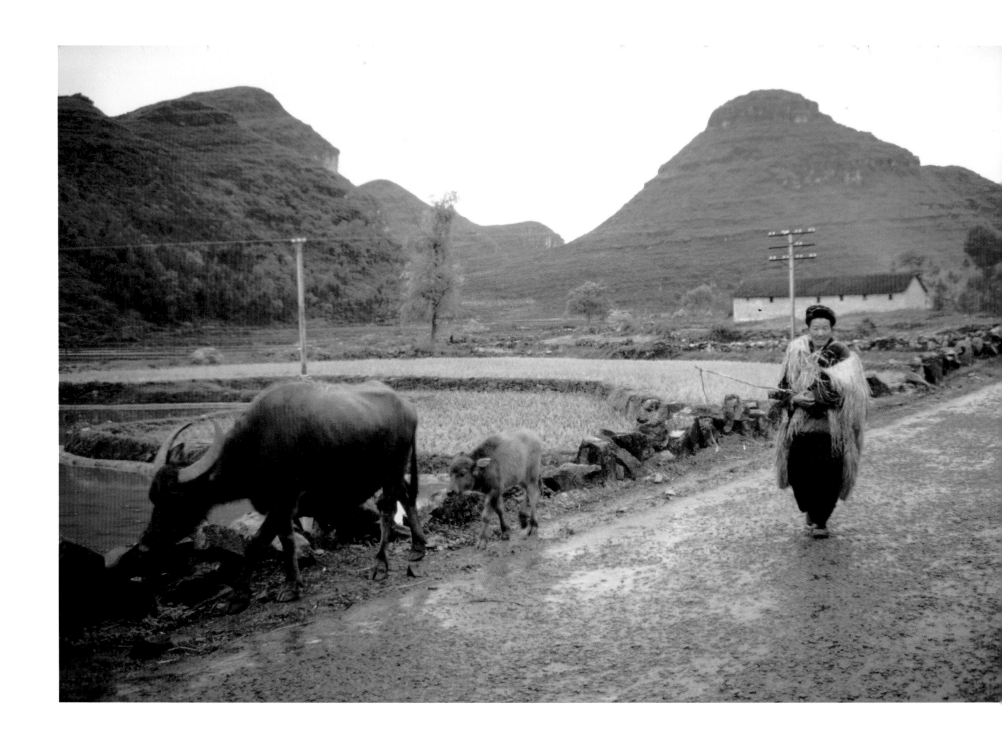

In my first visit to Guizhou Province in 1981, my attention was focused on the minority nationalities. Here a local farmer walked behind his buffalo with a calf, wearing a straw raincoat which today has all but disappeared.

/

Guizhou's southwest region is filled with pristine rivers and waterfalls. This one showed a wide cascade descending while in the background harvested crop were laid to dry. The province was famous for its gloomy weather, often overcast. The saying, "The sky has not three days clear". For a long time, due to its rough terrain filled with karst limestone hills, agriculture was marginal, contributing to Guizhou being one of the poorest provinces in China. Today, Guizhou has long lifted itself out of that poverty and has contributed to China's new nation building.

/

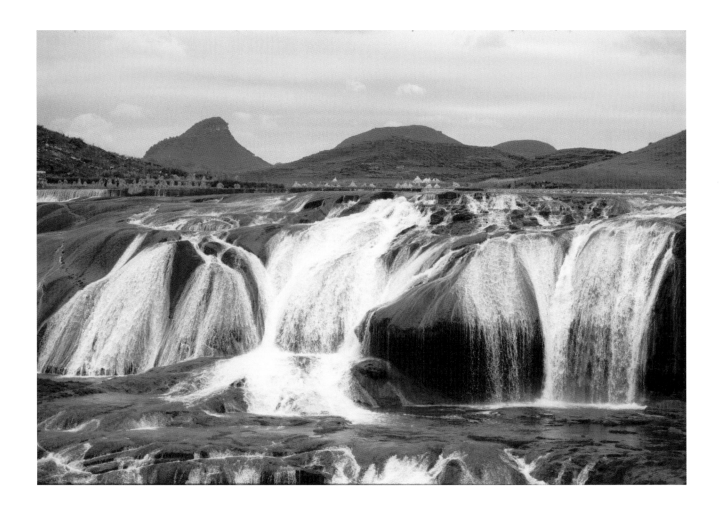

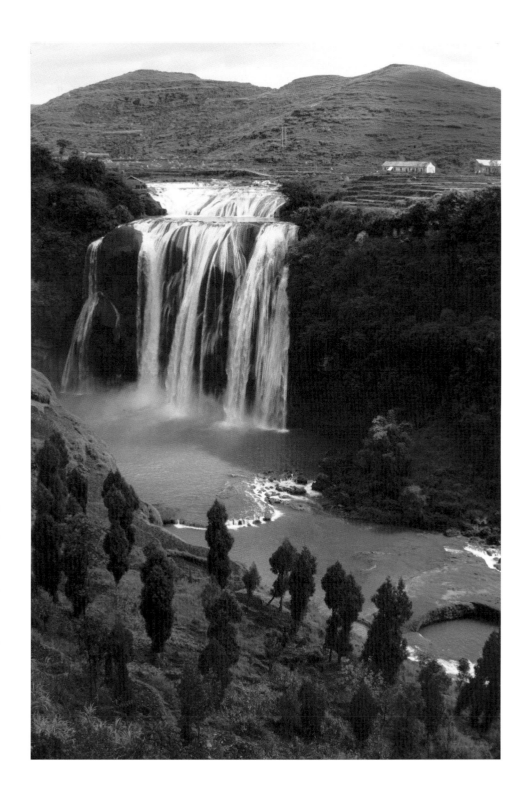

The famed Huangguoshu waterfall has a drop of 78 meters and has been considered since ancient time as one of the most spectacular scenery in China's southwest region. But even by the early 1980s, few visitors had seen it given transportation was inconvenient and the waterfall rather out of the way. Today, it is one of the most famous destinations within Guizhou province.

/

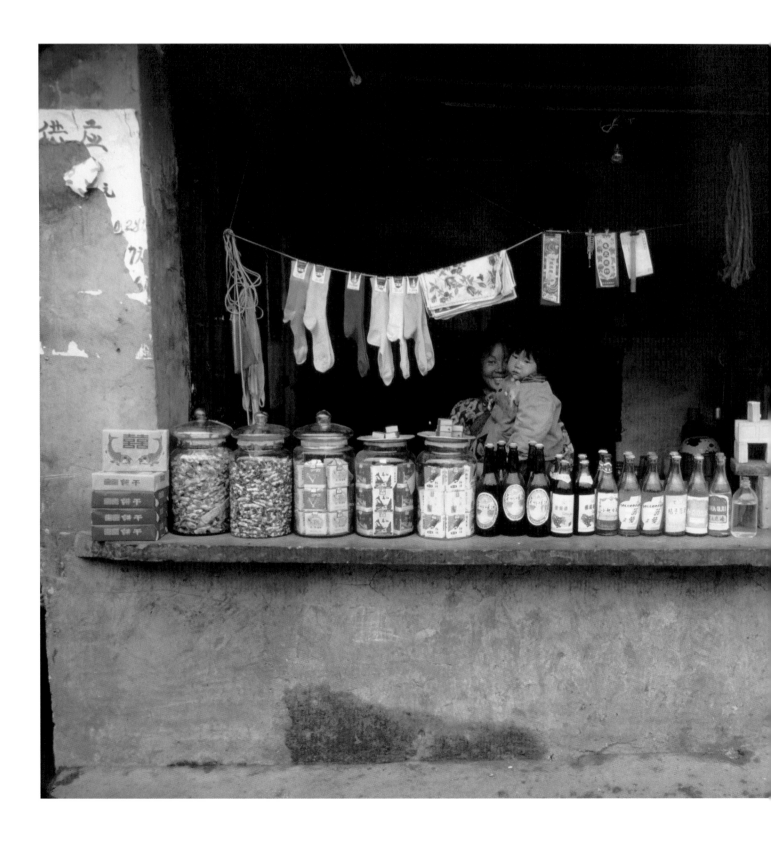

A shop near Huangguoshu had scanty items on display and for sale, a reflection of the poor economy and the limited financial resources of this remote corner of China. However, people seemed quite happy and contented despite living under very basic conditions.

/

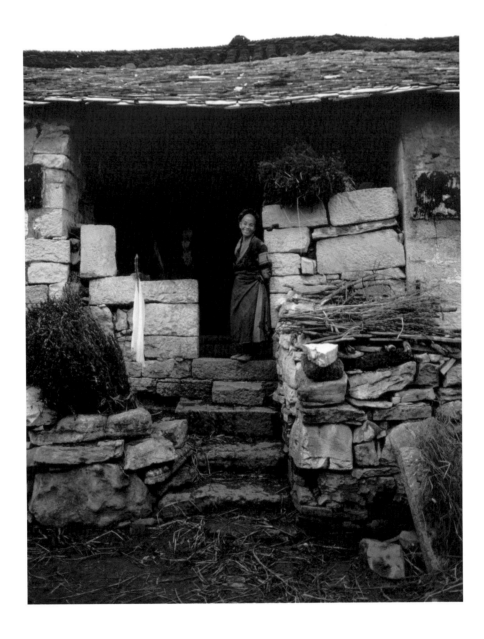

The houses of stone masonry with slate stone roof were most common among the Puyi nationality of southwestern Guizhou. The minority inhabit the villages near Huangguoshu waterfall.

/

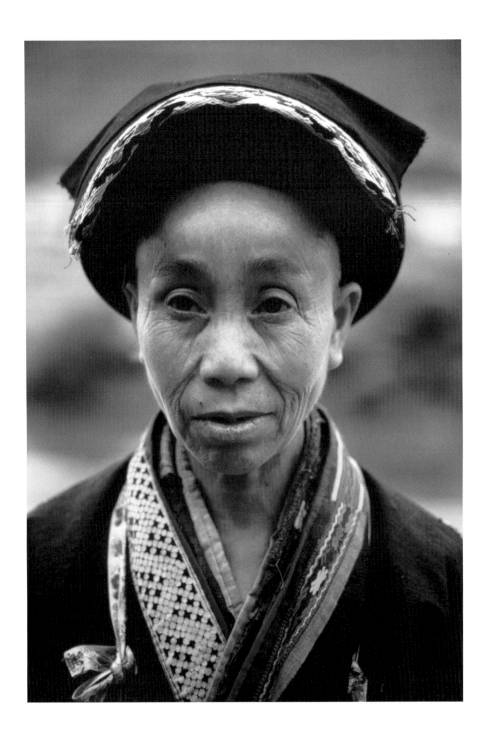

A Puyi lady in traditional costume. Until quite recently, minority women all prefer their costume over modern western clothing. However, that is fast eclipsing with the younger generation, except perhaps during festival time and weddings when they want to be seen in their most colorful national costume.

/

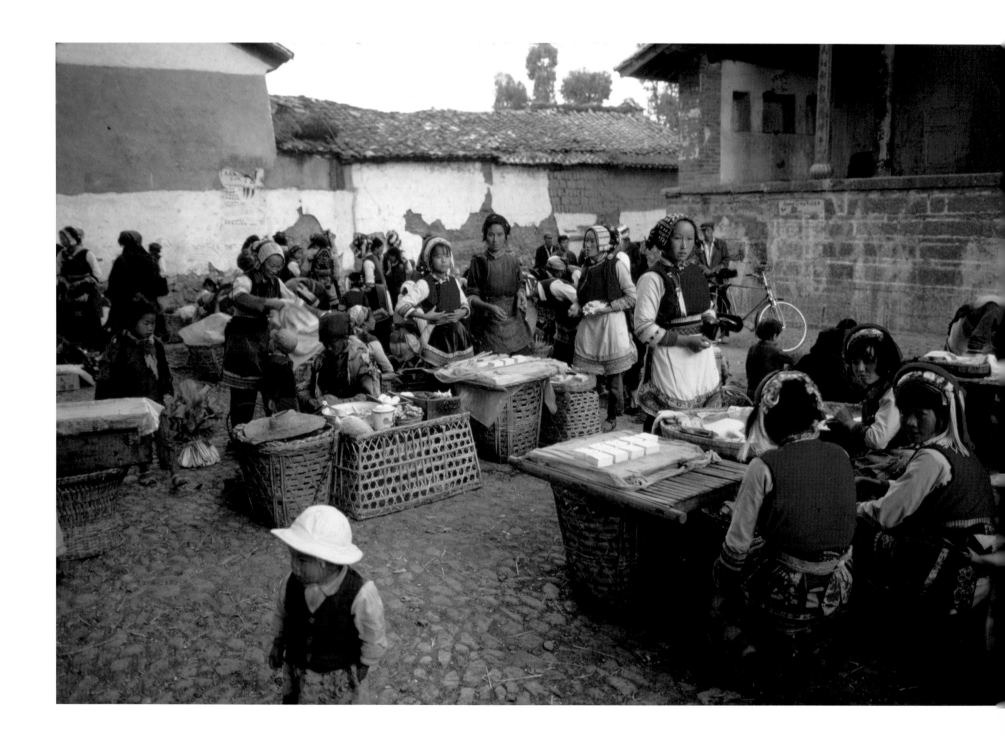

North of Dali at Xi Zhou by Er Hai Lake in Yunnan. The daily market was filled with women and children in their national costume as venders, peddlers and market goers provided a colorful scene of both their traditional clothing and merchandise.

/

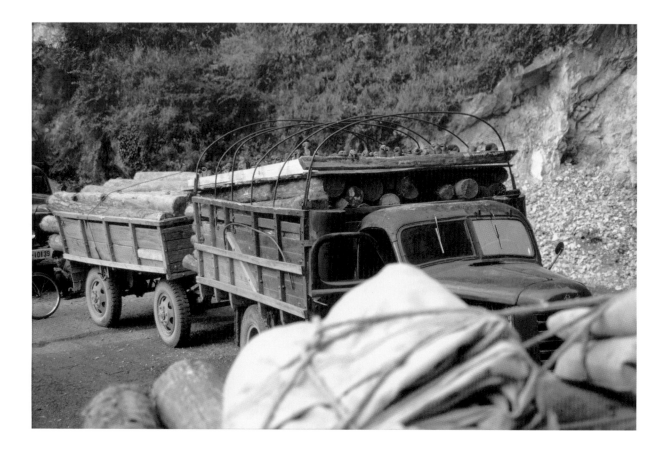

On way to Lijiang, a duo-carriage logging truck carried not only timber, but an extra and surprising cargo on top in the form of parrots.

/

Such green parrots were once abundant in western China, caught and sold in city markets catering to "bird lovers" who would keep them for entertainment at the numerous teahouses in Kunming and Chengdu.

/

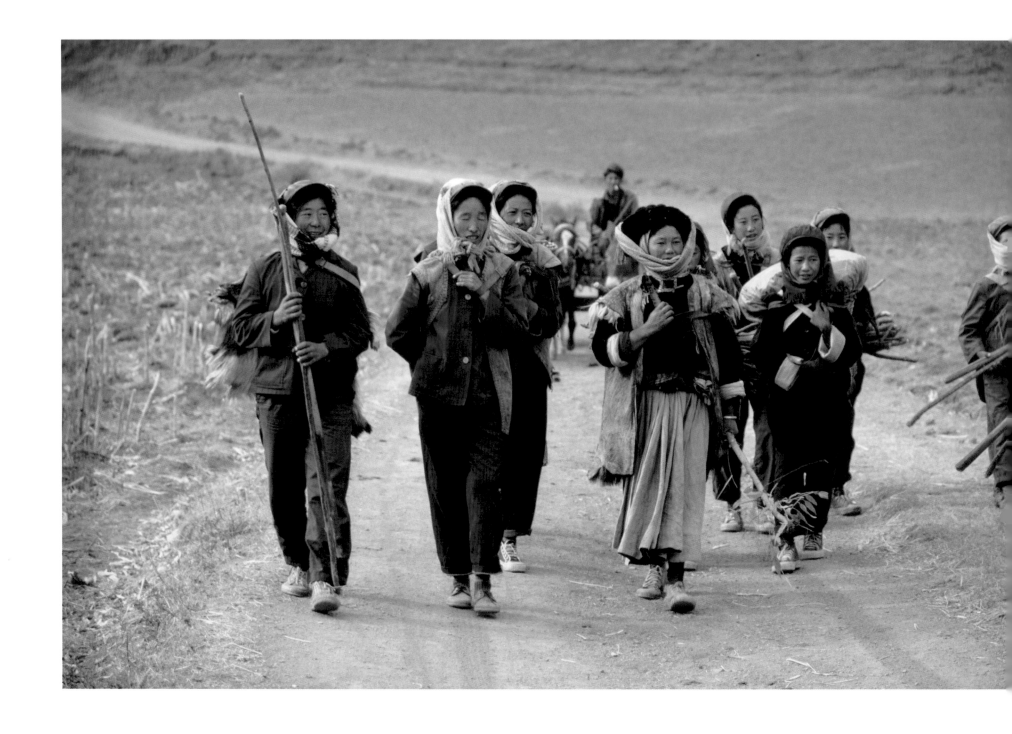

My first visit to Luguhu, an alpine lake at the border of Yunnan with Sichuan was in 1981. I would return many more times until the 1990s when we not only contributed to building a local school, but documentation and recording of the matrilineal Moso people. Here a group of Moso women returned to the village from the field.

/

A hot spring by the foot of the Lioness Goddess Mountain was frequented daily by the local Moso. Villagers from both Yunnan and Sichuan sides used this medicinal hot spring. A low wall symbolically separated the men from the women though in practice the matrilineal Moso, very liberated in the thoughts, did not feel restricted to this imposed government regulation.

/

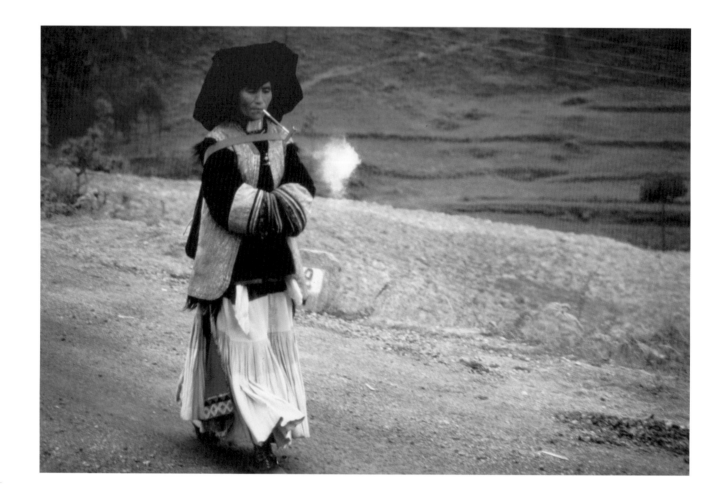

As I exited the Yi region, a Yi lady walked past while puffing her pipe. Most Yi, both men and women, are habitual smokers. Once infested with the growing of opium before the communist takeover of the entire country, these regions were under the grip of slavery and some Yi masters of Yunnan. Two of the Yi, Long Yun and Lu Han, rose to become warlords of the entire province during the first half of the 20th Century.

/

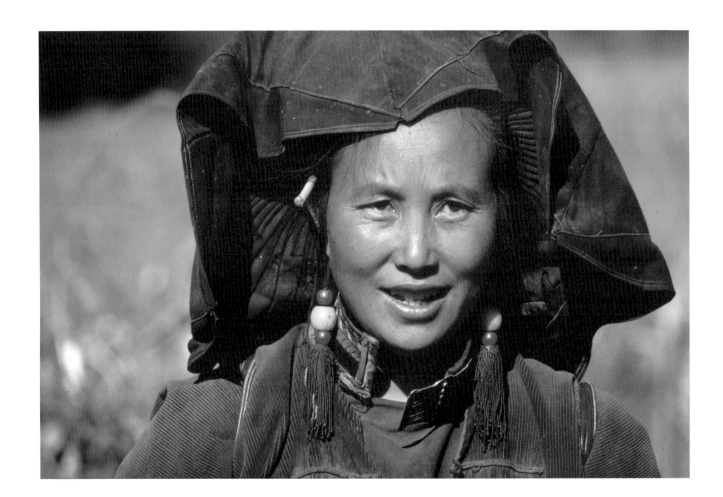

Adjacent to the Moso lived the Yi nationality of Xiao Liangshan, once a slave and caste-based society until recently. Wearing a wide stylized headgear daily, the Yi women also prefer their high-neck blouse, making their posture look very dignified.

/

In 1982,

I began my stint as a writer/photographer/explorer

at the National Geographic Magazine,

allowing me more resources and resolves to conduct major expeditions

into China's deep interior and fringes.

Over the next few years,

I led six major expeditions with full support of the National Geographic.

My expedition started from Kunming with one jeep and two drivers.

At the beginning I had one young assistant from Hong Kong,

who left after Lhasa when he found working at high altitude too difficult.

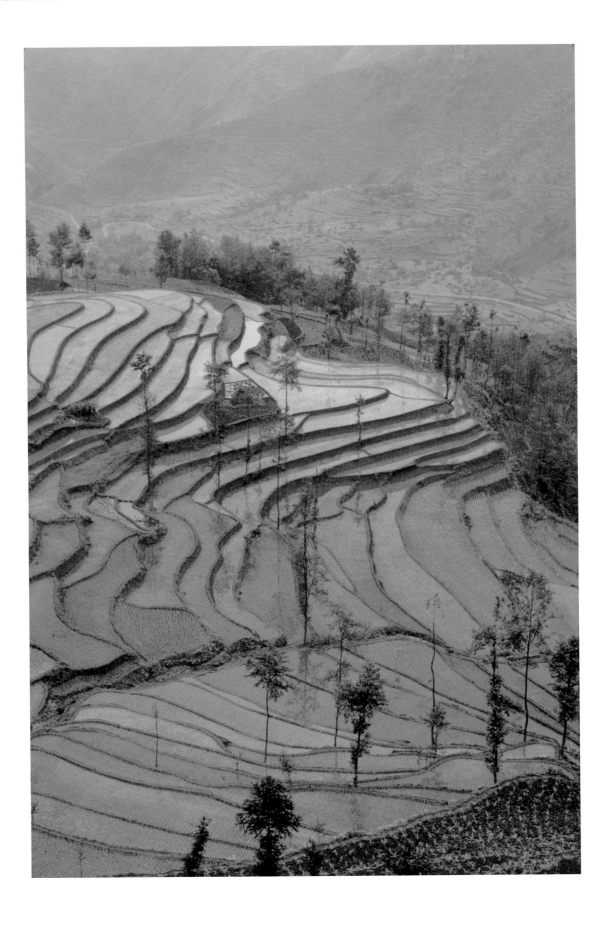

We drove north into southern Sichuan and went through some agriculture region bordering the Dadu River, one of four major rivers of Sichuan. Here terraced rice paddy help provide for a massive population of over 100 million in the province.

/

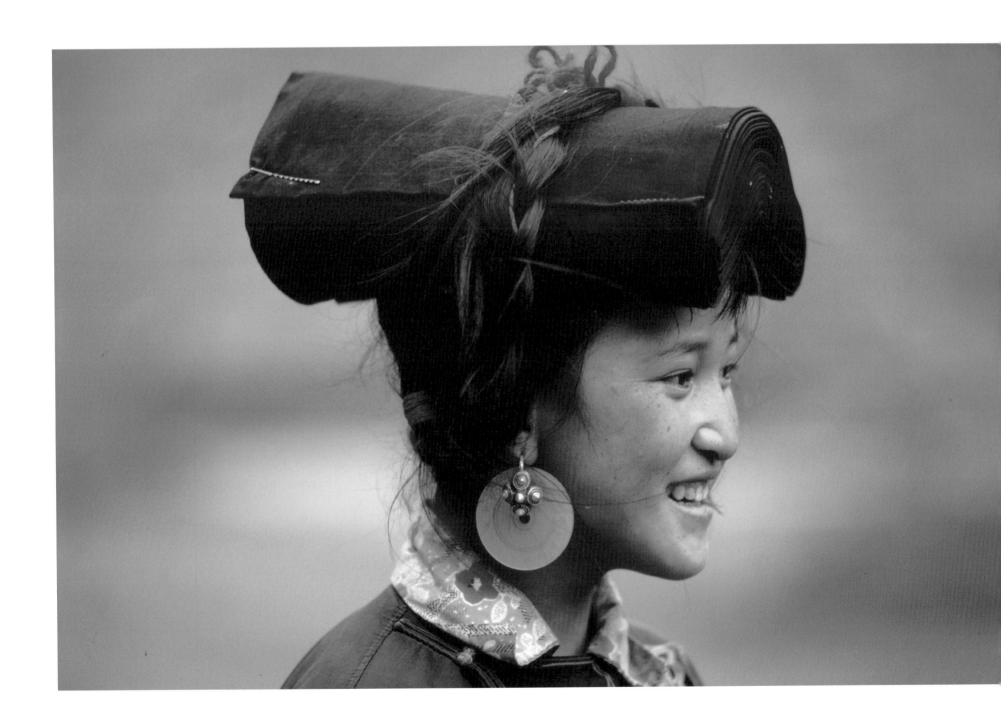

I started documenting the Liang Shan region of the Yi nationality prefecture in 1982. Such mountain fastness was prohibitive to outsiders long before the founding of the PRC in 1949. The few explorers who tried and survived had horror stories to recount. By the early 1980s, the area was relatively peaceful by the time of my visit. I was perhaps the first outsider in decades to be able to photograph these people at their natural state. This Yi lady was dressed in her best, with a headdress made from a long roll of fabric, heading to a local market.

/

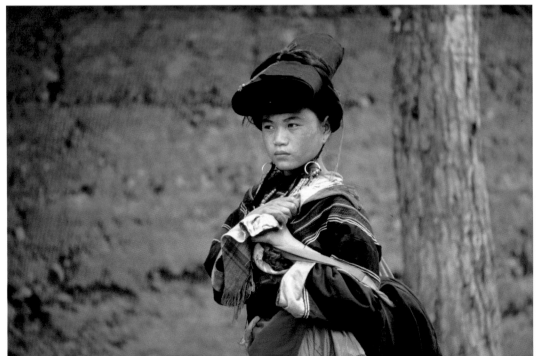

This photo that appeared with my article in the National Geographic was of a Yi lady at a local market of Zhaojue, formerly an important center for the local chieftains who retained their slave society until the mid-1950s. The community was then demoted to becoming just a township when nearby Xichang replaced it as prefecture capital. In time, Xichang would become famous as one of the few launching pads for China's space program.

/

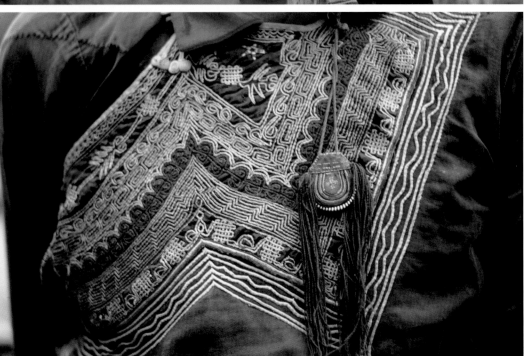

The top blouse that a Yi man wear had motif of fine needle work with their favorite pattern. This particular sample showed the design then popular and was in daily use, especially when heading into the market. Market day was once every ten days, falling on the 10th, so on and so forth. However, such costumes are now disappearing fast and replaced by machine-made substitutes.

/

The pleated skirt of the Yi is very stylish and swing from side to side as a lady walkS. Their capes, weaved from wool or pounded down into felt, are warm and waterproof, providing shelter during rain or a cold night. At the time, a cape, depending on quality, would cost between Eight to twenty Yuan Renminbi. The hat is weaved from straw and shaded them from the sun. Despite wearing a spectacular outfit on her upper body, most people were still shoeless and walked in countryside and market place bare-footed. It was considered grave taboo to touch a woman's skirt, and for a man, never to touch his hair, usually tied to a knot or with long string-like middle land sides shaved, the prevalent hairstyle for men at the time.

/

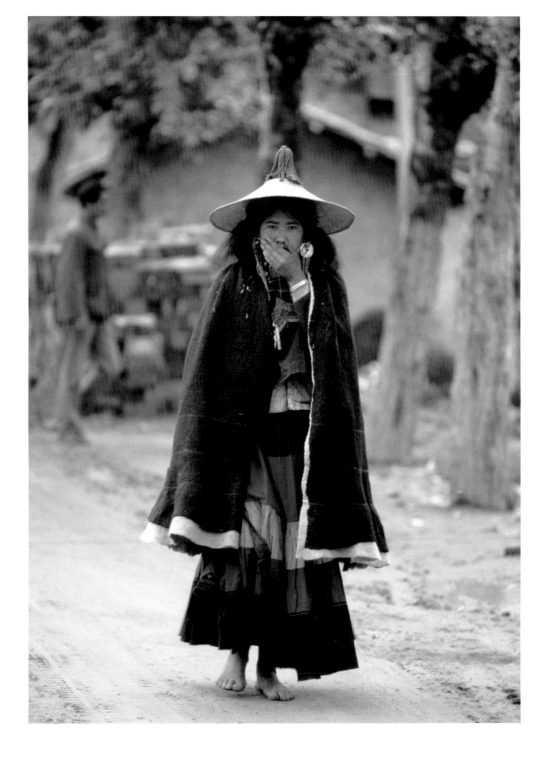

Crossing the Dadu River, one of the four great rivers of Sichuan, locals used a steel cable bridge like a zip line, sliding from one bank to another. In more primitive region, instead of steel cable, a hemp rope was used. One could see loads like livestock or a bicycle being brought across the river in such a fashion.

/

The Yi of Liangshan lived a rudimentary lifestyle. This small abode offered marginal space for a Yi man as he was laying out to dry some of the forest product, in this case a black fungus, that he had collected in the nearby mountains. Both men and women of the Yi love to smoke pipe, a local tobacco they grow in the hills. Before 1949, the Yi were known to grow much opium, but such practice had since been eradicated.

/

Crossing a mountain high pass over 4000 meters onto the real plateau of Kham region, or eastern Tibetan plateau, a lone prayer flag marked with a pile of stone reminded one of the prayer Tibetan would offer to the mountain deity. Today such landmarks would be filled with colorful prayer flags fluttering in the wind serving as the same tribute to heaven.

/

At the old town of Kangding, wooden houses lined the main street where Tibetan and Han people converge. At 2700 meters, this was the lowest the yak caravan would travel, bringing tea and other merchandise into Tibet while other products from the plateau like animal skin, wool or herb would be transferred to mule caravan, heading further down to the plain of Sichuan.

/

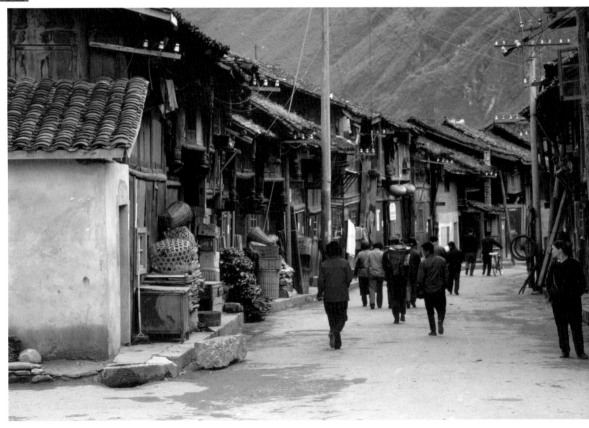

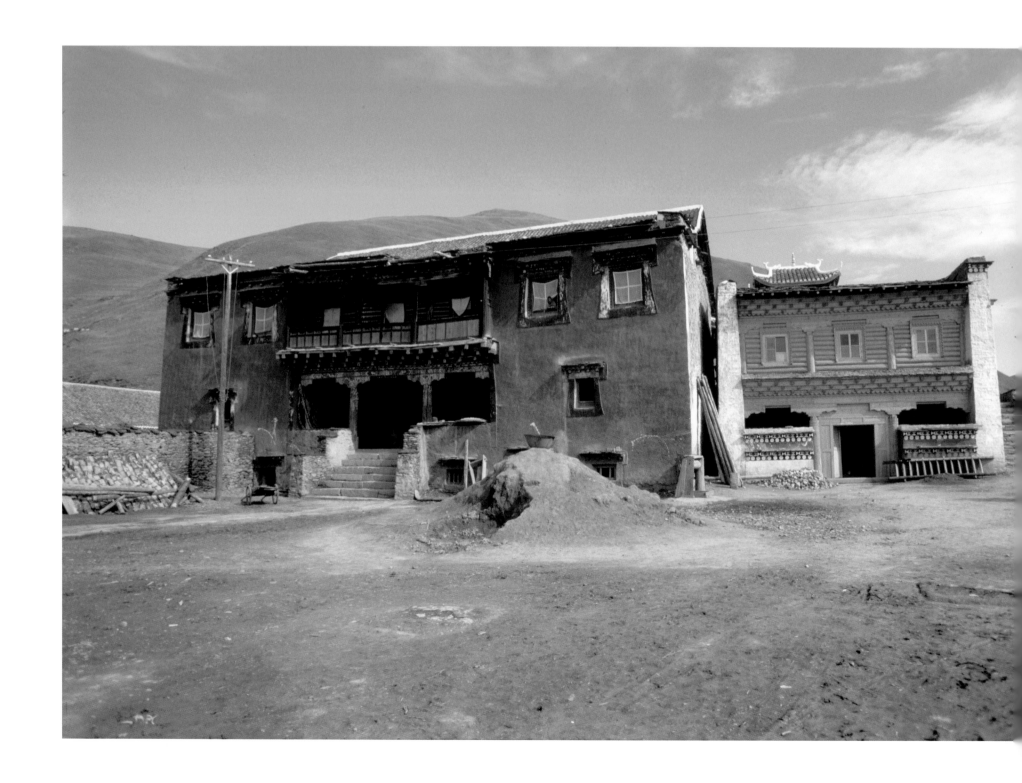

The monastery of Tagong, a Nyingma (Red Sect) Buddhist temple survived the Cultural Revolution with the main hall being commissioned for use as a storage house, a feat many local Buddhists somehow managed to safeguard such religious buildings through a functional use proposition. A new wing was recently built as religion revival was just beginning to be allowed in the early 1980s. /

Inside Tagong monastery, young monks were being recruited, though few in number. Here, a senior monk taught the novice monk how to print sutras from old wooden block. /

At Tagong, the first major monastery as one travel west beyond Kangding, a chorten gave early indication that there was a religious revival starting to take shape as a local Tibetan circled around the small pagoda in the morning and evening offering prayers. /

My first sighting of a Tibetan Mastiff, at a nomad's camp near Luohuo of Ganzi Prefecture. At the camp, I met Bubulangja who had just returned from serving in the Army for three years. The Tibetan mastiffs are fierce, and would chase people who are running away from them. I was told I must stand my ground, pick up a stone to throw at them and they would retreat. Even if there are no stones on the ground, just lowering my body pretending to pick up a stone would see them backing off. I have tested this motion over the years and it worked every time.

/

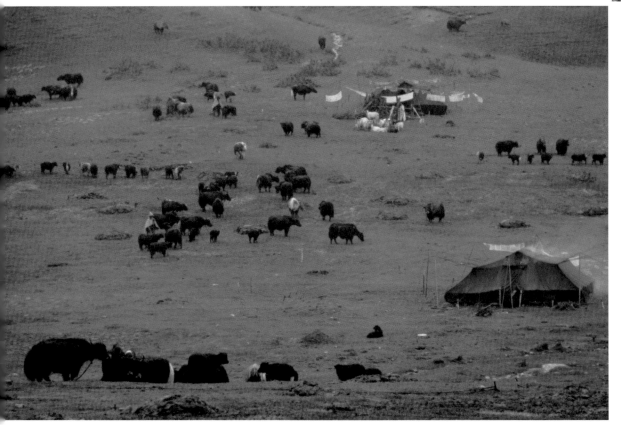

In high country beyond 4000 meters, there were sporadic nomads camp with their livestock of yak and sheep. Here a camp had set on the roof some prayer flags, fluttering in the wind. Such practice was barely allowed to be revived in the early 1980s as religious freedom gradually gained ground and was observed again, after long years of prohibition during the Cultural Revolution.

/

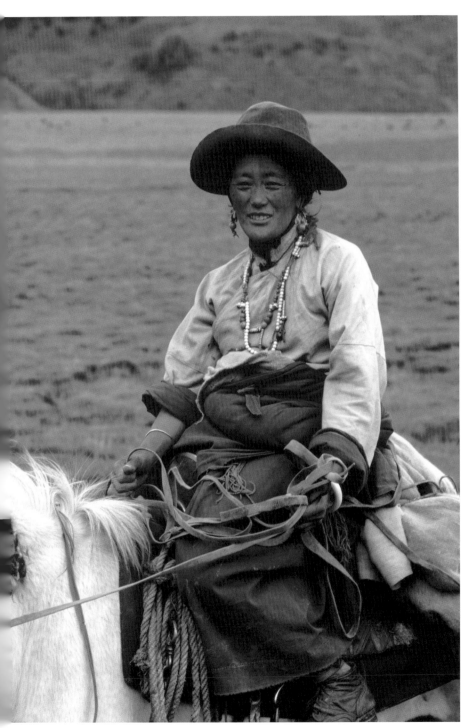

Horseback travel was the most common method of transportation, not only for the nomads but also for villagers going from place to place. Tibebtan ladies often are bejeweled even daily. During festive time, they would be decorated from head to foot.

/

Inside a nomad's camp, modernization came but in tandem with the age-old method of churning milk into butter and other by-products. Behind was one member of the family using the latest device, a simple and easier mechanical machine to separate milk into butter. I had seen over decades that nomads prefer the traditional hand churning to the new device.

/

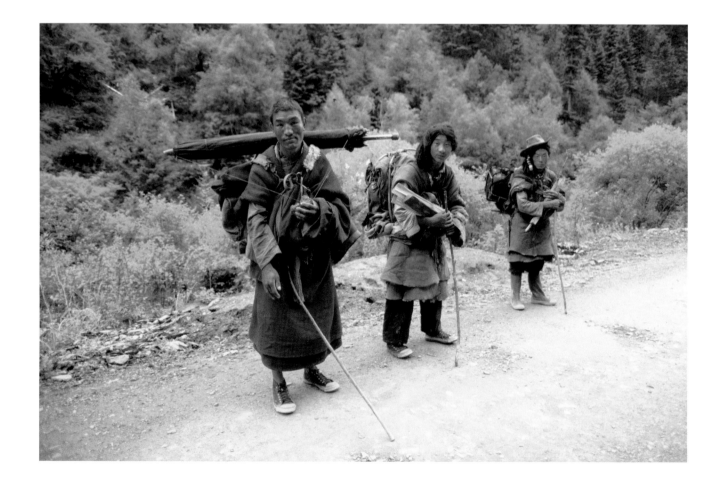

In the early 1980s, traveling by cars on the plateau was rare, by horses and yaks common, and on foot most popular.

Here a few pilgrims with their rattan-framed backpacks were traveling west on their long journey to Lhasa.

/

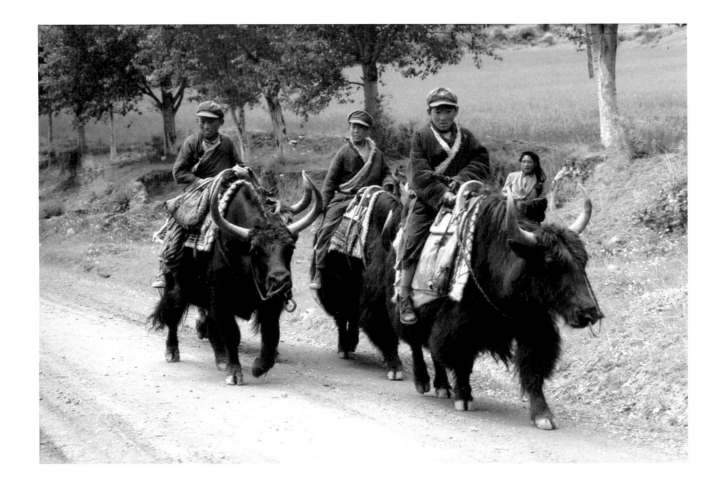

In Kham or eastern part of the plateau, kids herding their yak would often be riding them as well, not unlike young kids in southern China riding the buffalo. Here a few of them were riding saddled yaks along the road near Ganzi. The army caps were also common sights in those days.

/

At Dege near the upper Yangtze, the monastic printing house was just returning to printing the most sacred Buddhist sutra of Kanjur and Danjur from its holding of ancient wooden blocks. The printing house is a repository of over 210,000 Buddhist wooden blocks, a massive library and the only one that survived the Cultural Revolution. The ink used was made from cinnabar thus red in color. Today, the old blocks are too worn to be used and replacement blocks are carved.

/

During break time, monks and other worshipers would practice performing religious music and chanting at the corridor courtyard while the newly printed sutra pages were hung out to dry. It was only in the early 1980s that politics was slightly relaxed and religious practice was again restored.

/

Entering Tibet across to the west bank of the Yangtze, the terrain changed and after some high passes, the second largest city of Tibet of Changdu could be reached. Here karst hill rose above the surrounding plateau like a dragon with its spine presiding over the watershed ridge, a divide between the Yangtze and the Mekong.

/

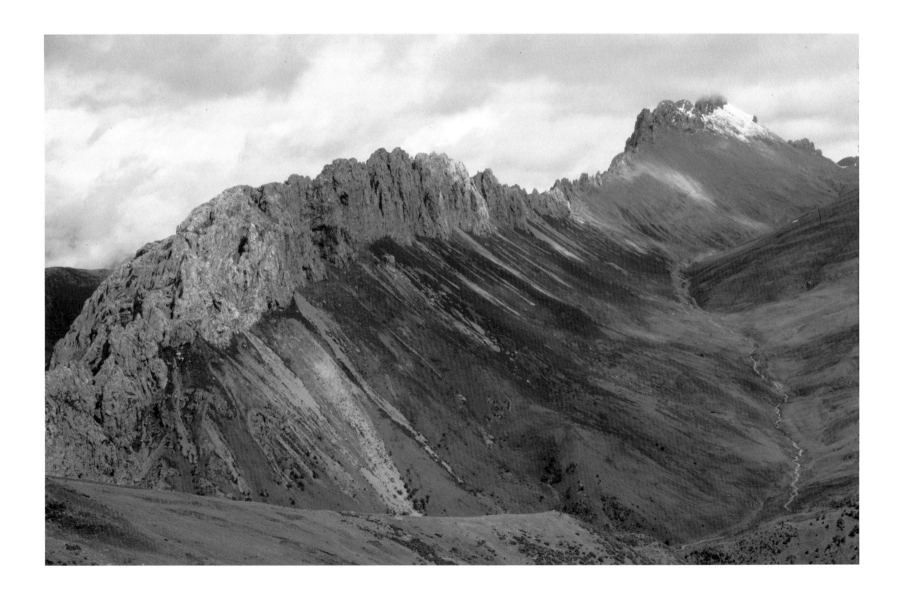

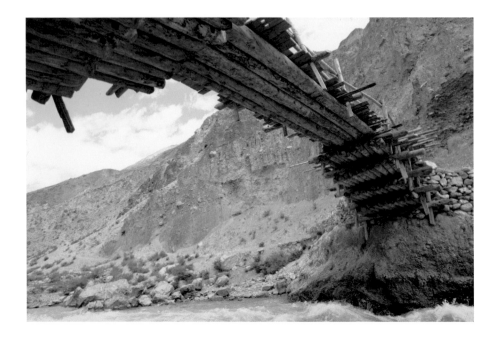

In remote regions, bridges were few and far apart. The traditional and ancient bridges built by Tibetans were still frequent sights in the early 1980s. Here a cantilever bridge spanned a fast-running river torrent.
/

The Mekong flows through eastern Tibet with some low point below 2500 meters where agriculture and pastoral lifestyle could be maintained. Here a Tibetan village hugged the hill with some fields cultivated with barley.
/

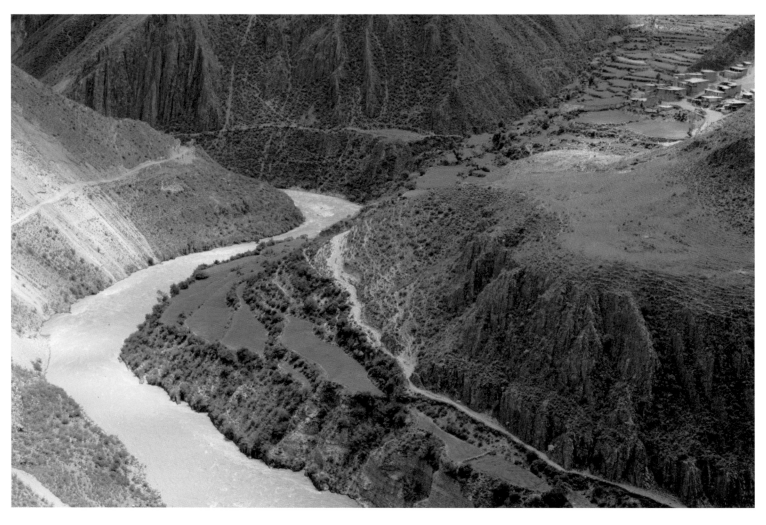

While there were two main roads cutting across Tibet from east to west, both roads were marginal during the rainy season and mudslides were frequent. Here along the southern road, a section was turned into a river torrent that our jeep braved to overcome driving up the hill

/

As we got near to Lhasa and finally driving along the Lhasa River, I ran into a local with a mule carriage bringing a yak-skin raft back upriver after he had carried cargo downward. Such skin raft could easily be seen in those early days as a means of transport up and down the Lhasa and Brahmaputra river at sections that are navigable.

/

Finally I reached Lhasa for the first time on June 30, 1982. The Potala Palace stood out as the highest building and landmark of the city, but at the time very much on the outskirt as Lhasa wasn't totally built up yet. Despite being a monumental architecture, there were hardly any tourist or pilgrims visiting, and the premise was open only once a week, on Wednesday, a far cry from the long line of visitors today.

/

Along the street of Lhasa, especially in the circuit pilgrimage route of the Barkor by the Jokhang monastery, I could see some venders selling a few simple religious sutras and incense, but it was a far cry from the busy market street of later decades. Here a traveling chanter with his family sat to sang his prayer songs while a few pedestrians gathered around to listen.

/

Outside the Jokhang, considered one of the most sacred religious sites throughout Tibet, Tibetans today from far and wide made pilgrimage here and gathered daily in the morning and evening to continue prostrating outside its main door. The gathering, however, on this day I took the picture was very special.

/

On this day in the morning of July 3, 1982, the people gathering outside the Jokhang was particularly crowded. By mid-morning the courtyard outside of the Jokhang was filled with pilgrims from all over.

/

Even along the road to the Jokhang, people gathered along the sidewalk waiting, and traffic police in white were seen everywhere trying to maintain order and kept the people, except stray dogs, from the main part of the road.
/
By 10am in the morning, even the main roads were filled with Tibetans of all ages, there was hardly any space left as I climbed a lamp post to photograph this crowd converging at the Jokhang.
/

By 10:30, the Panchen Lama arrived standing on a Beijing Jeep. He was making his first trip to Tibet and Lhasa after his long confinement during the Cultural Revolution and beyond. The people were seen bowing or holding incense in observance of their reincarnated Living Buddha's arrival. Some were seen with tears in their eyes as they finally caught a glimpse of a person they held as sacred throughout their life.

/

By the time I leave Lhasa,
I had been in China exactly one month, and had expended 74 rolls of film,
exposing 70 and exchanging 4 for courier service when I met someone returning to the US
willing to deposit them in Los Angeles.

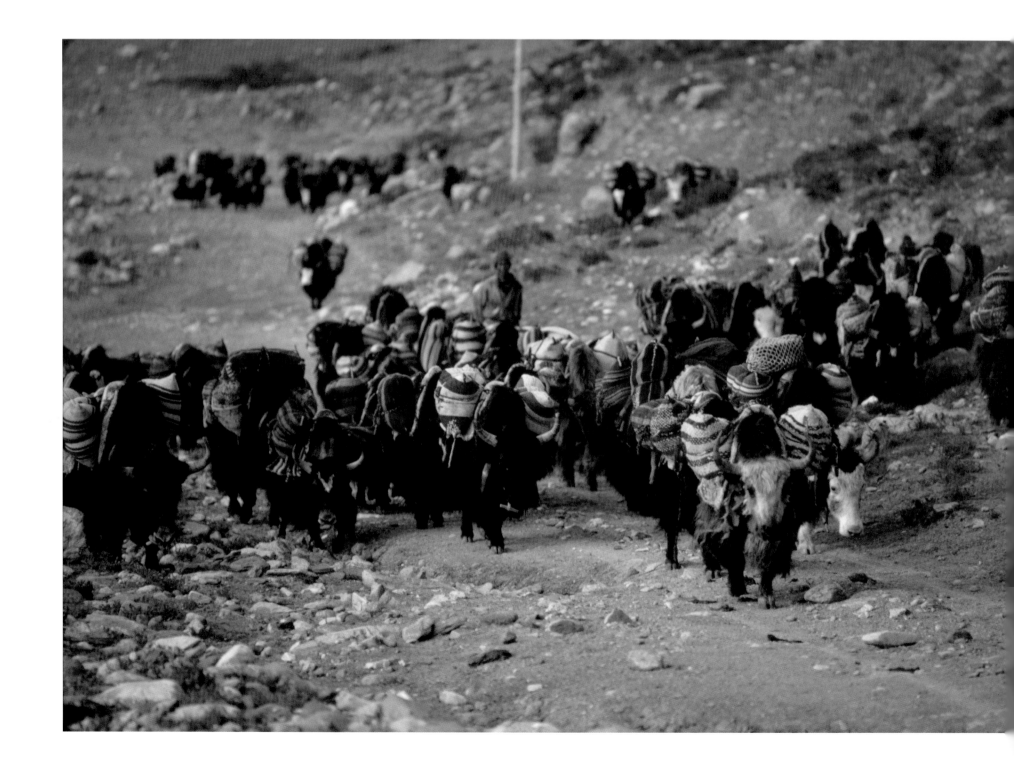

Upon leaving Lhasa, I headed north to the sacred lake of Nam Co, an alpine lake at 4500 meters. As our Jeep made its way through a rough unpaved switch back road, we ran into a yak caravan carrying loads of barley from the lower pastoral valley across the pass and going north to the nomadic high country of Banguo. There were 197 heads of yak in this caravan, tended by six helpers. Such caravan has since become obsolete as roads are being built and transportation method modernized. /

Tibetan caravan helpers in thick woolen coats walked with their horses behind the main yak herd. The lead yak generally knew the direction and the way, whereas the helpers would round up the slow and strayed ones from behind. It was then that I learned a person does not lead a caravan, but follow it, an error that many artists mistakenly depicted such millennium-old traditional activities when portraying a caravan. /

Though it was summer in early July, morning temperature at 9am was 41°F, barely above freezing. Tibetan nomad has to be dressed heavily for the night. With the yak saddles off their back, the domesticated animal graze during the night, and would continue their journey to the northern plateau. Clearing a high pass at 5100 meters, this caravan would descend to Nam Co, a large lake north of Lhasa here in the far side of the scene. /

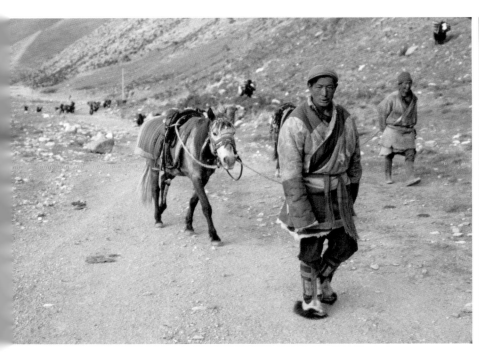

The northern road out of Lhasa to Qinghai was a highway of mud, especially during the summer rainy season. Convoy of trucks were often mired deep in this mess and had to be dug out, or pulled out by tractors or bulldozers one after another. The ordeal to free the vehicles could take hours or days.

/

At an elevation of 4700 meters, I ran into a lone biker Shi Jaoming. Using a single gear Yongjiu bike built in Beijing, his intention was to spend a year biking to every province, stopping by every provincial capital. He was more than half finished on his journey, whereas his film was all exhausted. When I met him, he was working hard to complete the most difficult section before winter set in. As a parting gift, I gave him ten rolls of Kodachrome X, five Ektachrome 400, and he thanked me profusely before riding on his way. His flag has rubber stamps of places he visited. This picture was later published in the National Geographic.

/

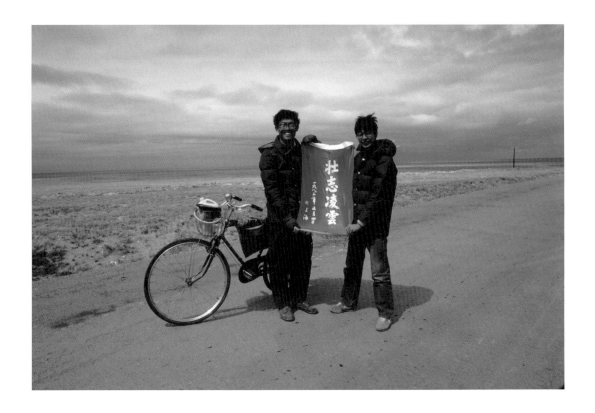

Once down to Golmud at the foothill of the Kunlun Mountain, a community of Kazak settled here since the mass exodus of Kazak out of northern Xinjiang in the 1930s. Their yurt, or felt tent, are similar to those used by the Mongols, but with a slightly lower profile. Poplar or willow branches are used to make a wicket framework, over which sheep wool felt are laid over to cover the entire structure, protecting its inhabitants from wind and cold.

/

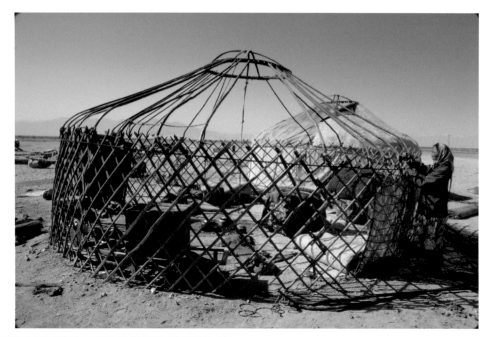

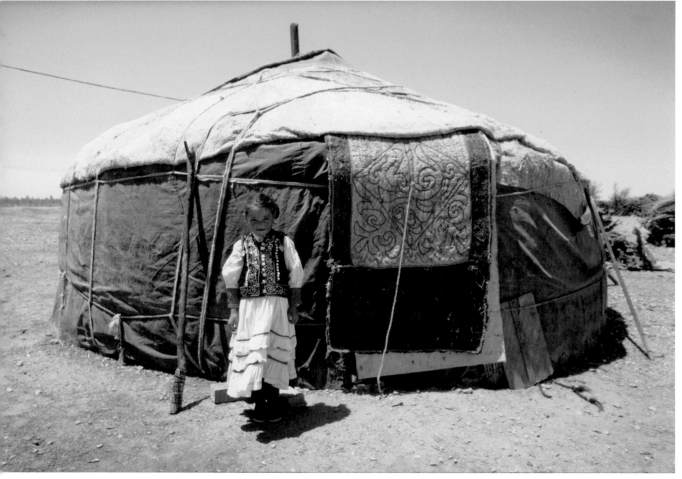

A full yurt has a flap on the top to let in air, as well as allowing passage of a chimney to pipe out cooking and warming fire smoke. A thick felt blanket with Kazak motif would become the door. A young Kazak girl in full costume provides a most complementary scene.

/

Two elder Kazak found shading and leaned on the side of a yurt. At their age, they might be small children when the Kazak marched out of Xinjiang in great numbers, some stopping in Golmud before continuing their journey to finally reaching Turkey. Others made their new home along the way in northern Qinghai bordering Gansu in the town of Aksay. A year after my first visit, upon the demand of elders in the community, the Kazak at Golmud migrated back to their traditional home in northern Xinjiang. However, they were to find difficulties in integrating, and many finally returned to Golmud.

/

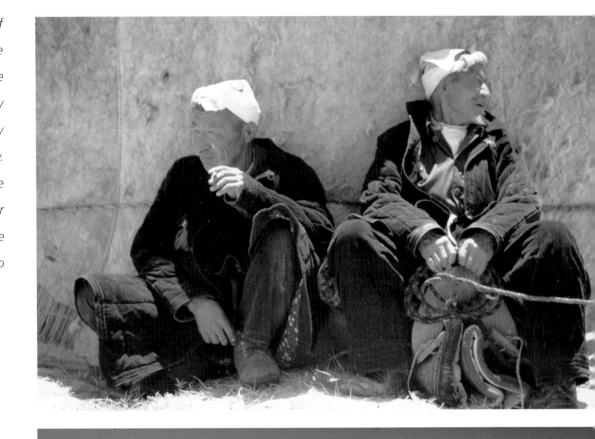

Moving camp for the nomads was a routine as they herded their livestock in pursuit of fresh water and greener pasture. The entire yurt and its contents could be loaded onto four camels while livestock would be driven ahead. The matriarch, carrying her infant, took off in the fifth camel.

/

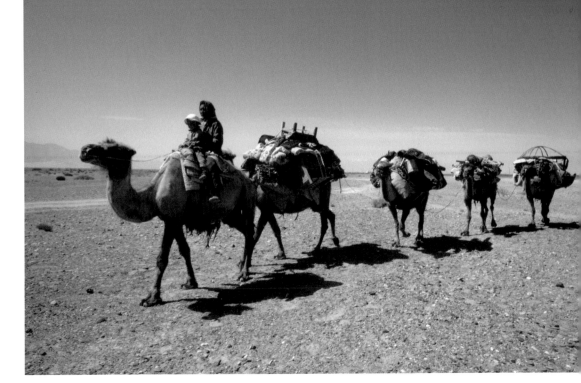

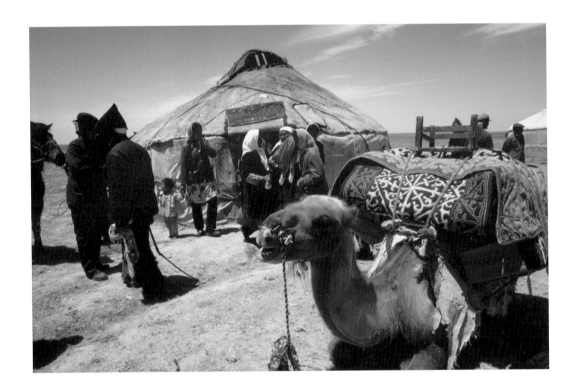

At a wedding ceremony, a decorated camel served as the limousine for carrying the dowry. As the bride left her tent with her mother and maternal siblings, she must start crying, real or act, during the parting in addition to singing some sad bridal songs specially composed for such occasion. Relatives would see her riding off in the back, sharing a horse with a brother, or a brother-in-law.

/

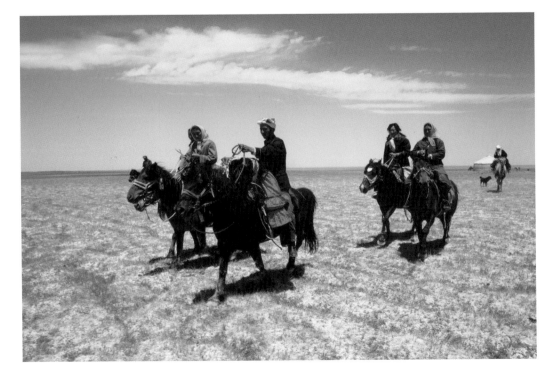

Brother-in-law delivering crying bride on horseback to groom's home.

/

The bride Chaolibun and the groom Muhan were both twenty-three years of age. At the final ceremony, a witness officiating the marriage brought out a small red book, presumably not Mao's Thought, and read out the government approved wedding statement. For some reason, the bride and groom reacted as if being sentenced to death. The same picture was published in the National Geographic without the fatalistic remark.

/

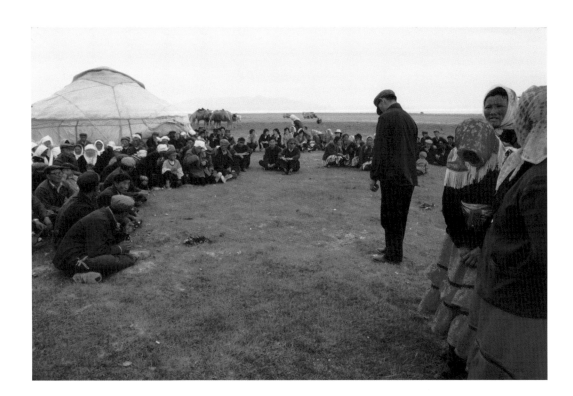

My host Baoshike was from the United Front Office. The one-child policy did not apply to minority nationalities in general. His brother was the party secretary of the district and had nine children. I visited Bao's home which was inside a brick house, but decorated as if inside a yurt, with full color draperies in Kazak design and motifs. Here were his three children at home over their bed.

/

Between Golmud and Qinghai Lake, I observed at the elevation of over 4000 meters Tibetans herding their sheep into a roadside indent to sheer wool for summer sale. At the time, many Tibetans still carry matchlock musket guns or even semi-automatic rifles when traveling on horseback throughout the plateau.

/

I stopped by to visit the Tu nationality in northeastern Qinghai. The autonomous county of Huzhu has around 47,000 Tu at the time, and nationwide around 120,000. I went to Donggou Commune and Dazhuang Brigade. The village organized a welcome party and greeted my entourage of government officials accompanying me before entering the village. Three cups of white liquor were offered as toast, followed by three more before entering the house of reception, and another further three cups when seated. These were the ceremonial gesture, before the meal and serious drinking commence. It was followed in the courtyard by a bit of tipsy dance performance of the ladies in full national costume of the group. /

A lamb was slaughtered, boiled, and served as the main dish of the banquet in my honor. A ceremonial dish, was set up like a small pagoda on a bowl. It was made of tsamba or parched barley, with some yak butter carved as a tripod representing the sun, moon and earth. This dish is in memory of the Tu's nomadic and pastoral past, though today they are sedentary farmers. The Tu are Buddhists similar to those following the Tibetan religious heritage. Over half of their words are similar to Mongolian. Someone having a first grandchild, male or female, must ride a cow and stroll around the village, such that everyone would take notice. In the past, if a girl is not married by the age of 15, a ceremony would take place to marry her symbolically to heaven. Besides a sumptuous meal, I was entertained to many other interesting stories. /

Lanzhou along the upper Yellow River was a major crossroad of the ancient Silk Road. The Muslim and their mosques had a long heritage and history in the city. On this Friday, mass gathering of over 3,000 devotees took place for their religious service near the big mosque for Ramadan. /

Luo Jengui was 34 years of age and had been conducting skin rafting since 12. Along this stretch of the Yellow River in Lanzhou, his family was the only one remaining that knew how to maintain such business going down the river. After selecting the right sheep and going through a special way of slaughtering and skinning, it takes a week to dry it to make a floatable skin, lining the inside with oil and salt. Each raft requires 13 skins, weighing about 25 kilos. In the past, some rafts had hundreds of skins, floating downriver for hundreds of kilometers carrying cargo. At the other end, after the load was delivered, the skins were sold as well. A basic raft can take up to eight persons or half a ton of cargo. The iron bridge behind, first one built by German engineers to span the Yellow River, was constructed in 1907. /

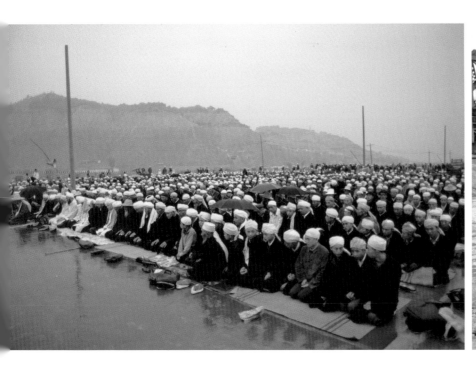
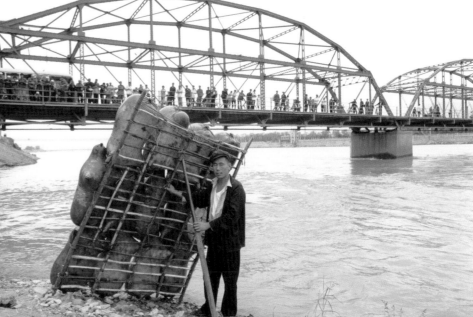

A high lama gave a lecture to younger monks in Labrang monastery. Despite the monks were driven away during the political turmoil for over a decade, the main halls of the premises remain intact and began to serve religious functions with vitality in the early 1980s.
/

In Labrang monastery of southern Gansu, religion was recently revived after the Cultural Revolution and monks began to arrive back at the monastery. As one of the five most important Tibetan monasteries of the Gelugpa or Yellow Sect, Labrang used to host over 10,000 monks. The red robe and yellow hat gave a classic image of both ceremonial dignity and authenticity
/

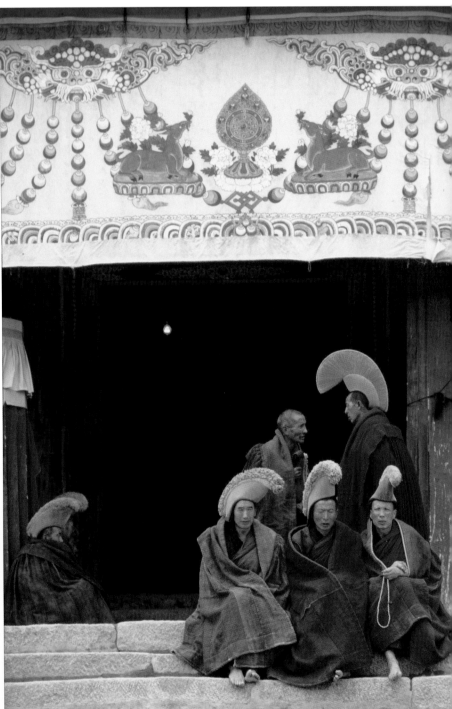

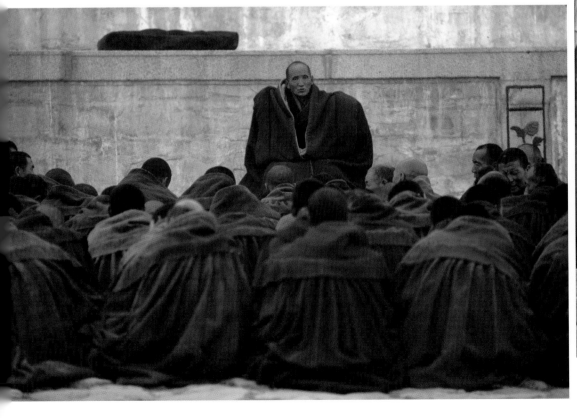

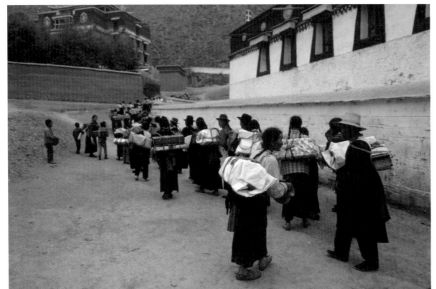

During a special religious day, Tibetans living in the neighborhood of Labrang came to borrow sutra volumes from the monastery's library and carried them around the periphery of the premises in circumambulation as a way to gain merits.

/

Three senior monks with their ceremonial red robes sat and chat outside the walls of Labrang monastery. A picture of these monks was published in the National Geographic magazine subsequently.

/

At Songke, a grassland neighborhood near Labrang, a festival for the summer took place as nomads and pastoral Tibetans pitched decorative tents for their annual party in the grassland for up to a couple weeks. In the evening, wealthy families may set up their television facing outward, using a generator and broadcast programs for everyone to view.

/

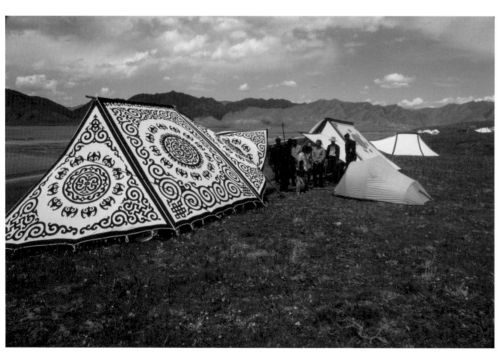

Such decorative tents with Tibetan motifs were common sight during festival time, each trying to outdo the other in a competition of vanity. I set up my small tent, an early model of the North Face Westwind, adjacent to a group of Tibetan tents in order to interview the festive occasion.

/

A tug-of-war competition was one of the highlights of the festival, with the nomads putting on

their best costume in this display of strength among various tribes of the region.

/

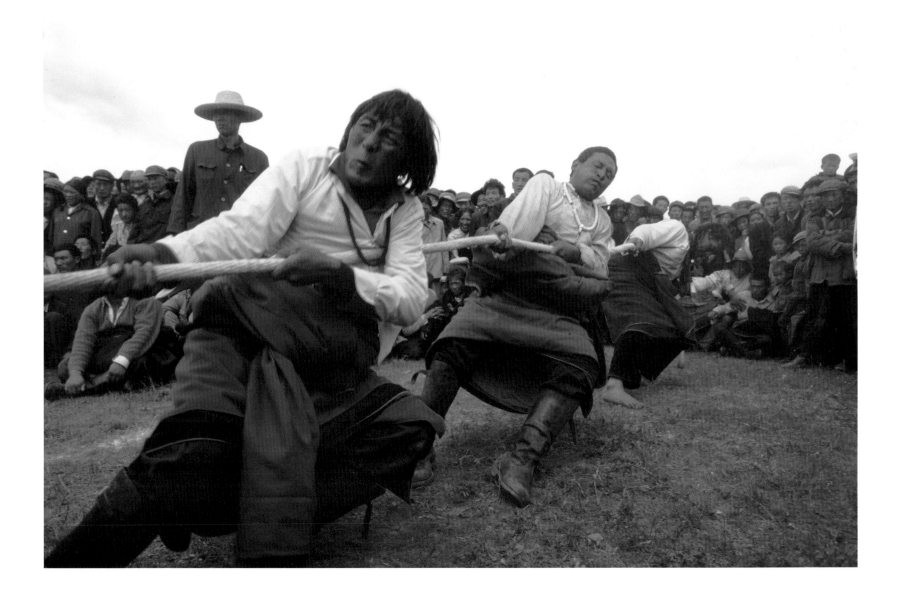

Horse-racing, usually with riders being boys of young age, was a much-awaited event as the champion would bring fame and glory to both horse, rider and the village the winner came from. Besides, there were prize money and maybe some valuable consumer items much sought-after in those days.

/

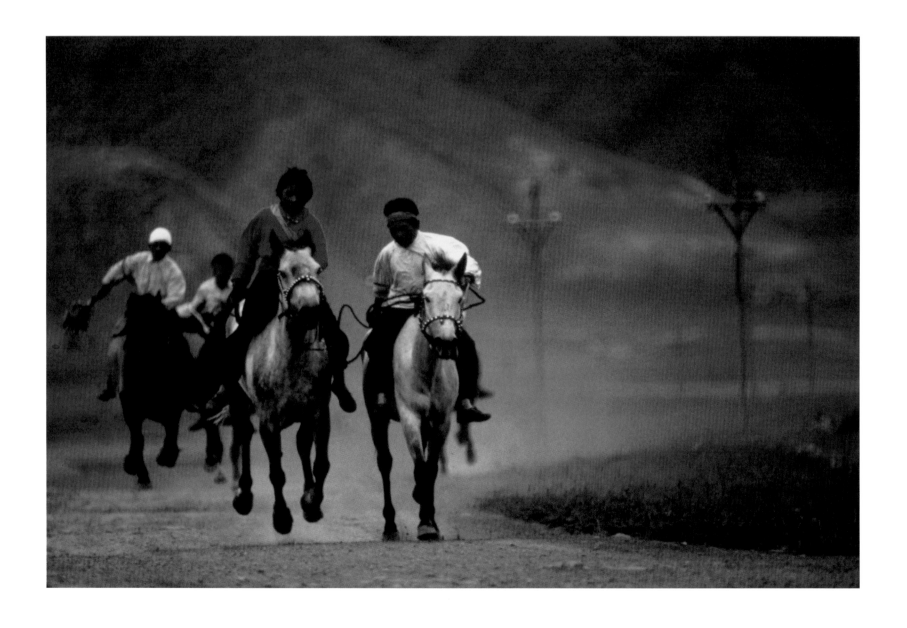

The Gongtangsan Rinpoche of Labrang was much revered as one of the most-educated lamas throughout Tibet. He was imprisoned during much of the Cultural Revolution and was only recently released when the author visited the area. Here nomads pay respect to the high monk, a reincarnated lama, by offering the Tibetan Khata, a ceremonial white scarf. The Rinpoche and I became fast friends and in subsequent trips met several times. A picture of him in his yurt tent was published in the National Geographic.

/

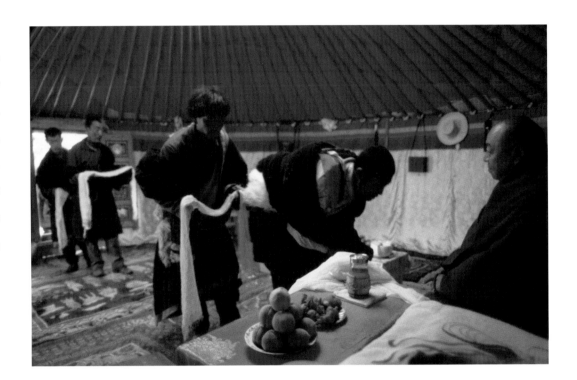

At a hill top which is a local sacred mountain of the village of Tawa near Labrang, Tibetans put on their best costume and each family would bring up the hill a long and colorful arrow staff to be planted in an Obo, which would help the respective family to secure safety and avoid enemy or evil spirit.

/

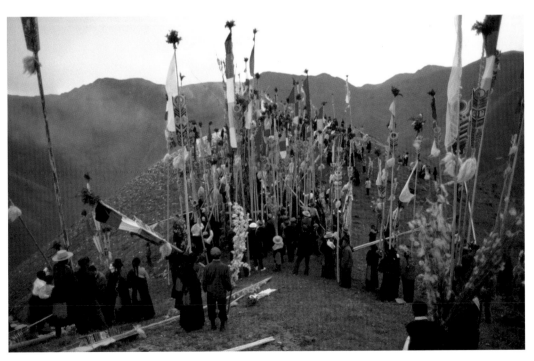

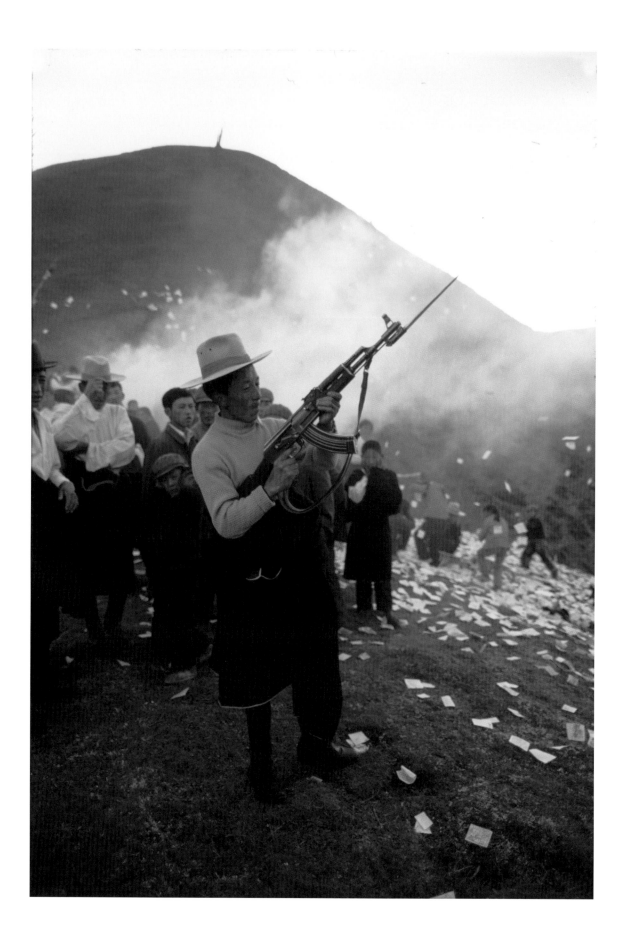

In the 1980s, Tibetans were allowed to carry arms, including even semi-automatic rifles. Such guns were considered highly valuable by Tibetan men, both for dignity and as show of vanity when they travel around. At festive gatherings, it was not unusual to hear the firing of such machine guns, as a salute to the deities or simply as a show of martial prowess.

/

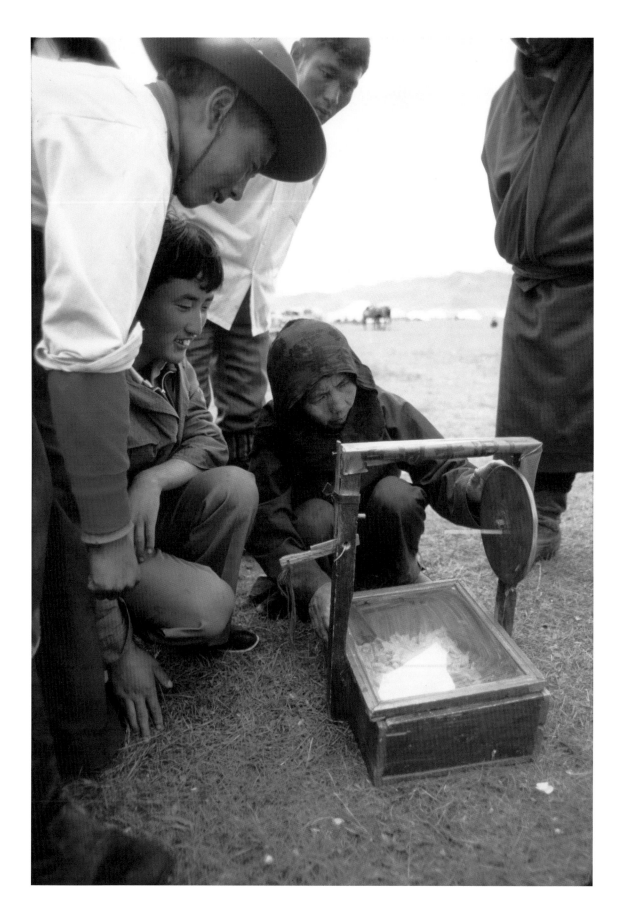

Among Tibetan community are usually found Muslim merchants and shops. Here at the festival ground was a Hui lady with her box of dart game, for the lucky player who win a small prize, or the common loser who would go away parting with his small change.

/

In the hills bordering Gansu and Sichuan are huge tracks of pine and fir forests. In the early 1980s, even pristine sites like those around and inside the very scenic Juizhaigou was considered forestry logging grounds. Deforestation was rampant, and it wasn't until the mid-1980s and into the 1990s before more stringent measures were taken to protect China's remaining forests.

/

The Baima Tibetan are considered by some scholars to be remnants of the ancient Di tribe of northern China. Today they inhabit the border region of southern Gansu and northern Sichuan. Their stockaded villages are concentrated in Wenxian and Pingwu in Gansu and Sichuan respectively. At time of my visit and subsequent publication of a few photos and their legends in the National Geographic, hardly anyone outside of the region and academic ethnologists had heard about them. Their area is also known for being one of the important habitats of the Giant Panda.

/

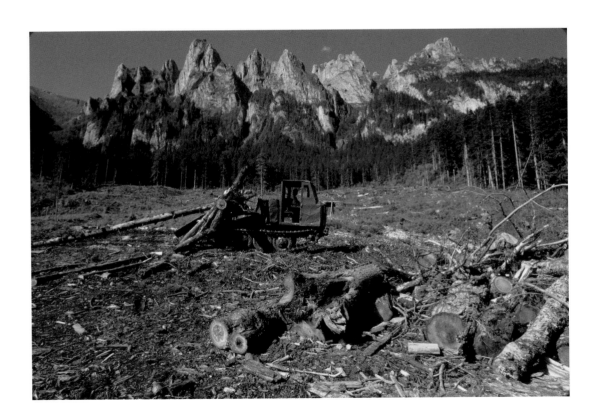

In rural Nanping and Songpan counties of northern Sichuan, local Tibetans were traveling in horses and yaks, and in this case also a dzo, a hybrid between a yak and a cattle. Cars and buses were a rarity even by the early 1980s.

/

Near Mao-er-gai where the red Army had passed through in its Long March, a Tibetan family looked hesitantly at a stranger as few from outside would penetrate their mountain fastness. The grandfather was spinning a large Tibetan prayer wheel. Outdoor of the house were yak dung pasted against the wall for drying, to be used as fuel in the stove for cooking and heating.

/

At Jiuzhaigou a Tibetan lady in home-made leather boots was spinning sheep wool into a bundle of thread for knitting into clothing.

/

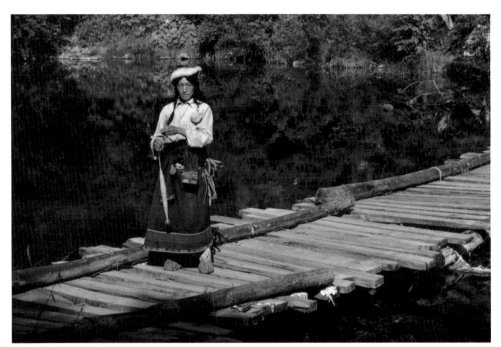

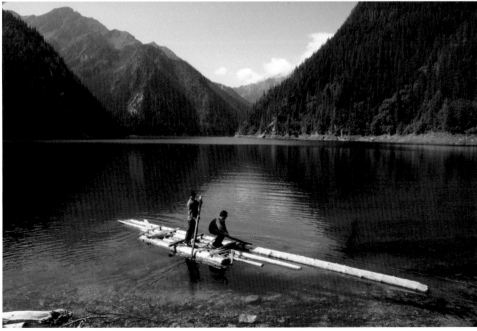

Before Jiuzhaigou was made into a tourist mecca, the few visitors who came were able to use local felled logs and fashioned into a raft for use over the crystal-clear turquoise lake. Here were my two drivers maneuvering a makeshift raft.

/

Nearby is Huanglong, another natural scenic spot with pristine terraced lakes and limestone deposit that makes the area soon to become another major tourist site.

/

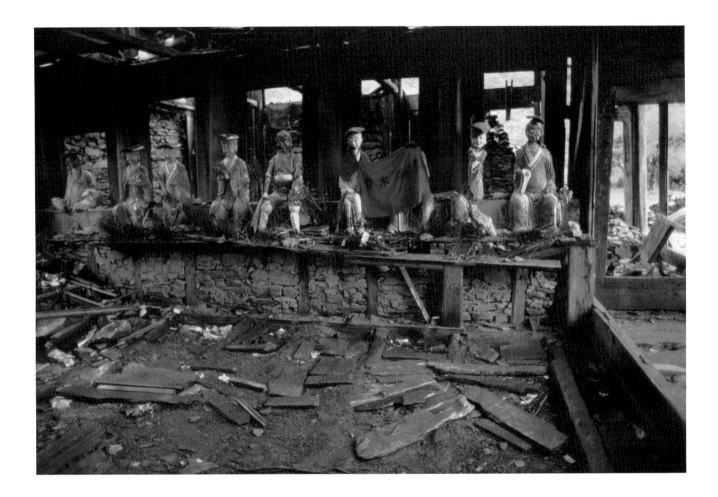

High up beyond the terraced lake of Huanglong, or Yellow Dragon, the historic Daoist temple that reveres local deities

was in ruin and disarray, not yet recovering from the ravages and excesses of the brutal Cultural Revolution.

/

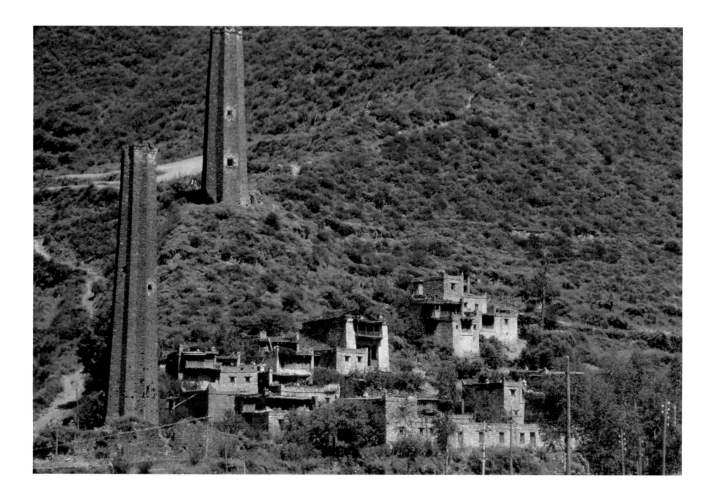

Near Markham, also known as Ma-er-kan, the capital of Aba Prefecture, the village of Xonggang has several high defense towers made from layering of bricks. Such Tibetan architecture extends through several neighboring areas, with the highest concentration within Danba County. Many "explorers" lay claim to discovering these special architecturally unique structures, when pictures were already published in English journal as early as the 1930s.

/

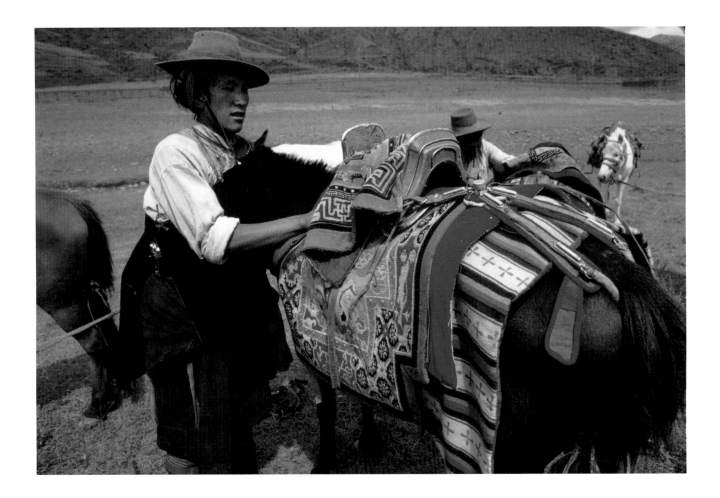

At Markam of eastern Tibet, not to be confused with the similarly named place in Sichuan, a Khampa prepared his colorfully saddled horse for the annual horse racing event. The Khampas are the fiercest fighters who inhabit the southeastern part of the Tibetan plateau, and Markam was notorious for its violent banditry and turbulent history before 1949, and well into the 1960s. I happened to arrive here for the first time a day after my 33rd birthday, on my way back to Kunming where I started the expedition almost three months ago, covering five provinces and autonomous region

/

1983.1 -

By February 1983, I again embarked on another expedition, fully supported by the National Geographic. I wanted first to have a brief look at Hainan Island, then considered part of Guangdong and soon to become a separate province.

I timed my visit to be there during Chinese New Year, but in those days, flights were infrequent and easily canceled due to weather, which of course happened to my flight. I flew out on February 13, New Year's Day, and by then four days of flights were canceled, adding up to 15 flights piling up. Thus, by the time I got to Hainan, New Year was over and I was only able to see the tail end of the festivities.

After exploring Hainan for ten days, I flew back to Guangzhou and onward to Kunming, beginning the next leg of my expedition, now named the Southwest China Expedition at National Geographic, covering Yunnan, Guizhou and Guangxi Provinces. As for Hainan, I would return again to explore the entire island another year.

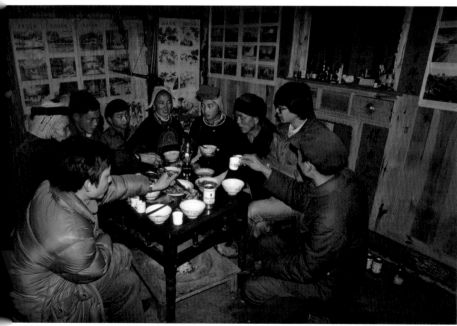

The thatched roof houses of the indigenous Li people was a common sight once into the rural villages. At the time, there were about 800,000 Li based on census made, but that number would grow to 1.2 million thirty years later, when CERS, the organization that I founded, would conduct preservation to the last village remaining with such thatched houses, a rare specimen of the past.

/

Inside such long houses, living quarters and dining area are all but one. Any big or small occasion, be it a wedding or funeral, would bring together all the village neighbors for a drinking and feasting party. Locals brew simple rice liquor and bowlful of these were consumed by the host as well as offered to guests. It was here that I first heard about leeches that infest the jungle forest of the island, and a bat called "red mist" that is used by women as contraceptive.

/

At the tail-end of the Chinese New Year festival, martial art performers as well as dragon dancers would go from village to village, symbolically bringing sound and action for good fortune while collecting some lucky money. These performers are always most welcome by the children. At Dan Xian County, now renamed to Danzhou, Su Dongpo was exiled here in the Song Dynasty. Visitors come pay respect to the literary great who left behind many popular poems. Party Secretary Hu Yaobang was just here for lunch two days ahead of my own visit.

/

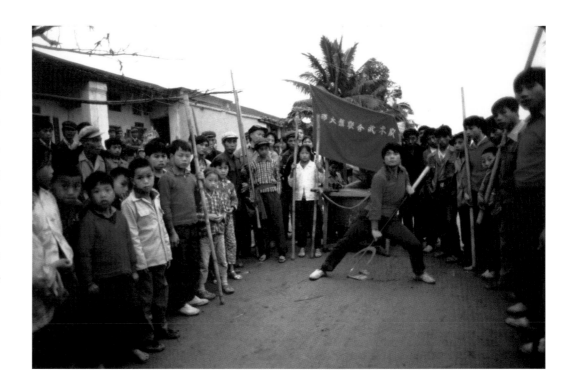

In the farms of Hainan, the most common crop is rice and sugarcane. Here a buffalo was used to plow the field while patches of paddy was already sown with new seedlings and began to show some green. Most village houses, even for the Han farmers, used thatched roof rather than tiled, as the latter would cost money to buy.

/

從來水牛為人愁，
近日水牛少煩憂，
農業指日現代化，
水牛終於要退休。

Cow and buffalo were used for many duties. Here a cow pulled a cart with two retractable wooden combs, one on each side, to scrap loose stones in order to level the unpaved dirt road. Another two carts pulled by buffaloes had wheels fashioned together with a few pieces of wood. Such sight, though used for generations, would soon become obsolete in just a few short years.

/

Tattoo designs adorn faces of the Li people. Usually the older generations all had face and body tattoos. But in this case, a middle age lady also sport tattoo on her face, probably performed in the 1950s. Each tribe and even each village may have its own pattern of tattoo design, a way to identify one group from another. On this trip, I saw one teenage girl with face tattoo, obviously done in the 1960s, most likely secretly as the practice was abolished by the government. /

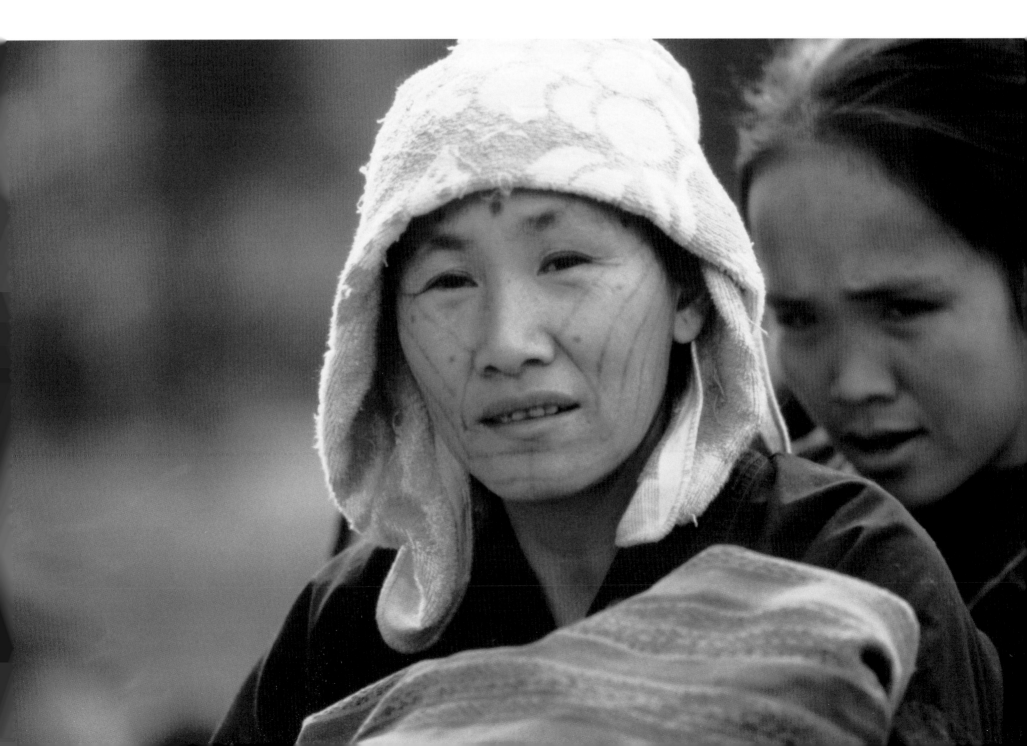

Both young and old Li people were wearing their traditional costume. Each tribe is slightly different from another in design and style. Some would have longer skirt while others may have fully embroidered short ones. This group of girls from Qiongzhong County have black dyed blouses with colorful trimmings.

/

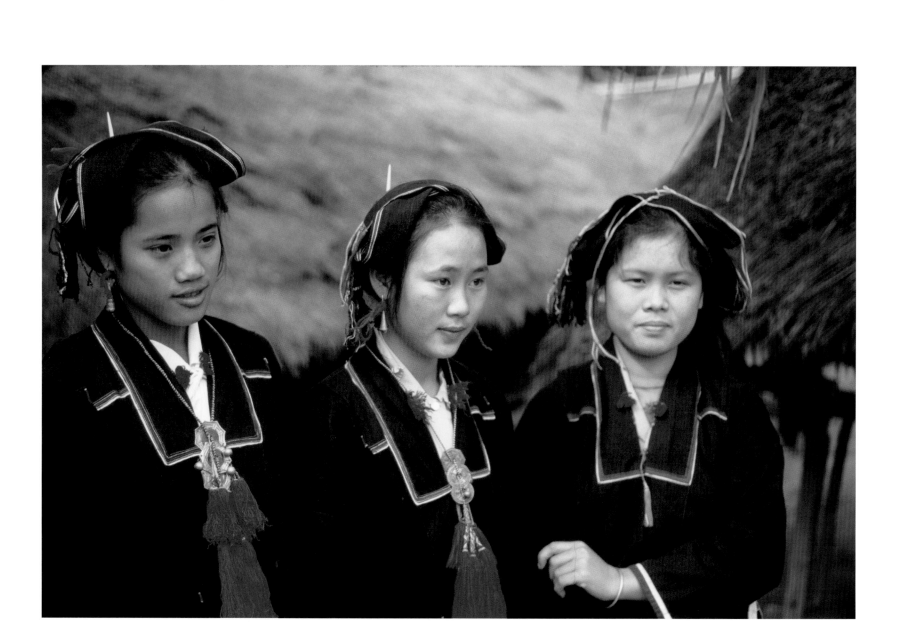

Fishing people seemed to have more colorful dress than city folks who only wear blue or green during those days. Here a woman at a nearby fishing village of Ningshui County was interrupted from repairing her fishing net as she observed this stranger from overseas in jeans and sport boots, which at the time was a rarity in China.

/

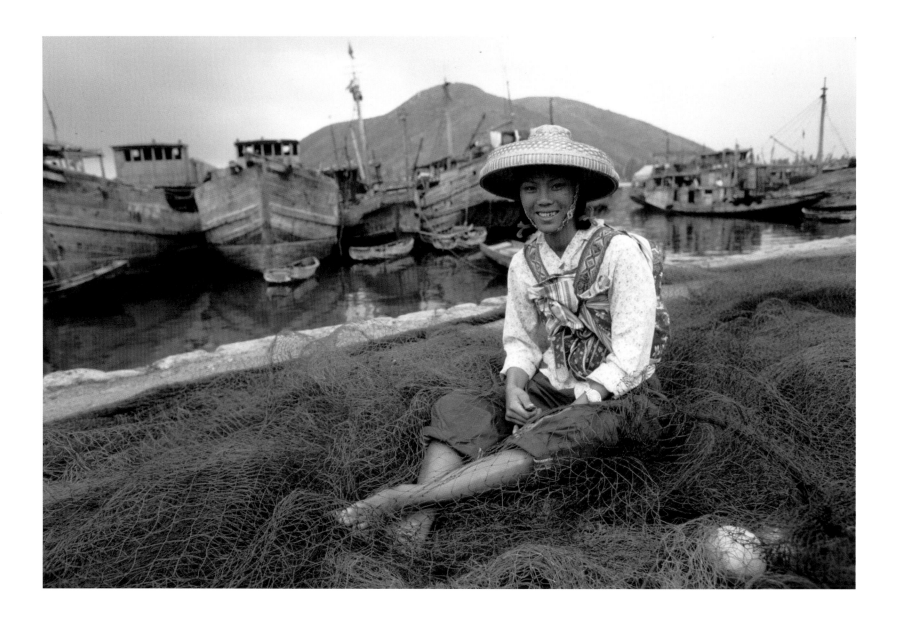

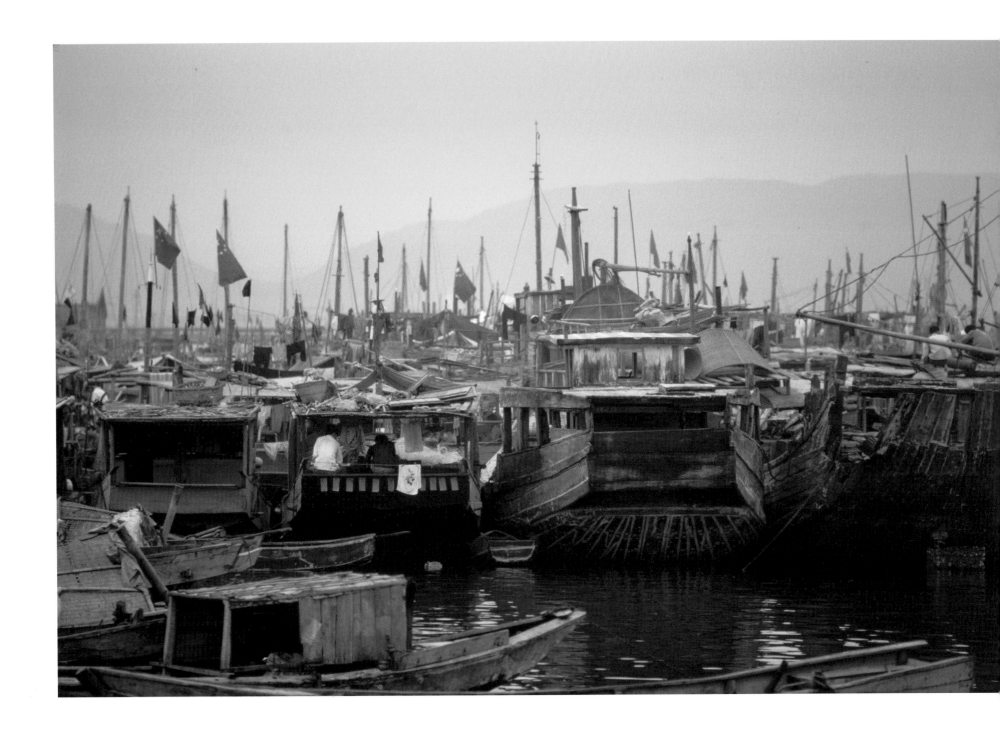

As it was Chinese New Year period, all fishing boats returned to port and many had red flags or the national flag flying on its masts. In villages and towns, the public loud speakers would blast the East is Red theme song of the PRC at 6am, and at 6:30 the national anthem followed by Beijing Central Radio Station's news broadcast of the day.

/

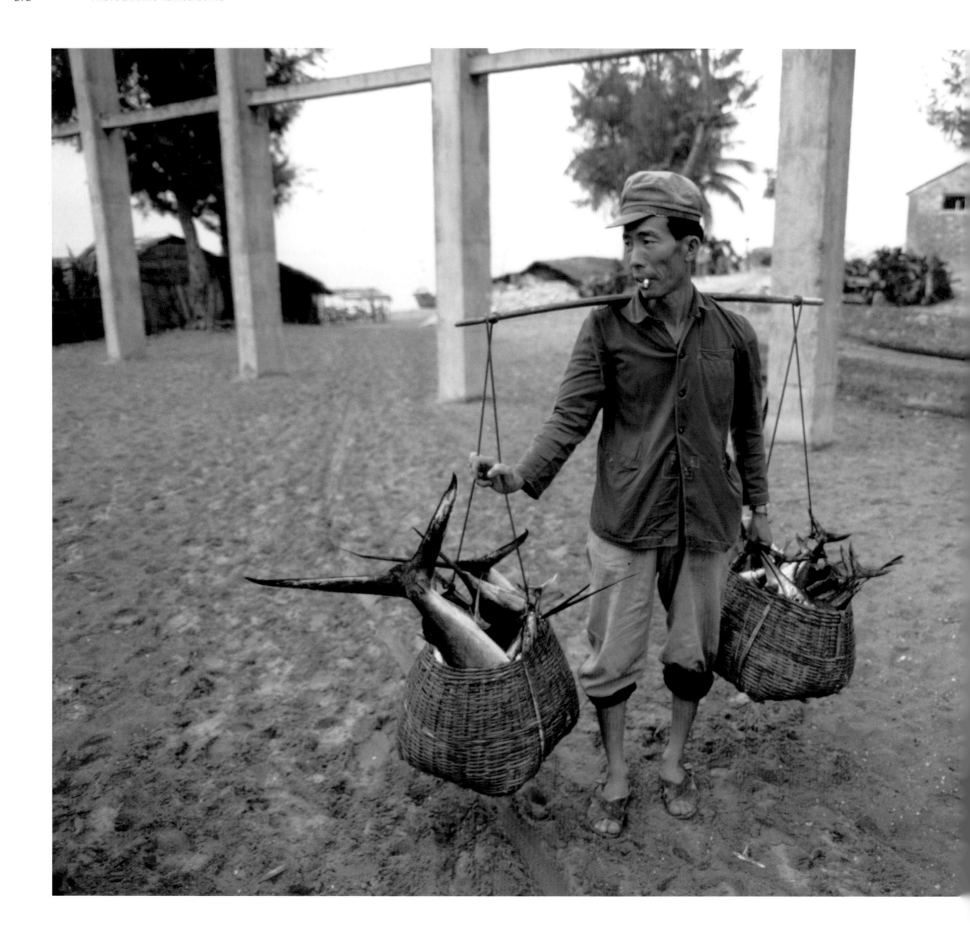

A fisherman returning from sea had two baskets full of fish that he was hauling to a nearby market. The long and split tail fin revealed that most of the catch were tuna or barracuda, though they were small ones as large ones could get to the size of over 100 kilograms.
/

An upturned Mantis Ray Fish was brought to shore by fisherman. Such a catch would be cut up into pieces and sold in the market. This particular one weighed over 70 kilos and was sold at Sixty Cents per catty or half kilo, with the entire fish netting around 80 Yuan. It was said the largest ray fish could reach over 500 kilos, costing close to 400 Yuan. Locals called the Ray Fish as Yen Yue.
/

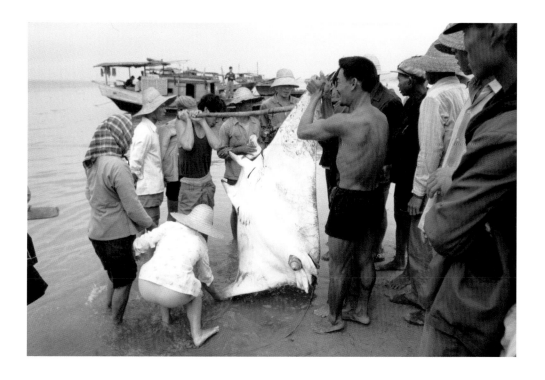

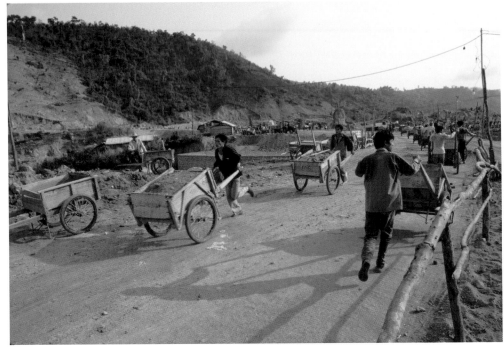

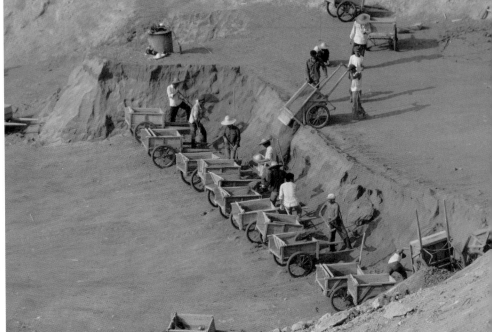

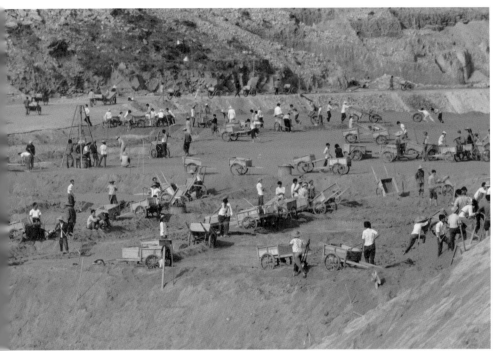

Nearby a dam was being built to serve as both a reservoir and for flood control. It would also generate 3000 kilowatt of power when complete, costing 15 million Rmb in construction cost. A corps of over 6000 laborers worked all day round the clock in shifts, aiming to finish the earth dam in 100 days. As China became mechanized in equipment for infrastructure projects, such scene would soon become totally obsolete.

/

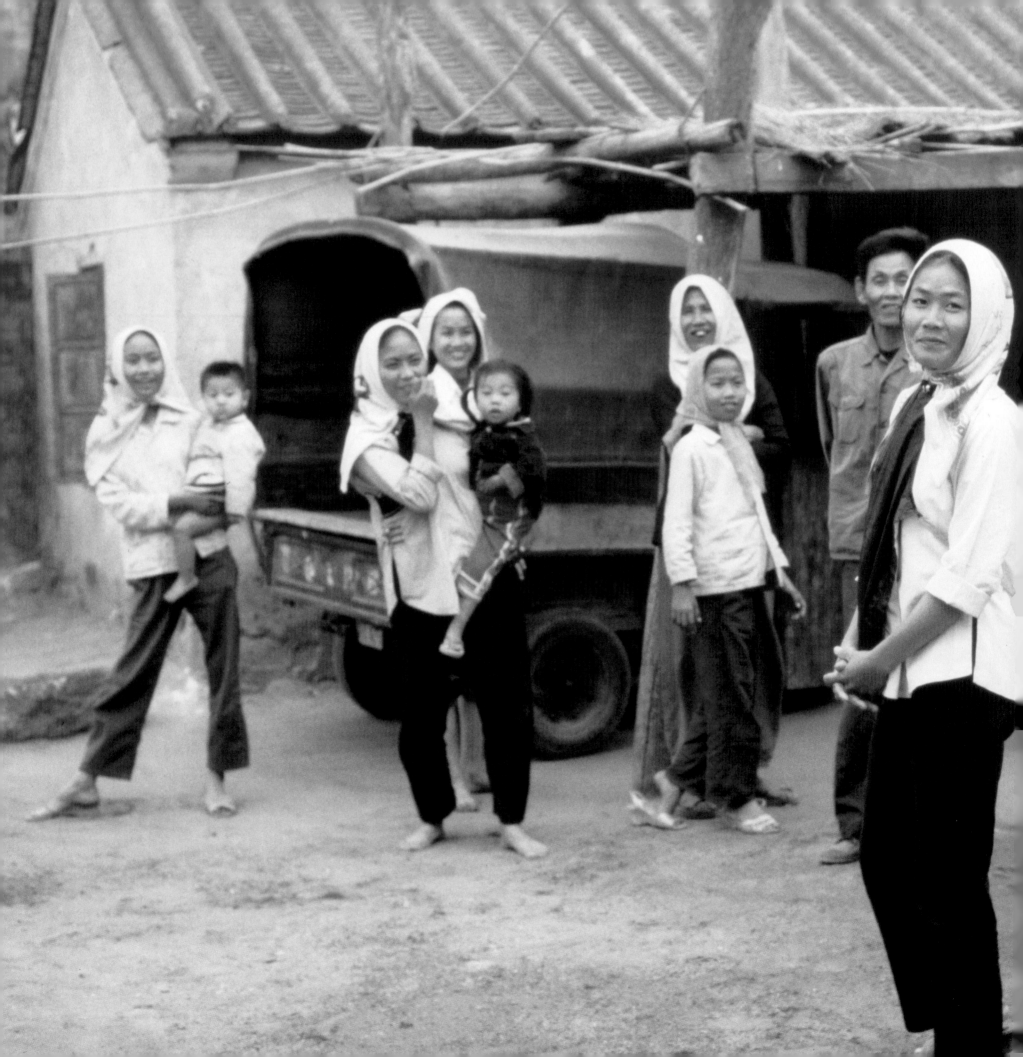

At Ai Xian's Yanglang Commune's Huifei and Huiqing Brigade, I visited the two Muslim villages where women used a color cloth towel fashioned as their veil. They did not celebrate Chinese New Year, but instead would have their major religious holiday of Ramadan, during the Sixth Moon of the year. Children and adults all learn Arabic. Ai Xian County, in another year after my visit, would be incorporated into the new City Prefecture of Sanya by 1984.

/

A woman showed features slightly different from the common Han, though she too would wear the straw hat when working in the field. The Hui Muslim of the region are both farmers planting their fields, raising livestock, as well as being fisherman. /

The Muslim elders usually wear a bear and speak Arabic fluently and could read the Koran. In Hainan at that time, there were over 3800 Muslims, almost all living in the southern tip of the island near Sanya. They would attend religious service five times a day, wearing white cap and robe. Retired older men would generally hang around the mosque during day time. /

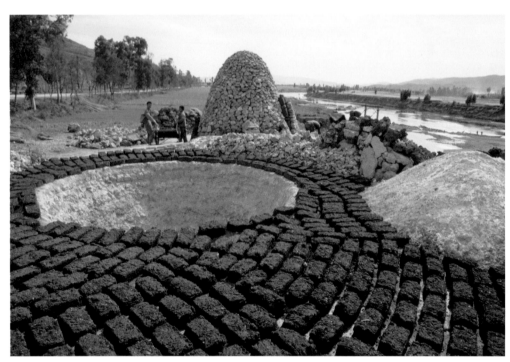

Starting from Kunming in Yunnan, I stopped taking the Malaria pills which I was on for over two weeks, and traveled east to Yiliang County. At the time, crossing provincial border still required several papers of permission, from both the public security office, as well as gasoline quota transferred from one place to another, issued by the oil company. Outside of town is the Nanpan River where at the river banks there were many kilns for the making of lime from karst limestone which are prevalent in the nearby hills. The black bricks surrounding the kiln were coal blocks used for heating inside the furnace. Coal at the time was 1.80 Yuan for 100 kilos. Each brick would weigh about one kilo. It was early March, but the rape seed was already in blossom with yellow flowers. These are used to make cooking oil.
/

Six kilometers into Xingyi County across the border of Yunnan into Guizhou, I observed a roadside workshop that was making rice noodles, by pounding the rice flour through a small holed container and what came out is the favorite staple of the Yunnan and Guizhou people, called MiXian, or rice strings. The finished product went for 0.55 Yuan for half a kilo.
/

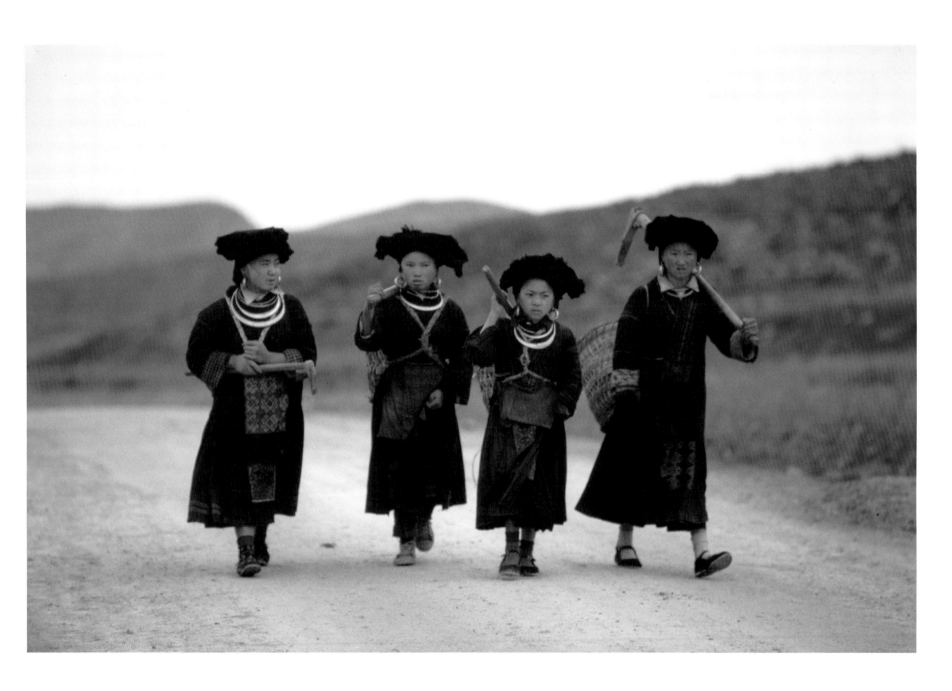

At Anlong town of Xinren County in Guizhou, the Miao wore mainly black costume with colorful trimming, silver necklaces, and embroidered apron. The cloth was dyed from indigo dark purple ink from a plant. Here a group of youngsters, all women, were walking to their field with hoes on the back.

/

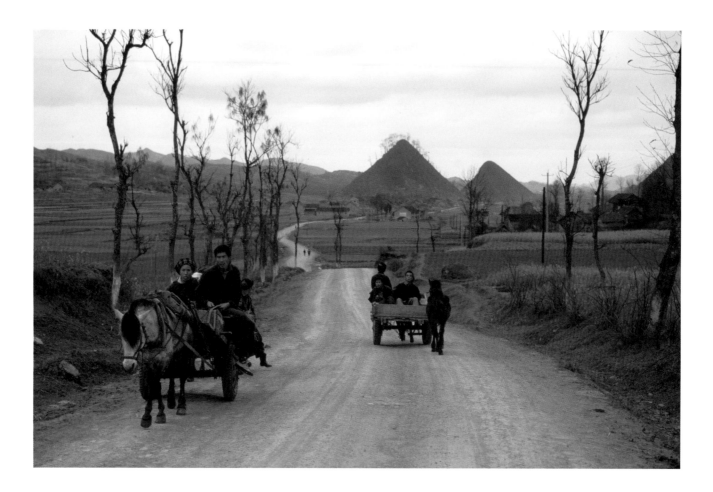

Guizhou is filled with karst hills and the sky is often overcast. The use of horse carts was common and once outside of the city, that became the main transportation means besides being on foot. Scenic sites are plenty within Guizhou. The ancient kingdom of "Yelang" of the province remains a mystery to historians.

/

夜郎考：

貴黔自古風景皆，莫怪夜郎能自大，

史書古蹟可盡看，故國何在費君猜。

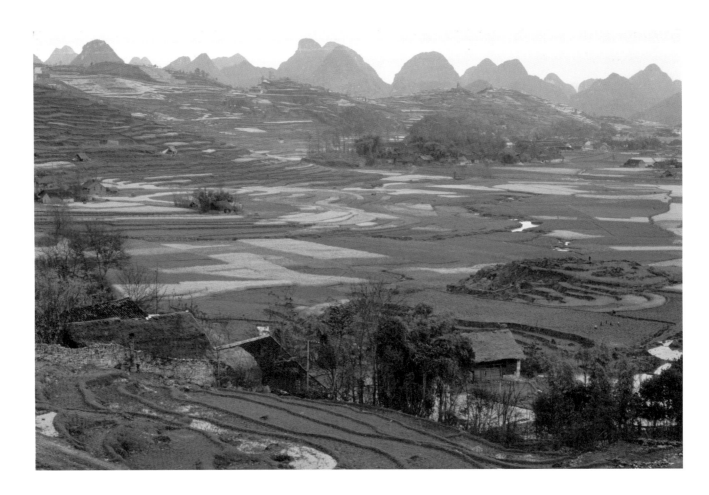

At Jingfeng County, the landscape was beautiful due to the blossoming rape seed flowers. The houses in scattered villages were all thatched roof whereas the walls were made from stone quarried from nearby hills, much of them being limestone.

/

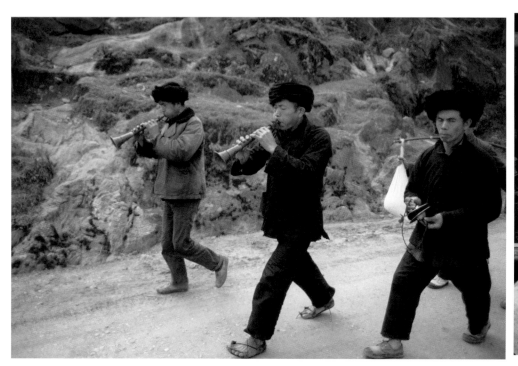

A funeral procession outside of Jingfeng saw a group with a wooden coffin led by two men playing the "Suona", a traditional wind instrument like a small trumpet, while another man hit a small gong and a fourth one, out of the picture, was a teenager hitting a hand-carried drum.

/

Merchandises at local shops were few, with the most popular being cigarettes, candies and soap. Beer and firecrackers were also favorites.

/

The Puyi nationality near Huangguoshu waterfall were as colorful in the front as in the back. Here a few of them traveling on the road revealed the batik skirt and the embroidered baby carrier. Rain seemed frequent as those leaving home always bring with them umbrellas.

/

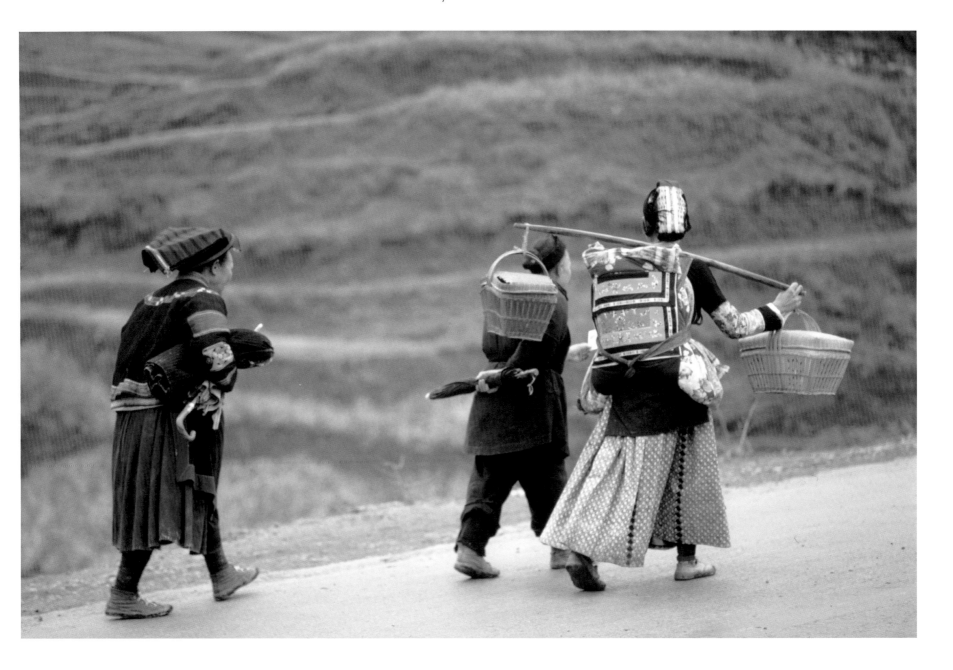

Some of the Miao lived near the Puyi and their hair style had their long hair wrapped around a red buffalo-horn-like wooden comb, below surrounded by heavy silver chain as further decoration, though not visible in this woman. /

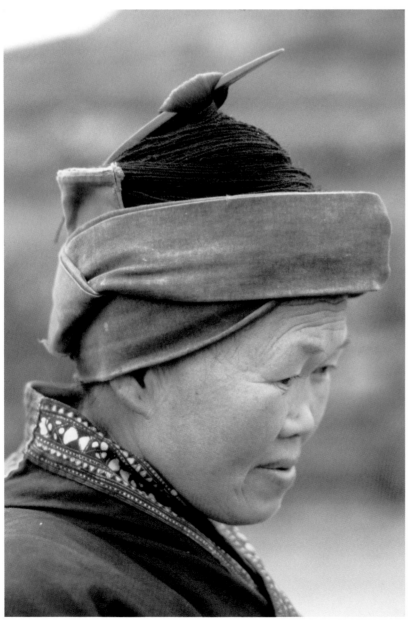 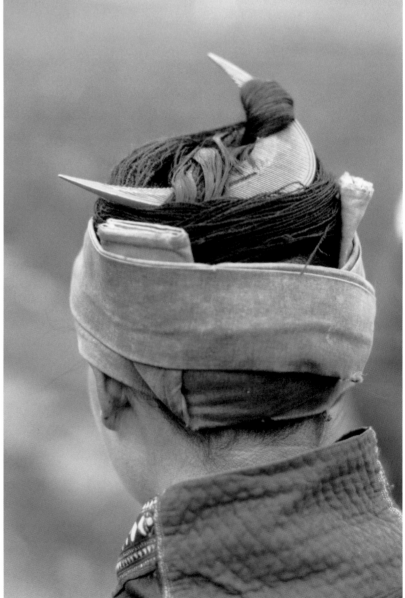

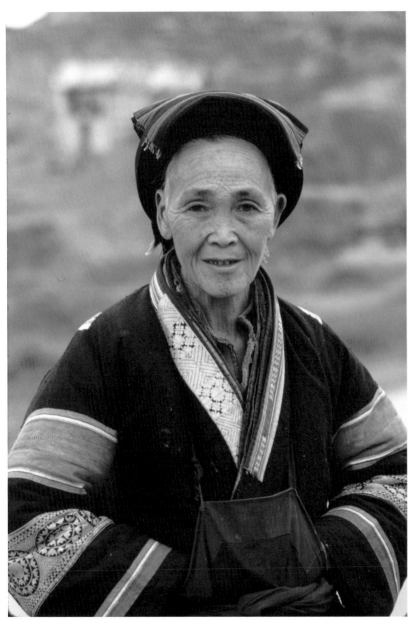

The Puyi must be appreciated from all angle, front, back and side profile, as in this case the fully costumed lady demonstrated the head piece was actually elegantly protruding beyond her head, with her forehead hair plugged bald. Their costume also use much batik and indigo dye from plant. /

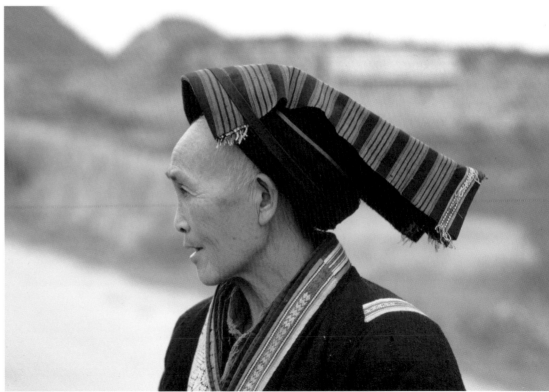

At the famous Huanggushu waterfall where I spent the night at a hotel, a newly constructed building since my visit two years ago, the hotel employer refused to give me a vacant corner suite with view of the waterfall as the manager returning later for night shift would need to stay in the best room. The daily long-distance bus from Guiyang, the provincial capital, to Anshung had stopped operating for over a year due to a court case regarding Guiyang bus station would not reciprocate and allow Anshung bus to travel to the capital, thus monopolizing the transport traffic.

/

At Puding and nearby Jijing of northern Guizhou, near the border with Sichuan,
houses were all of thatched straw roof, though made colorful by the Chinese
New Year red paper calligraphy posted. Children were occasionally letting off
firecrackers.

/

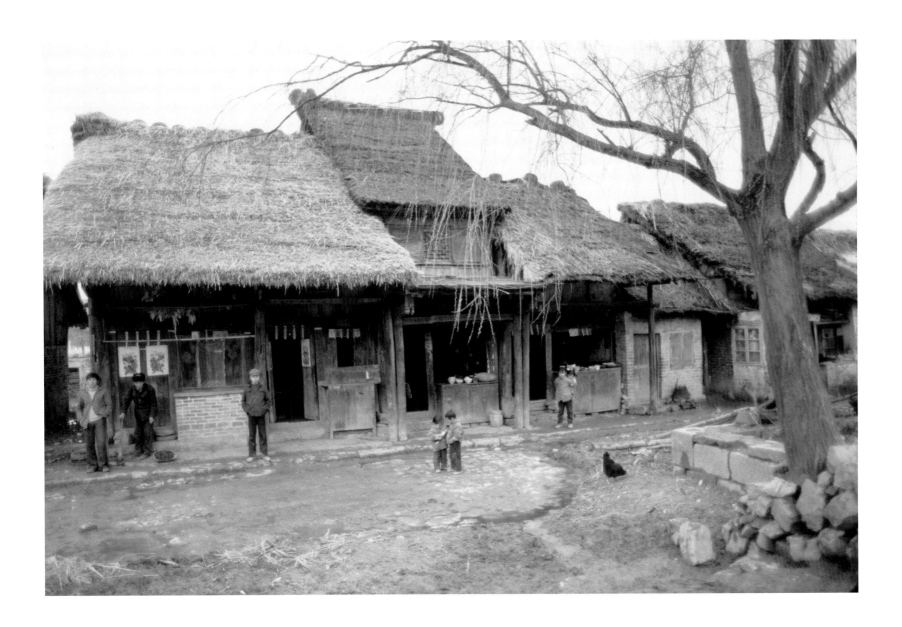

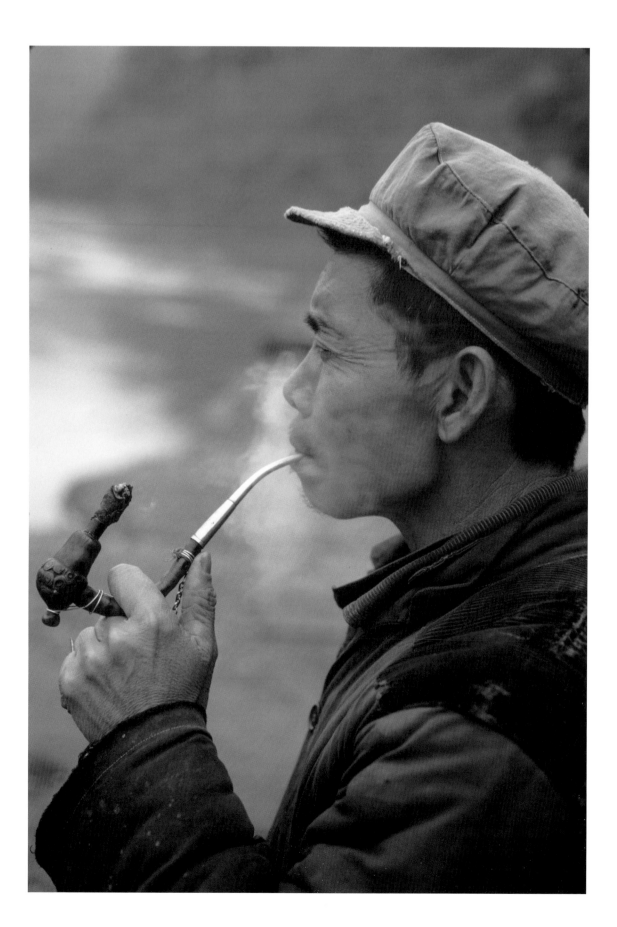

Though inhabited mostly by the Miao minority nationality, the men had already transformed and dressed like Han cadres and common people. But the bamboo pipe this Miao man smoked had a hand-rolled cigarette with tobacco leaf, rather than using branded cigarette.

/

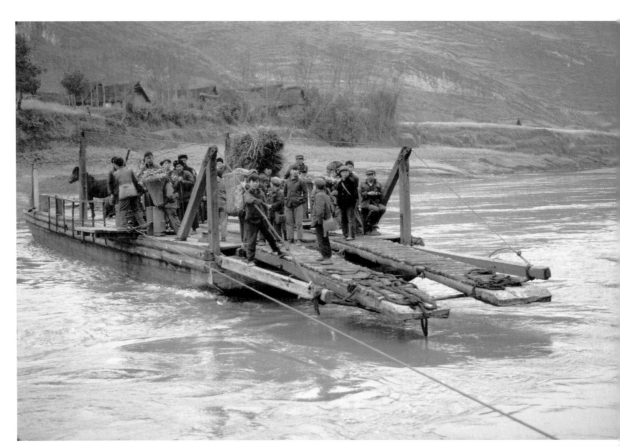

Rivers in remote China were plied by simple hand-pulled or winched ferry platform. This one is near Dafang at Liu Chung He. But at the time, a bridge was being constructed, soon to make the ferry obsolete.

/

Terraced fields, especially when flooded with water for new planting along the hillside, caught my camera's eye. While in Yunnan fields were already blossoming with new seedlings and vegetable flowers, here in northern Guizhou, spring was still around the corner in early March and night-time temperature still lingered below freezing. The planting season had yet to begin.

/

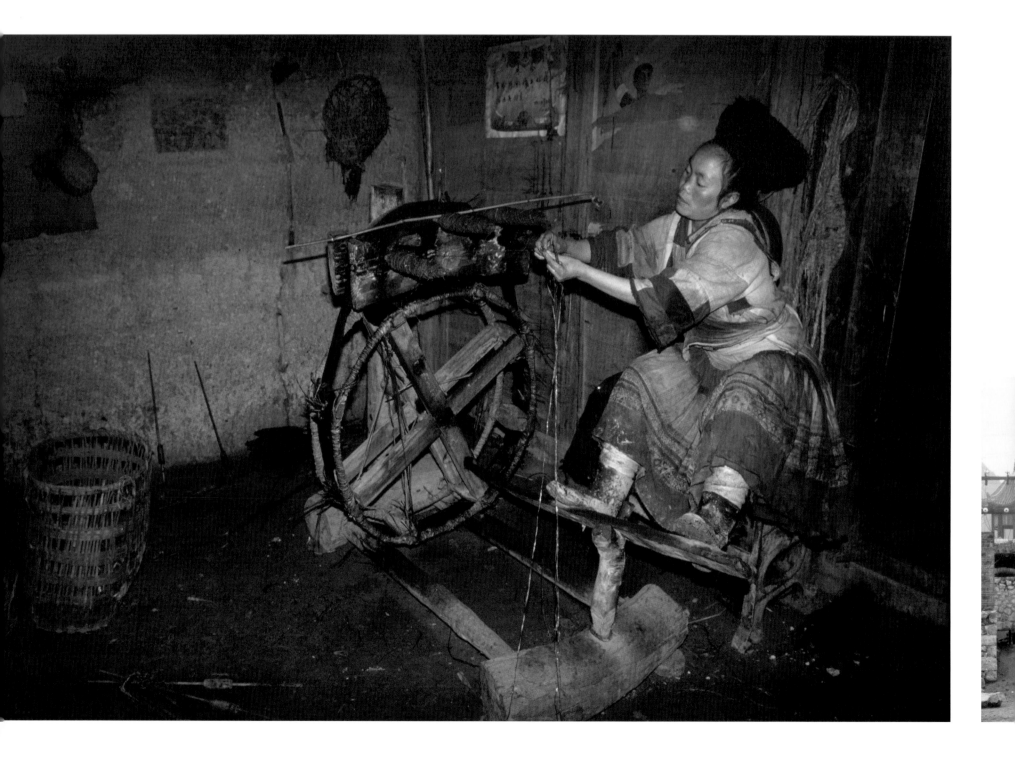

The Miao of Zhijin wear far more colorful costume, much of it made from hemp cloth. Here inside a home, a Miao lady was working a spinning wheel to prepare strings for weaving. Their headdress consisted of a wooden buffalo-horn-like piece, wrapped around by hair and dark cotton or wool strings. A girl would start wearing such hair style at the age of 12 or 13, and it could take half an hour to an hour to prepare the hair, which would usually be kept intact while sleeping. /

At Zhijin, a rarely visited remote county in the early 1980s, I found the architecture quite unique, with the thatched roof lined with a column of old and used cooking woks or wash basins turned upside down to hold down the ridge. Most of the utensils were already cracked with holes. /

A tall building in Zhijin from a distance gave the impression it may be one of the palaces and pavilions of Japan. The multistoried structure gave indication of where the Japanese may have learned their architecture style from China, and incorporated them into their massive and ceremonial buildings. /

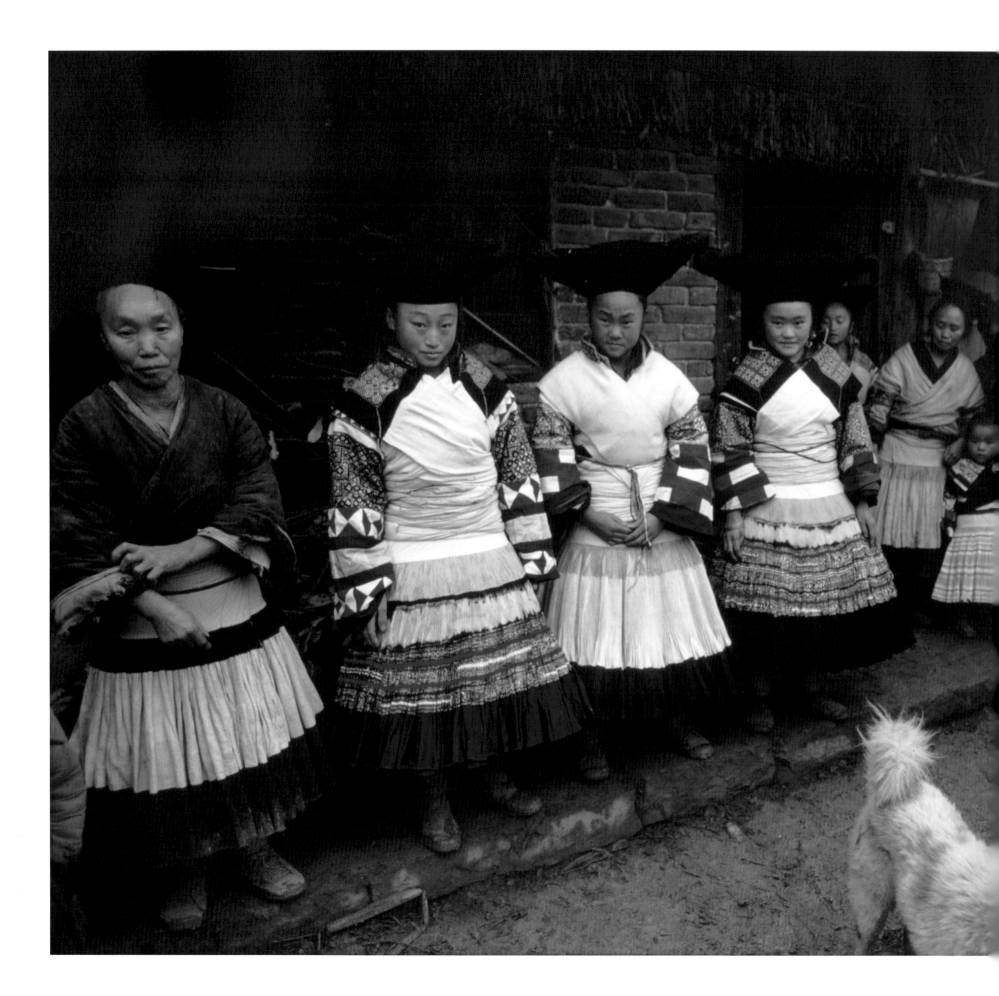

Batik skirts were favorite of the Miao of Zhijin. At the time, hunting was still allowed and a Miao man could be seen armed with a long rifle and hunting dogs when they went hunting in the hills. Most Miao tribe here were Christians, being converted to Christianity in the early 1900s by western missionaries who came to their area to set up churches.

/

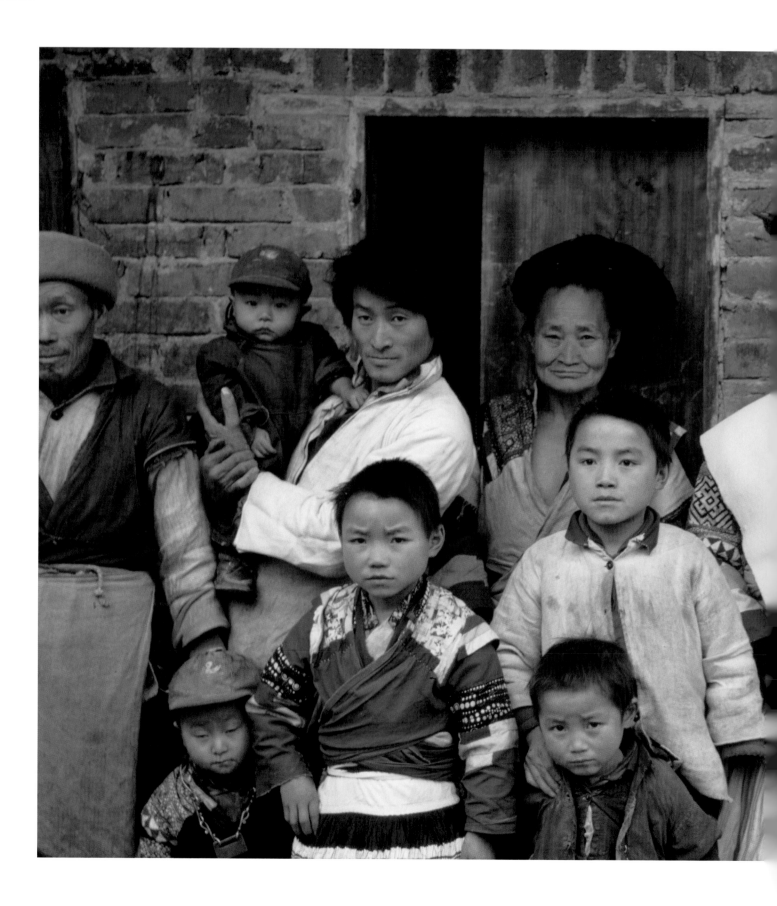

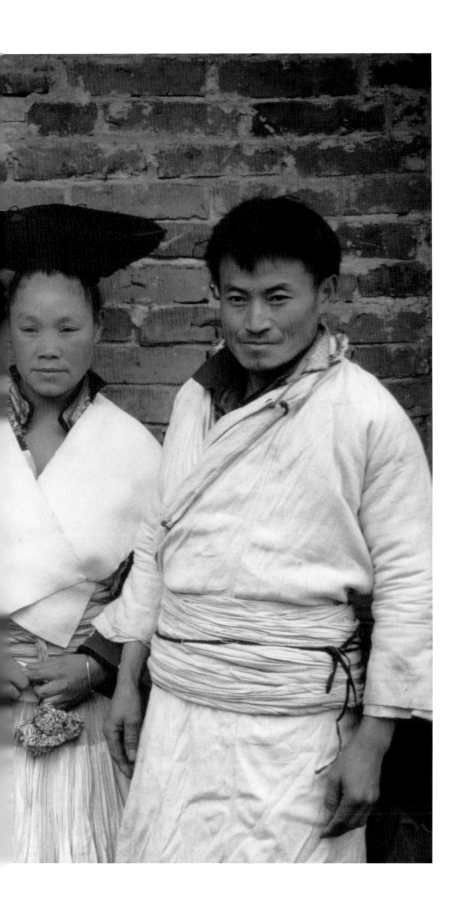

At Bijie County's Ganhe Commune, the brigade by the same name had an extended family with the mother and two sons. Tao Mingyang was the older brother, and with his younger brother and their family and kids, they posed for a picture. The father was at the edge of the photograph. Their biggest festival falls on the 18th day of the First Moon, named as "Tiao Hua", or Flower Dance Festival. /

I often ran into Miao groups along the road. As Chinese New Year had just passed, many families were having wedding ceremony. A group here carried two large jars of rice wine and a chicken, while the rest of the team were carrying rice grain as part of the gifts to a wedding.
/

The most popular musical instrument is the "Lusheng" or reed organ. Here an older Miao man played a tune while following the music with a traditional dance in circular steps.
/

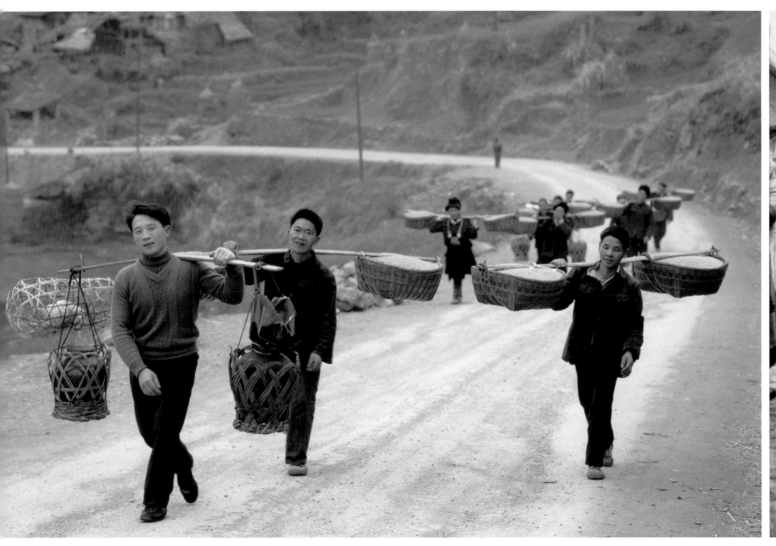

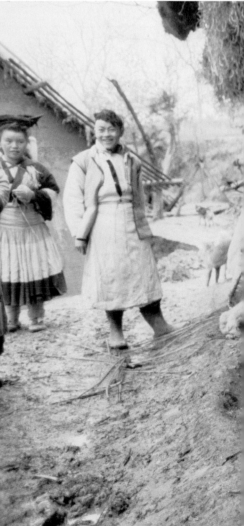

For centuries, the waterwheel had served the remote regions of Guizhou
for irrigation. This one at Danzhai along a river was made from bamboo,
carrying water from the stream upward to the paddy field above.
/

萬里遠遊永濟橋，

無奈只能留一朝，

坐看侗寨斜陽晚，

水車列陣送歸僑。

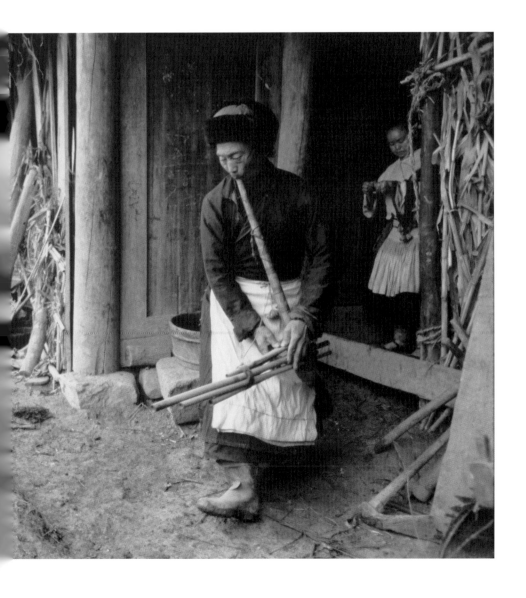

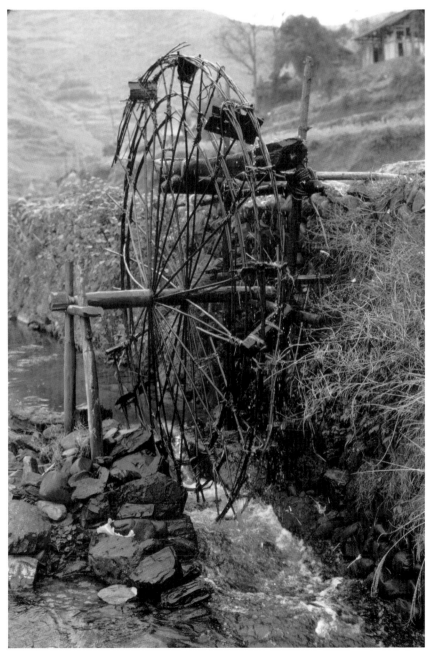

The Shui nationality at Sanduo had some of the most elaborate embroidered baby carriers. Here were three women and their babies with the carriers draping all the way to their ankles, with full motif designs. Near Guiyang the provincial capital, I purchased a bottle of the famous Maitai liquor for a meager 11 Yuan, today sold at over 1500 Yuan, with many being fakes in the market, at times refilled in used and old bottles.

/

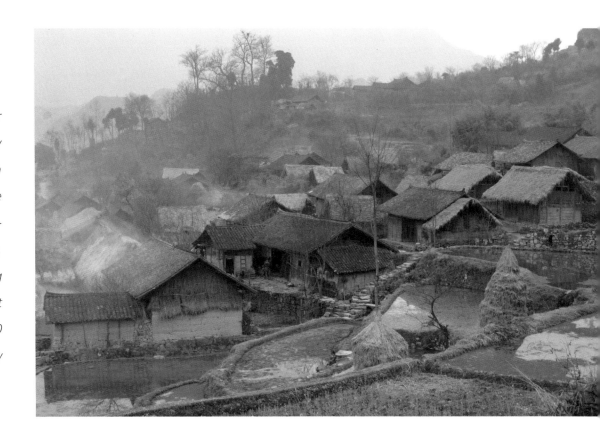

Near Huang Ping County at Chong An Jiang by a river market, I chanced upon two teenage girls wearing very colorful costume and followed them home some seven kilometers away, to Fengxiang Village, a mountain enclave of the little-known Ge people, then classified as a sub-group of the Miao. Within the commune of Chongxing, there were over seven thousand Ge people, and Fengxiang alone had over four hundred households, it was said that their ancestors migrated from Jiangxi to here over 300 years ago. Nationwide there were a total of over seventy thousand Ge.

/

At Fengxiang village, almost all families had the family name of "Liao". Here at the home of Liao Ruqi, I made a portrait for the entire family with three generations present. Liao was the headmaster of a local elementary school with 415 students and 28 teachers. Liao joined the People's Liberation Army for seven years and traveled widely during his military days before returning to Guizhou. A road to the village was only opened five years before my arrival, due to construction of a reservoir. Prior to that, it took over three hours to get into the nearest town at Chong An Jiang.

/

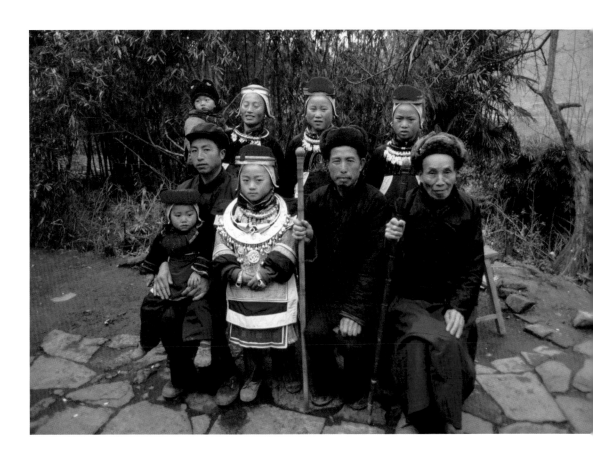

A young girl begins to learn how to embroider a costume at the age of eight, and it would generally take fifteen to twenty years to complete a full set of costume with many layers before marriage. Just the apron under piece, some twelve inches square, may require up to five years to complete the delicate needle embroidery. The batik motifs are elaborate and the embroidery extremely refined and detailed. It is not used often except during festivals and special ceremonies.
/

A young lady held on to her baby brother with elaborate silver hat. Such costume is reserved for the most important occasions like wedding or during the New Year festival.
/

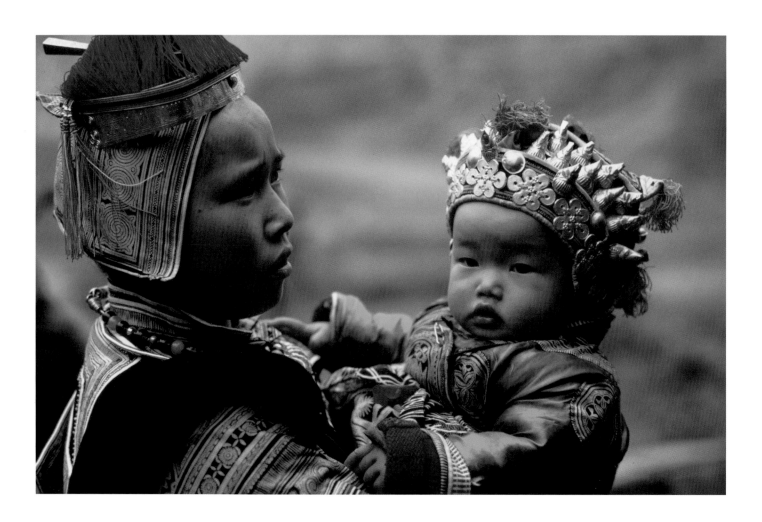

A fully be-costumed set would include heavy silver necklaces and bracelets, handed down from mother to daughter as heirloom. The red tassels over a silver headband signifies the lady is still unwedded and available. On the top of the red tasseled crown is a hole where a single silver chopstick would hold down the headdress to the hair curled into a bun. Once married, the red tassel would be removed.

/

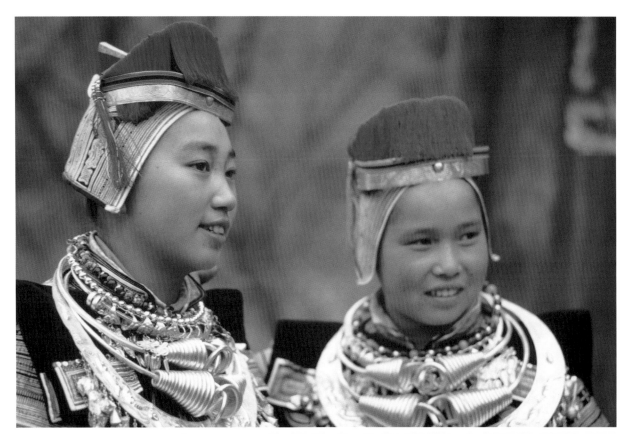

When the fully costumed Ge went into town at Chong An Jiang, they would stand out among all the locals and Miao who wear mainly indigo black, dark crown and dark purple colored costume.

/

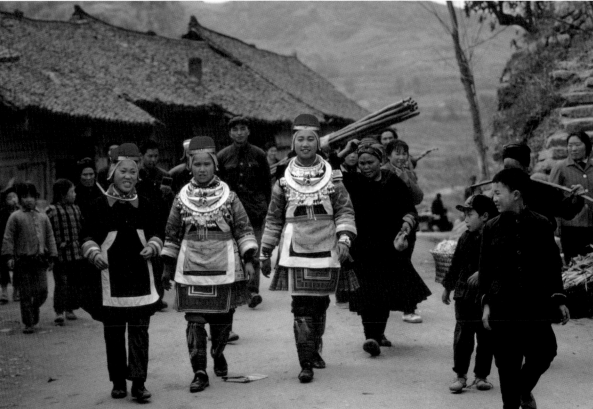

The once-every-five-day market of Chong An Jiang was set next to the river and tributaries. Large crowd would converge, selling or bartering pigs, cows and other livestock by the river banks. The Miao women, all in their costume, would be trading other sundry products.

/

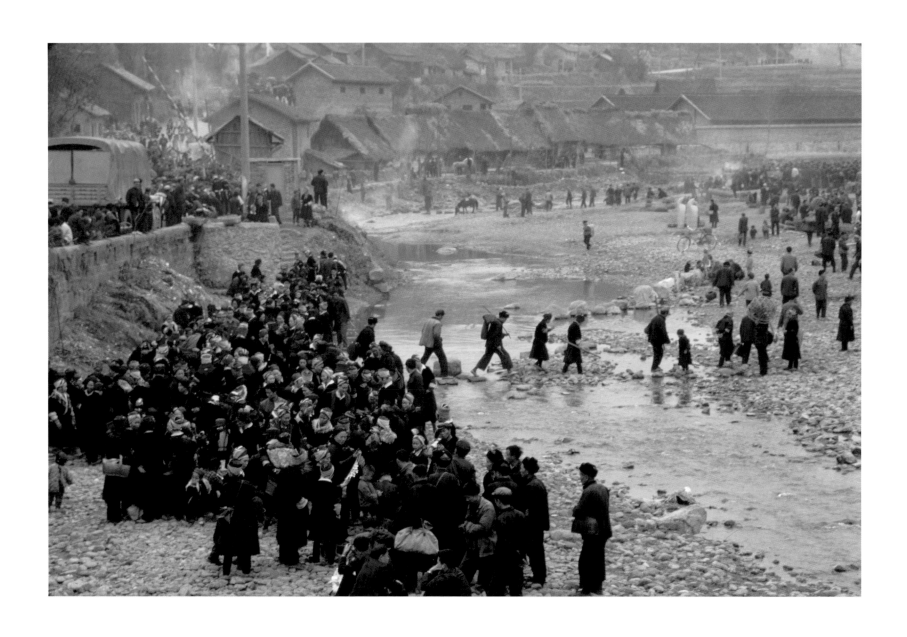

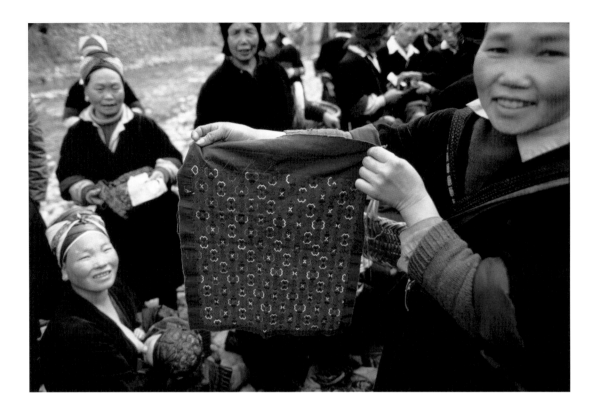

At the bank of the river, a Miao lady displayed her very fine needle work in embroidery. Such items, used as apron piece in second layer of the skirt, or smaller pieces as sleeve links, were frequently bought and sold at the market.

/

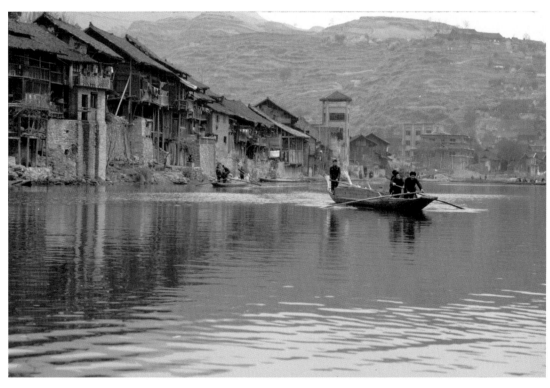

Neighboring villages would join the market day, some coming on boats temporarily serving as ferry for the villagers. The old building façade of Chong An Jiang still retained much of old charm China, in particular what rural Guizhou was like for centuries. As modern changes come rushing in, most towns are turned into non-descript ensemble of buildings, with no cultural or architectural significance.

/

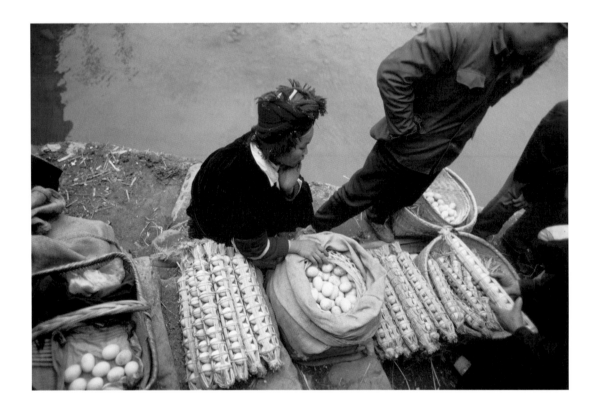

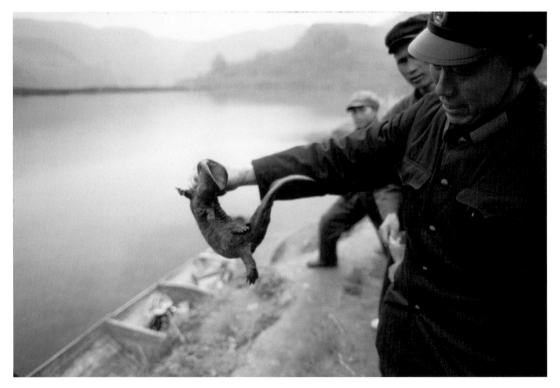

Another vender was selling "home-farmed" eggs. Tied with straw into a bundle of ten for safe and easy carrying, they were also sold individually. The Chong An Jiang is also famous for its WaWaYu, large salamanders that at times grow to over fifteen kilos, and cries like a baby, thus the name. A three catties one, around three pounds in weight, cost five Yuan Rmb. Now the amphibian is fully protected.

/

河邊苗民愛穿花，水中魚兒像娃娃，
躤陽河岸皆新事，畫眉野鴨賽烏鴉，
敬客牛角豬油巴，糯米甜如姊妹花，
清水江旁趕囍日，遠報海外情意加。

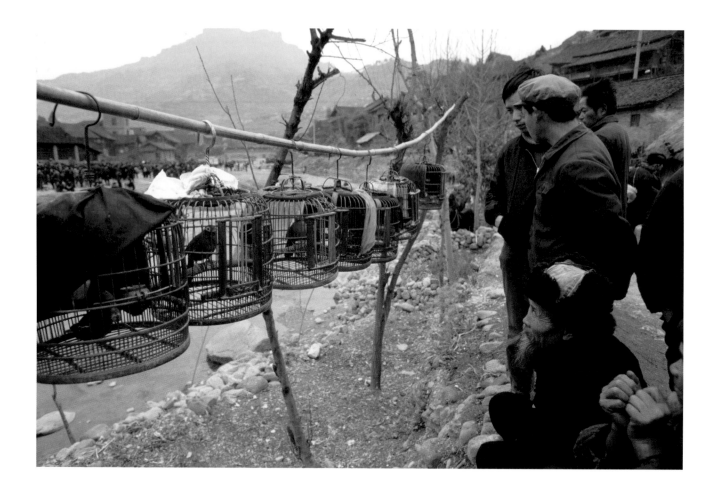

Also sold in the market were many song birds. Guizhou was home to the best "Huamei", or painted brow birds, priced for both their singing as well as fighting ability, when two males would challenge each other for a mate. Such activities were still prevalent in both Guizhou and Sichuan in those days.

/

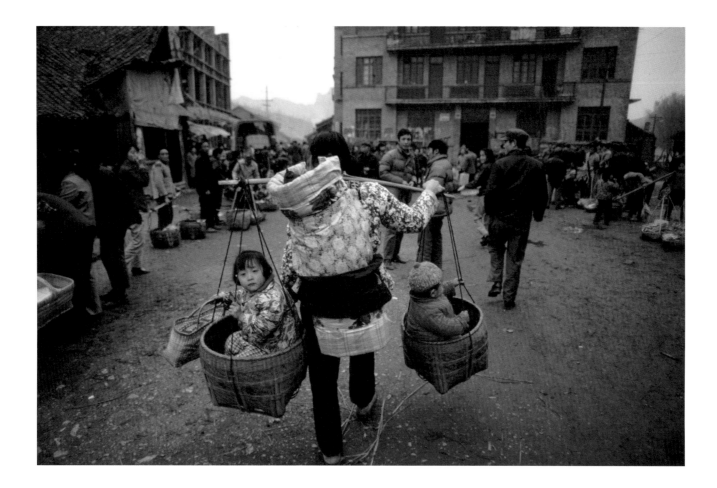

Near Huangping, a lady had obviously defied the government one-child policy as she carried one baby on her back while in two baskets over a carrying pole, she had two more young children she was taking along to market, presumably not as merchandise.

/

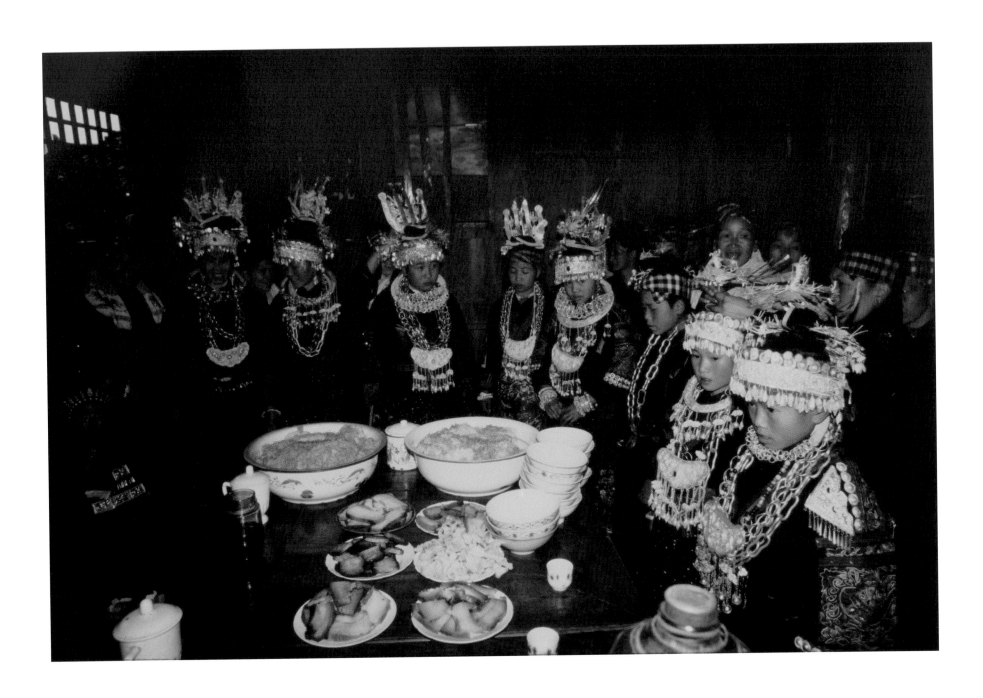

Xibing County is predominantly a Miao community. I visited many Miao villages by the Wu Yang He river. This was a special meal at Sheungjin Commune along the Qingshui Jiang river, set up inside a home, in my honor upon my arrival. The two-colored yellow and white rice was said to be "sister" rice, signifying the closeness of two persons. Young ladies came out in fully bejeweled costume to accompany me as host of the evening. Much rice wine was consumed, while the hostess would personally picked the fattest pieces of pork meat and feed it directly into the mouth of the honored guest.

/

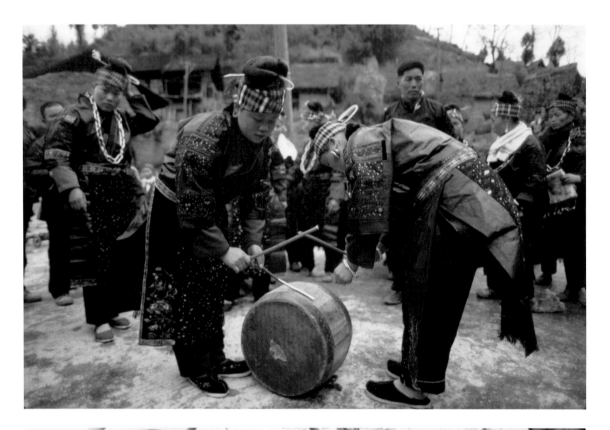

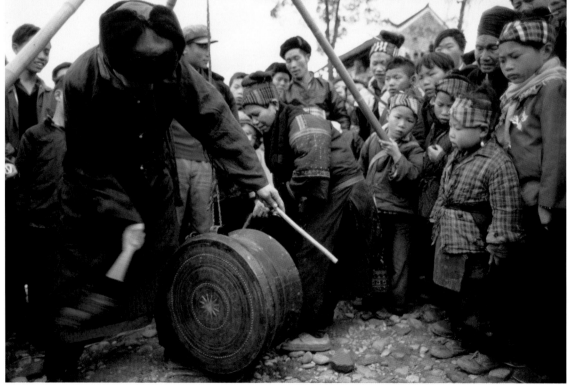

Despite age, old men as well as old ladies could play the bronze or wooden drum with percussion and rhythm. Such bronze drums were a relic of the past, but carried into the current century. They are used throughout Guizhou, Guangxi, Yunnan, and well into Vietnam as well. Every village in the ancient days had several bronze drums for ceremonial use. During the Great Leap Forward political movement in the late 1950s, many drums were taken and smelted down for the metal. Later during the Cultural Revolution, many more were destroyed. Surviving ones, especially still being used, are rare.

/

At Pingzhai Brigade, an entire festival was set up out of season for my benefit. Fully costumed Miao conducted the ceremonial dragon boat ceremony with elaborate decorations along the Qingshui Jiang river. Even the traditional act by a fortuneteller carrying a yellow umbrella chanting while sacrificing a chicken, followed by the hanging a chicken and three live geese around the dragon head was performed. Twenty rowers in two long lines stood and rowed with long oars. Their costume shiny and with yellow hats made from horsehair looked particularly dignified. A drummer in red would sit in front to conduct the rhythm and beat to unifying strokes. A young boy with a gong would be dressed up to impersonate a lady, fully bejeweled with all the silver necklace and bracelets, would sit in between. Now and then, fireworks and a double boom with flare would be shot off from the boat by a third man at the bow, using a bamboo-made canon.

This photograph, like many others, would grace the pages of the National Geographic with a 52-page article, the longest piece ever on China. /

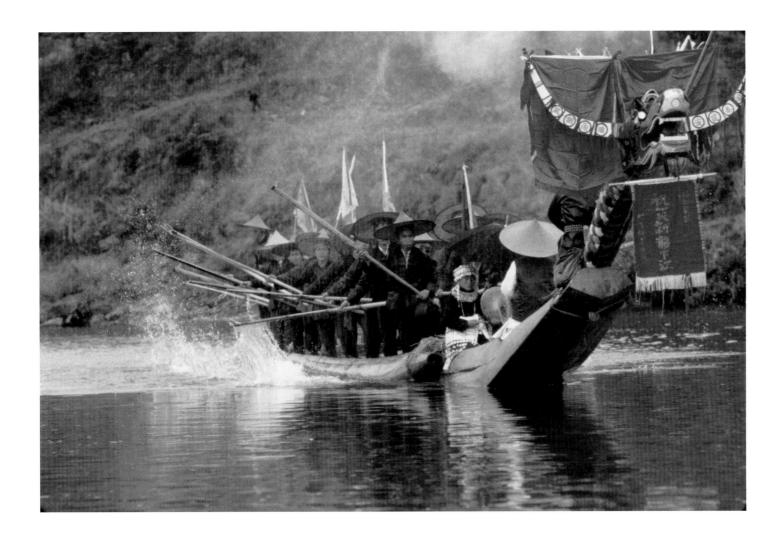

At Shaoxing within Liping County live the Dong nationality. It is said the Dong would first build their ceremonial drum tower before construction of their village. Here at Shaoxing, of the original five towers, only two remained and were restored. The one on the left was 11 story and the right one 13.
/

At another nearby village, a drum tower took up center piece of the village community. Each village must have at least one drum tower. Some larger villages may have four to five, with each clan building one for its own use. Old people often relax under it, and in time of alarm, the drum on top would be sounded.
/

At Shaoxing village, a third drum tower was in construction process. It takes between two to five months for its construction and all able men of the same clan must help to perform labor. This particular tower will have 13 levels. At Shaoxing, eighty percent of the people share Lu as their family name.
/

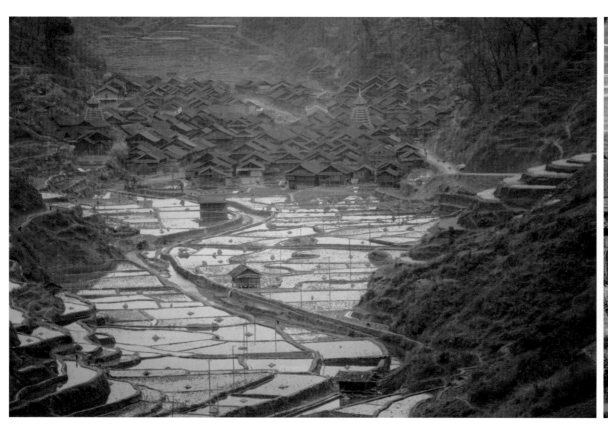
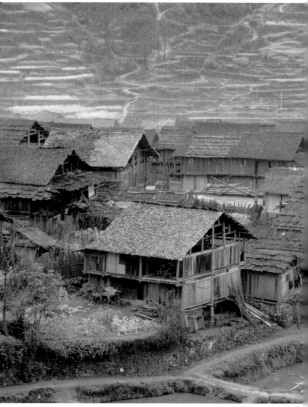

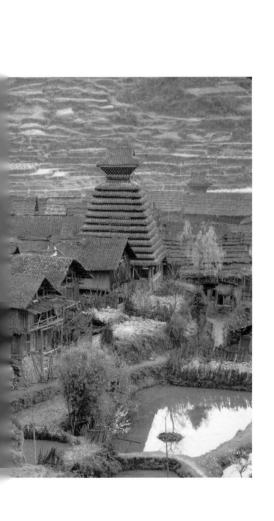

A young lady of the Dong group gave a natural smile though in those days, many were camera-shy except when going into a studio for portrait photography.

/

Large group of women, marching along country road, would arrive Diping Commune which was the festival ground. This seemed to be a gathering mainly for ladies.

/

On the Sixth Day of the Second Moon, women would gather for their Spring and Autumn Club Meeting. All neighborhood villagers, including some from Guangxi border region, would converge and enjoy a festive occasion. The Dong would dress in their best costume as a market place would be set up along the river.

/

The Qinyang Bridge, with five pavilions above it, is a hallmark of Dong architecture and is situated at Sanjiang just inside Guangxi Province. Such bridges spanned rivers large and small and could be seen along many countryside villages near the border of Guizhou with Guangxi. They are generally called "Wind and Rain Bridge", allowing farmers to shield themselves when the weather suddenly turn bad. Many waterwheels were used along the river, but such scene would soon disappear as I traveled to the region again a decade later. By then, the bridge would become a major tourist destination.
/

三江程陽風雨橋，
五樓並立欲飄飄，
飛檐重樑雖木砌，
溝通山河志不搖。

As a passing scene, a farmer and a bicycle crossed the Chengyang Bridge as the sun set to the west, carrying with it only a shadow of the past. At the center of the bridge were inscribed several poems by a well-known Chinese scholar who was also famous for being very patronizing to the leadership, in particular to Chairman Mao.
/

此公治史又治詩，
無奈亦修馬尾詞，
好放新言行舊事，
勸君供奉要三思。

1983.2 -

By October of 1983, I again embarked for China from Los Angeles, now heading to China's northeast, into former Manchuria. At the National Geographic, this was named the Northeast China Expedition.

With twelve pieces of luggage, I would travel by plane, by train, by car, then by horse, camel and ultimately even on a reindeer and snowshoes, through the blistering cold yet beautiful winter landscape of China, bordering the former Soviet Union.

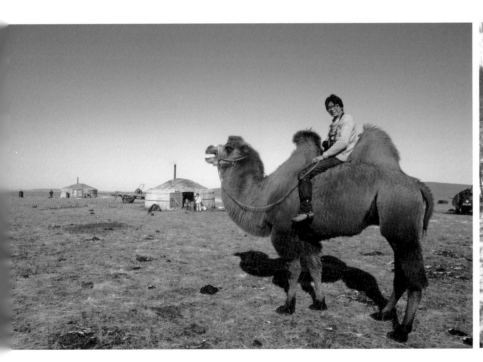
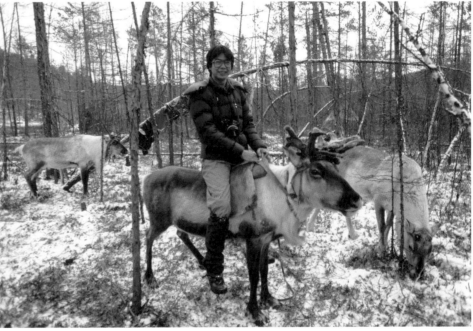

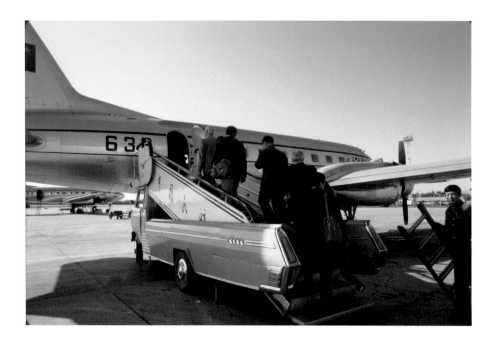

I took a flight from Beijing to Hohhot, capital of Inner Mongolia, then by train to Hailar in the eastern part of the autonomous region. At the time, the bridge car, serving as a ladder to the plane, was designed with Art Deco detailing.
/

Outside of Hailar is the Mongol community of Xilinhexi Commune, some 35 kilometers away. A sheep was slaughtered and cooked to entertain me, a rare visitor to such remote places. Behind was a Mongolian yurt, serving as home for the nomads in the Steppe country.
/

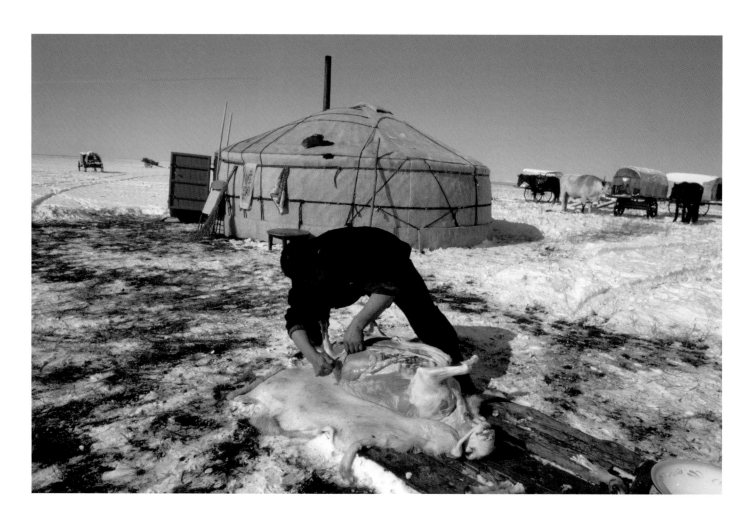

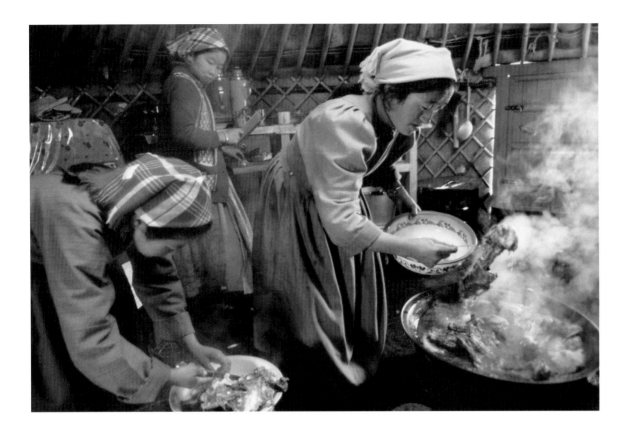

The Mongol tribe here, belonging to small periphery group, the Buryat in the north, wear long robes in light brown color. Here inside their yurt home, two ladies prepare freshly slaughtered mutton with soup for the guests.
/

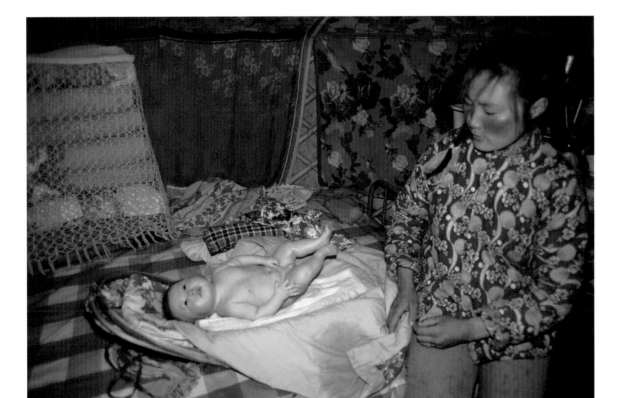

A Mongol young mother had just given her infant son a warm bath. Living inside a yurt made with felt wool on the outside, once a fire is burning in the fire hearth, the interior would become a very warm home even during the bitter winter.
/

I visited a group of Ewenki nationalities, one of three sub-groups of this minority. Around Hailar, they lived much like the Mongols in yurts. A portrait of an extended family showed how such family, with special child-bearing quota from the government, had become rather large.

/

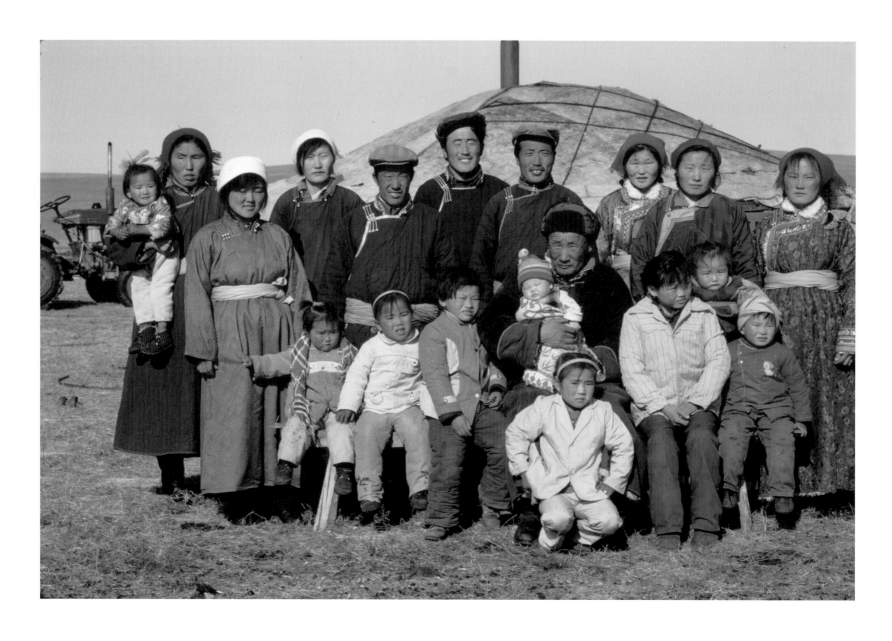

At a local school yard, the students got onto a seesaw in group, enjoying a rather

communal experience, similar to the commune village they were then living in.

/

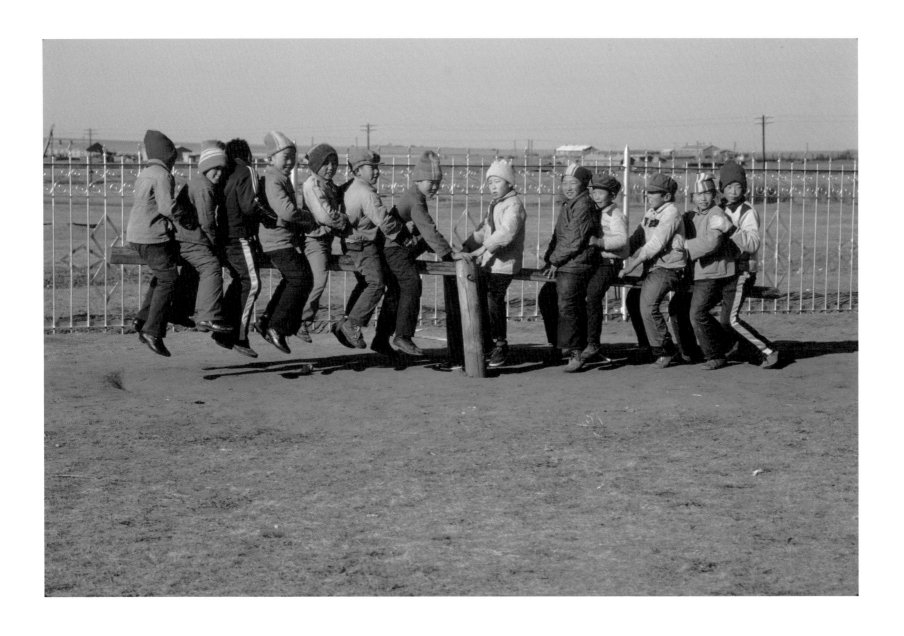

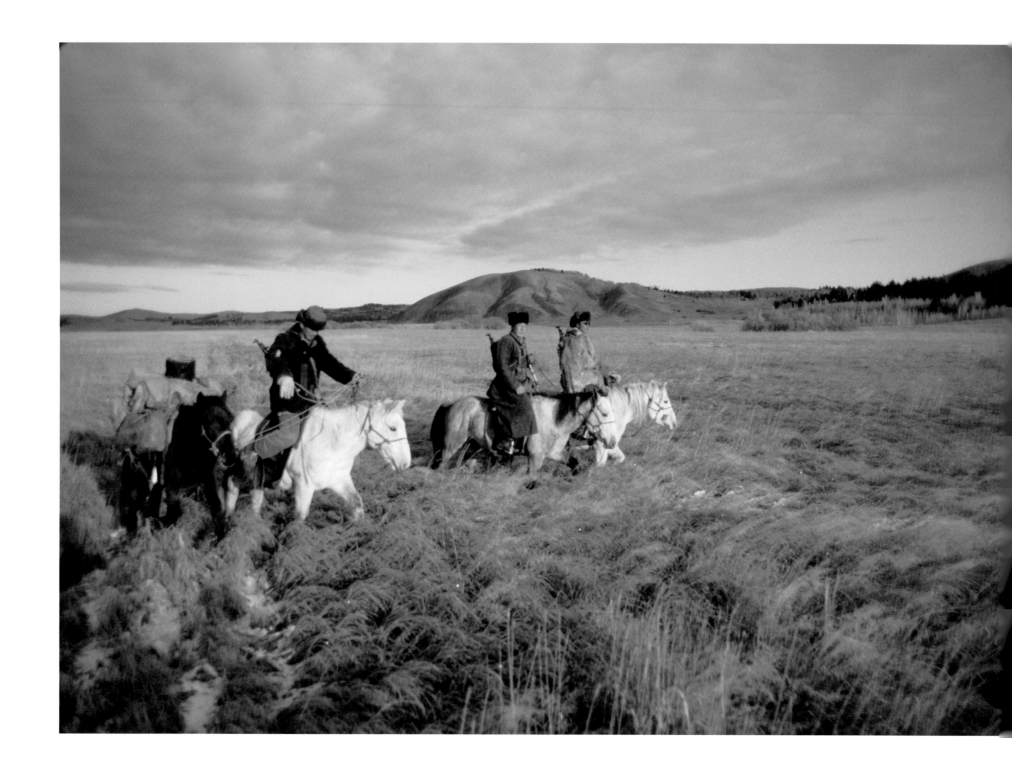

On horseback, I went with a group of four Ewenki men for an overnight hunt with semi-automatic rifles. The field had already taken on a coat of frost and the night temperature dropped way below freezing. But with a couple bottle of rice liquor, the hunters spent the night inside a wooden shed while I was hugged to my down sleeping bag, nursing my rear-end after riding for long distance on a wooden saddle. The yearly hunting quota for moose here was eight animals. One extra quota was specially allocated during my outing, but none was gotten. /

Sheep were counted from the hold, then herded to a nearby town to be sold and slaughtered as winter set in. Here they were counted one by one, as they left their hold to be driven off. Each time, the government purchase would be in thousands of sheep and goats. A sheep would cost approximately 30 Yuan depending on size and quality. The best sheep would cost around one Yuan per catty, or half a kilo. /

Buildings of the area were painted largely in yellow and blue, with motifs and designs reminiscent of those I had seen in films on Russia, then the Soviet Union. Clothes left for drying would return with a layer of ice on the outside. /

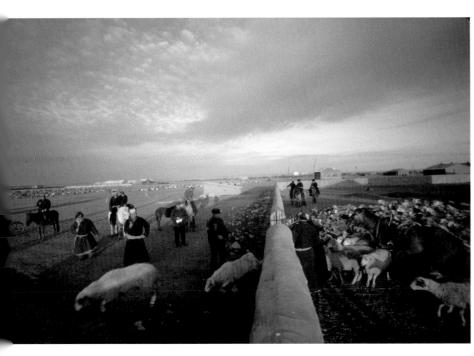
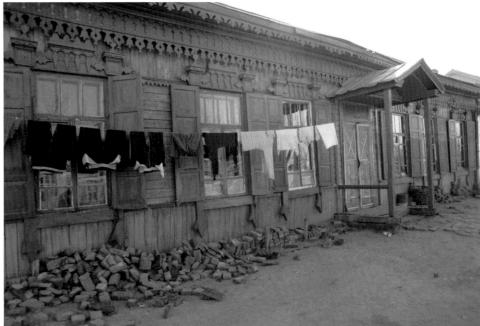

 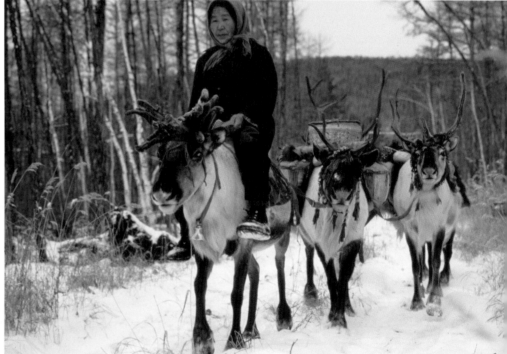

A logging train with only one passenger carriage would take me to the end of the line at the town of Mangui. Here outside of town I reached Aoluguya, translated from Ewenki as poplar forest, a settlement of the Yagut Ewenki, the only nationality sub-group that remain nomadic hunters and raising of reindeer as pack animals. They had a total of thirty-two households with 166 individuals remaining in their tribe at time of my visit in 1983. They were moved twice, first from their nomadic camp at Qiqian adjacent to the national border with the Soviet Union, and finally settling down outside of the forestry town of Mangui in 1965. I were to visit three more times in subsequent years. /

When moving camp from one location to a new hunting ground, the ladies would follow with their herd of reindeer, using them as pack animal to carry load. Each reindeer could carry up to a hundred pounds of load. /

In a week of staying with the Yagut Ewenki, I tried to document remnants of their past as much as possible, though it was fast eclipsing. To demonstrate their hunting prowess, they tried to get a moose, shot it half dead, so upon my arrival I could photograph them finishing the prey off. But it was not to be. Instead I spent much time in camp, observing their daily activities feeding reindeer, a job of the women. With a salt bag made with moose skin with strings of moose toe nails hanging outside, the sound it made would attract the reindeer to lick up the salt the lady would dispense by hand. /

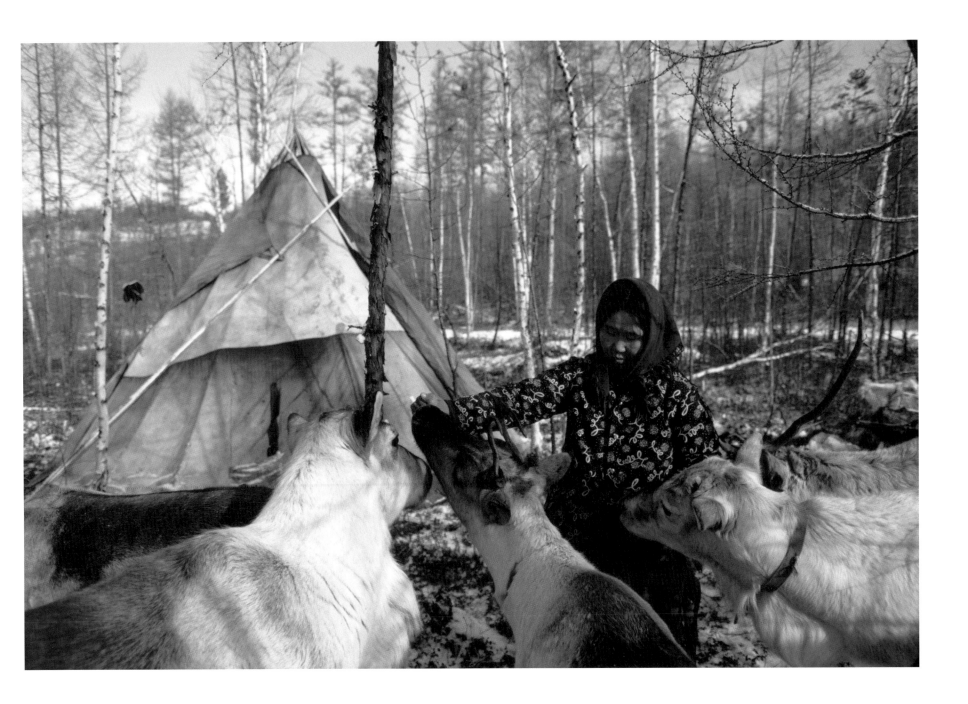

An Ewenki older lady proceeding to skin a squirrel, called "Hui Su" or gray rat here. She started with the legs with a small incision, such that the entire coat could be rolled back and saved as one unbroken piece. Such self-taught taxidermists are used to skinning animals, large and small, such that their pelts or skins could be sold to collectors and fur traders.

/

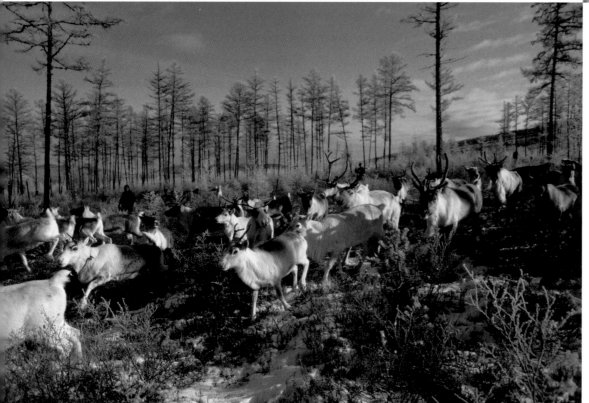

The entire herd of reindeer in China was concentrated with the few Ewenki families living outside of Mangui at the time. Total number may be less than 1100 animals. Over the years, some 400 reindeer had been sent to various zoos within China. Herding of these animals to grazing grounds, with the lichen being their main diet, are done communally which each family sending some of their abled bodies, both men and women.

/

A pure white reindeer is considered sacred by the Ewenki and would never be slaughtered. Here this full white animal even had white velvet anthlers.

/

Every family would have one or two rifles. For security reason, the guns were kept by the government and only dispensed when the hunters go into the forest to hunt. Here two Ewenki returned from a day's outing with a few squirrels and several "Feilong", a delicacy pheasant of the north that was said to be served in Beijing during state dinners.

/

The Tee-pee like tents of the Ewenki used oiled canvas or birch bark on the outside during summer, and wrapped with animal fur during the winter. These can be the skin of a deer, a moose or other furred animals. When a fire is started, the tent felt perfectly warm, even during the bitter winter. Here an older hunter Jessca, seated, was head of one household.
/

Mariasol, then a middle-age lady, was the wife of the best hunter Lajimi. Here she was making the Ewenki bread with flour inside a tent. She would later become a close friend as I went back three other times over the next few decades in documentating the Ewenki. Subsequently, a short film we made is focused on Mariasol, by then into her 90s.
/

As a teenager, Hexie with her elder sister Dekesha were demonstrating how a reindeer's anthlers could be harvested with a saw. While a spotted deer anthlers could fetch 300 Yuan per half kilo, that for the reindeer anthlers are considered inferior and was only paid 45 Yuan per half kilo. Each year, the entire herd yielded around 250 kilos of anthlers . The Ewenki were hoping the prices would be adjusted to be closer to those of the spotted deer.

/

Out on a hunting expedition, Lajimi on the left and Jiedao on the right were wearing leather winter clothing and pants. Lajimi's pants were made from moose skin, and both had long skis for going through the snow. The skis, acting like snowshoes, had a layer of moose skin on the bottom, with hair facing forward position so as to control sliding downhill.

/

Forty-two years old Liska led her grandson on a reindeer as they began to get ready to move camp to new hunting grounds.

/

Such birch bark container with moose skin lining had over time become a rarity as not many moose are left to hunt. Let alone the nomadic lifestyle had come to a close. But in the early 1980s, it was very much alive and I was able to collect some of these utilitarian relics.

/

Dekesha preparing saddles and saddle baskets made from birch bark with outer layer of moose skin lined up outside their tent, getting ready for another outing.

/

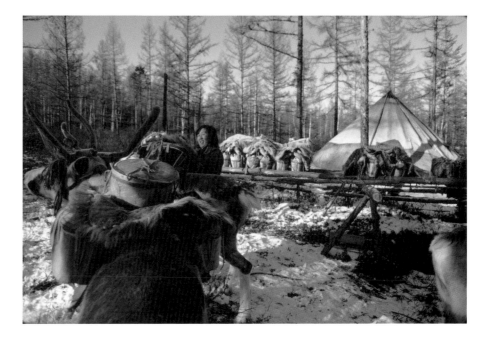

Birch bark objects were used by many people of the artic and Siberian region. Here with the Ewenki, they made many utilitarian items using birch bark with intricate motifs, like bowls for drinking and eating, match boxes or tobacco boxes. Larger ones, often with reindeer or moose design on them, were used to put anything from tools to sewing equipment or even food and flour. Such objects however had disappeared as modern products, easily gotten in the market, replaced such ancient crafts. /

Inside a tent, seated to the left was Heixi, then a young teenager, was a sharp shooter and an accomplished hunter. Soon he would be recruited into the People's Liberation Army and spent four years of service, becoming fluent in spoken Chinese at the same time. /

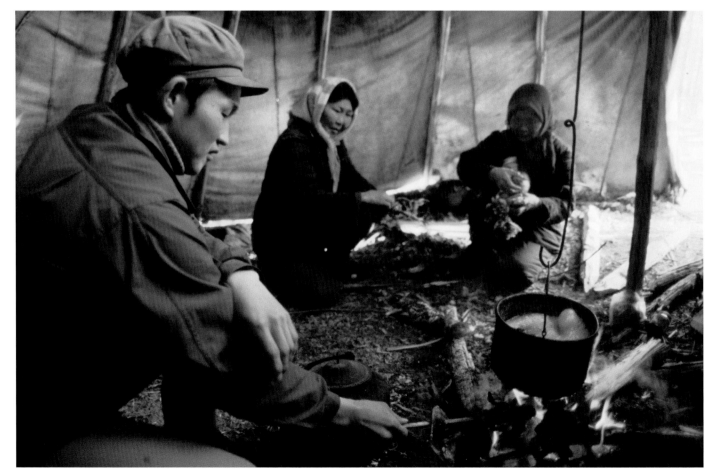

Dancing and singing around a bon fire was customary for the Ewenki, even during the colder months of the winter. Such gay making is often accompanied by much drinking and feasting, as all animals hunted were traditionally shared by everyone in the clan, though the successful hunter may receive a little more and special pieces of the prey, as well as the pelt which could then be sold.

/

Niuna was the last remaining shaman of the Ewenki. She would conduct daily chores like everyone else, and would only be called upon when needed to perform religious connection to the spirits. In such cases, she would put on her leather costume and with a drum got into a trance before being able to make fortune telling or proceeded to drive out evils. She would also make special spirit boxes for newborn infants, where their spirit would supposedly reside within, with a wooden bird representing that spirit. /

With a wooden horn, at times with carved motif of reindeer or a moose,
Alexander demonstrated how by blowing, it created the sound of a deer
ready to mate. Turning the horn around and sucking it, a low tone would
make a sound resembling that of a male moose. Wearing a semi-automatic
rifle, Alexander went out hunting and ice-fishing with me. He was also an
excellent carpenter in making wooden snow sleds. /

Alexander was another accomplished hunter with great experience. He showed me hidden away in the woods, the very last remaining specimen of a birch bark canoe. With a length of over ten feet, the slim canoe was used in particular for hunting of the moose, which like to come to the river or lake side for drinking water in the dark. Before the War when a young man, it was said no money was used for transaction. Everything was bartered. A catty of liquor is worth seven squirrel skin, and ten boxes of matches also was worth three skins. Sixteen squirrel skins could exchange for a bag of flour.

/

The early settlement in wooden huts from the mid-1960s were still visible while the Ewenki had recently moved into new brick houses, thirty-two such houses were assigned to the tribe, one for each household. In another three decades, they were to move into yet newer premises, posh alpine like lodges with a loft. /

I next visited the Oroqen nationality, another tribe that were former hunters but soon to be settled into a sedentary life. By the 1980s, few hunters remain. Their fur clothing and costume came with a hat made from a year-old deer with its anthlers barely showing as points. This outfit helps the hunter to camouflage himself when hiding in the bush while stalking his prey. /

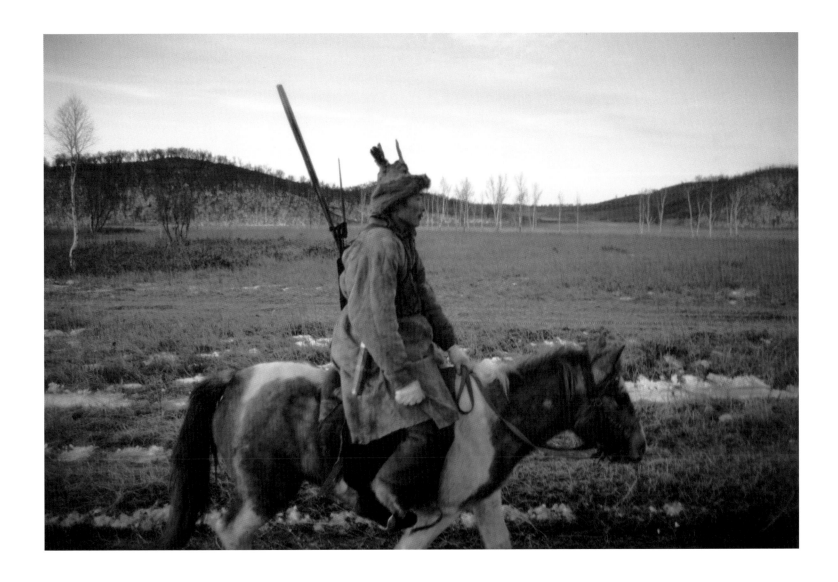

Three generation of an Oroqen family with the grandmother, the son, his wife and two children in their home. The husband was in his full winter hunting outfit using leather coat with fur on the inside. Gloves and boots were likewise made from skin. /

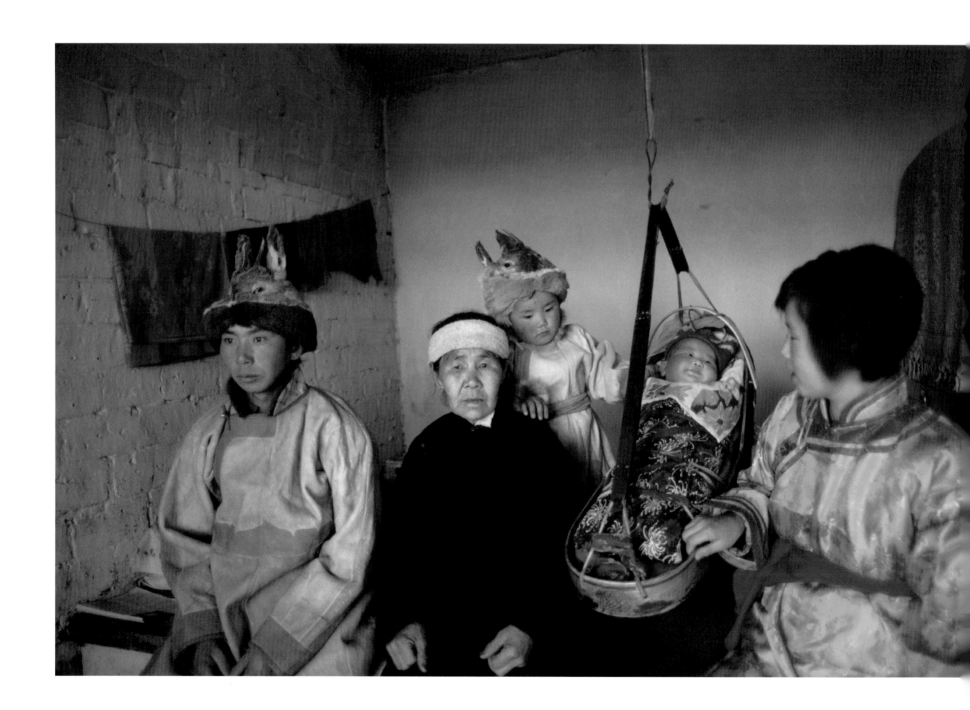

The cradle for an infant was made with flexible wood, birch bark, and painted colorfully on the outside. The boy, about four years old, had also a traditional hat made from a roe deer. At one year old, the deer head with eyes sewed in had become the most unique part of an Oroqen costume. At the time of my visit, there were less than 4000 Oroqen people remaining in China. /

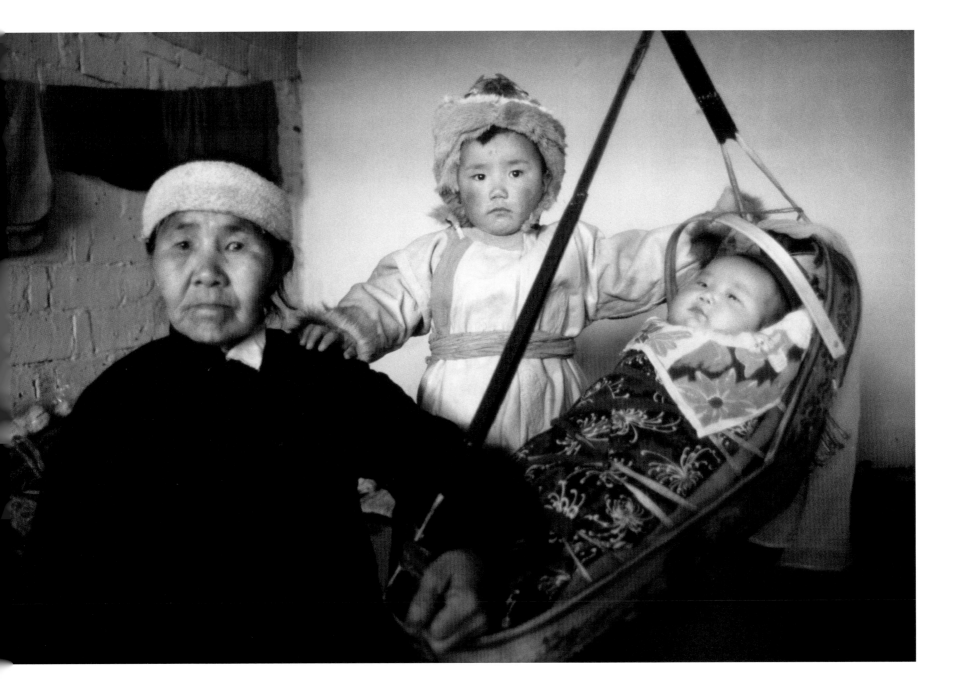

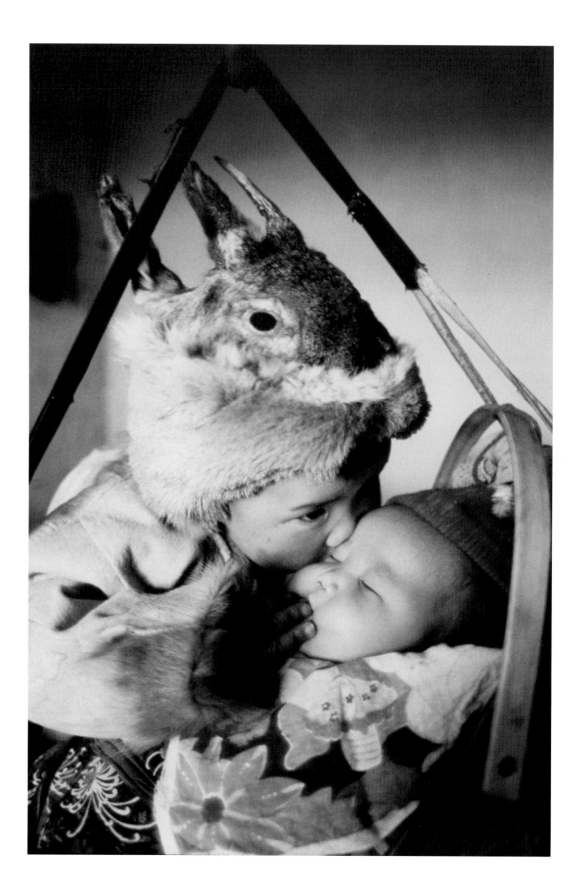

Without prompting, the young boy suddenly hugged his younger brother by the head and gave him a loving kiss, a perfect finale to my visit to one of the smallest minority nationalities of China.

/

Epilogue

Revisiting images and writing about the first ten years of my career, things from almost half a century ago, is not easy. It is certainly more than just "bringing back old memories". It is both a visual and mental journey, backwards.

I almost wanted to continue on that journey into the second decade, not stopping at ten years. That is not to be … yet. Life and work must still move forward, as I am charting new discoveries of exploration, and honoring ongoing commitments to projects in conservation.

Later this year, I will go on that particular journey, again backward, in order to salvage and salivate on those memories before they fade even further into obscurity. Fortunately, my early photographs have now largely been digitized, halting the deterioration which happens to analog slides on film.

For friends and the public at large, I hope the promise of a sequel to this first book is for the next one, and the next volume, and so on, each covering an additional ten years.

I have always said, "Go away for a week and it's a trip. Go for a month and it is a journey. Go for a year and it is part of your life." So, I am glad now to say that I have spent several lifetimes so far exploring. May that "life" continues.

Winter night while a full moon is high,
Final journey with a halo in the sky,
A bridge each year to meet your bride,
A century on earth turtle and crane now you ride.

臘月十五月中天，
外置一環送歸程，
七夕十年勤相接，
百歲回首鶴龜齡。

作者・Wong How Man ｜ 攝影・Wong How Man ｜ 發行人・劉鋆 ｜ 美術設計・羅瓊芳 ｜ 責任編輯・王思晴 ｜ 法律顧問・達文西個資暨高科技法律事務所 ｜ 出版者・依揚想亮人文事業有限公司 ｜ 經銷商・聯合發行股份有限公司　新北市新店區寶橋路 235 巷 6 弄 6 號 2 樓　電話 02-29178022 ｜ 印刷・禹利電子分色有限公司 ｜初版一刷・2019 年 5 月／精裝｜ 定價・3800 元 ｜

ISBN・978-986-97108-2-4 ｜ 版權所有・翻印必究 Printed in Taiwan

9 789869 710824

03800